MASTER PAINTINGS FROM
THE PHILLIPS COLLECTION

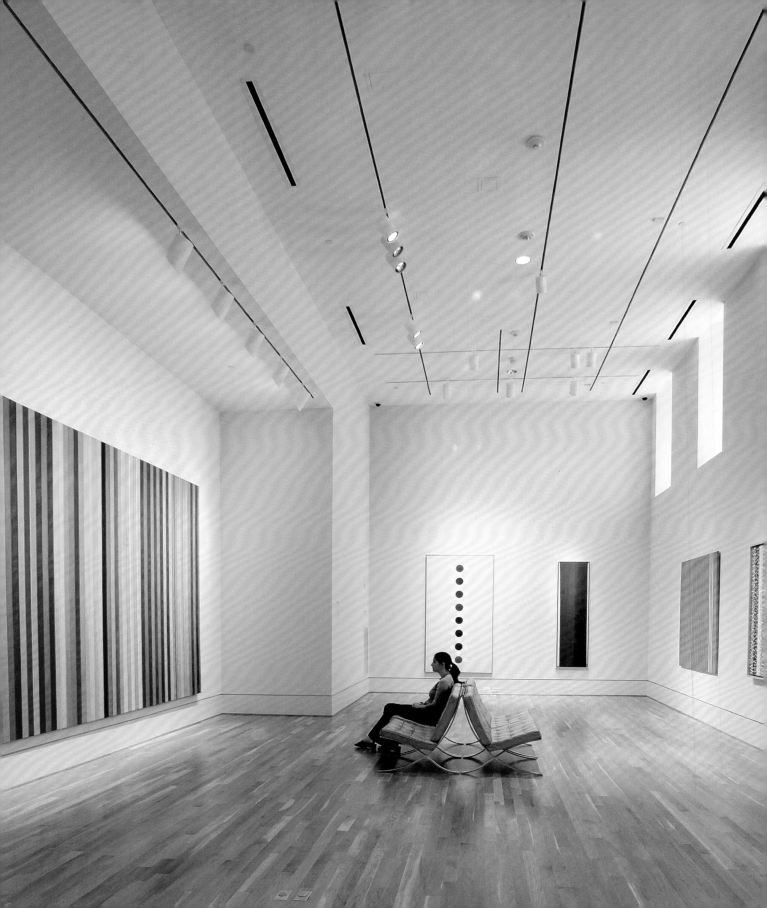

MASTER PAINTINGS FROM THE PHILLIPS COLLECTION

ELIZA E. RATHBONE AND SUSAN BEHRENDS FRANK, WITH AN ESSAY BY ROBERT HUGHES

WITH CONTRIBUTIONS BY SUSAN BADDER, JOHANNA HALFORD-MACLEOD, RENÉE MAURER, KLAUS OTTMANN, ELSA SMITHGALL, AND VESELA SRETENOVIC

THE PHILLIPS COLLECTION

The Phillips Collection, Washington, D.C., in association with D Giles Limited, London

© 2011 The Phillips Collection, Washington, D.C.

First published in 2011 by
The Phillips Collection
1600 Twenty-first Street, NW
Washington, D.C., 20009-1090
www.phillipscollection.org

in association with GILES
An imprint of D Giles Limited
4 Crescent Stables, 139 Upper Richmond Road
Lond on SW15 2TN, UK
www.gilesltd.com

ISBN: 978-0-9837694-0-8 (softcover edition)
ISBN: 978-1-904832-92-8 (hardcover edition)

The essay by Robert Hughes and most entries by Johanna
Halford-MacLeod were previously published in The Phillips
Collection's *Art beyond Isms* (Washington, 2002).

Dimensions are given in inches followed by centimeters.
Height precedes width.

For The Phillips Collection:
Project management and editing by Ulrike Mills

For D Giles Ltd:
Copy-edited and proofread by Sarah Kane
Designed by Anikst Design, London
Produced by D Giles Limited, London
Printed and bound in China
Photographs by The Phillips Collection, Washington, D.C.

Library of Congress Cataloging-in-Publication Data
Phillips Collection.
 Master paintings from the Phillips Collection / [Eliza E. Rathbone and
Susan Behrends Frank ; with an essay by Robert Hughes].
 p. cm.
Includes bibliographical references and index.
ISBN 978-0-9837694-0-8 (softcover ed. : alk. paper) --
ISBN 978-1-904832-92-8 (hardcover ed. : alk. paper)
1. Painting, Modern--Exhibitions. 2. Painting--Washington
(D.C.)--Exhibitions. 3. Phillips Collection--Exhibitions. I. Rathbone, Eliza
E., 1948- II. Frank, Susan Behrends. III. Hughes, Robert, 1938- IV. Title.
 ND189.P473 2011
 758'.4074753--dc23
 2011031102

Front cover illustrations:
Edgar Degas, *Dancers at the Barre*, c. 1900
Pablo Picasso, *The Bullfight*, 1934
Richard Diebenkorn, *Girl with Plant*, 1960

Back cover illustration:
Kenneth Noland, *April*, 1960

Frontispiece:
The Sant Building with work by Gene Davis,
Thomas Downing, Morris Louis, and Alma Thomas,
photograph Robert Lautmann, 2008

Contents

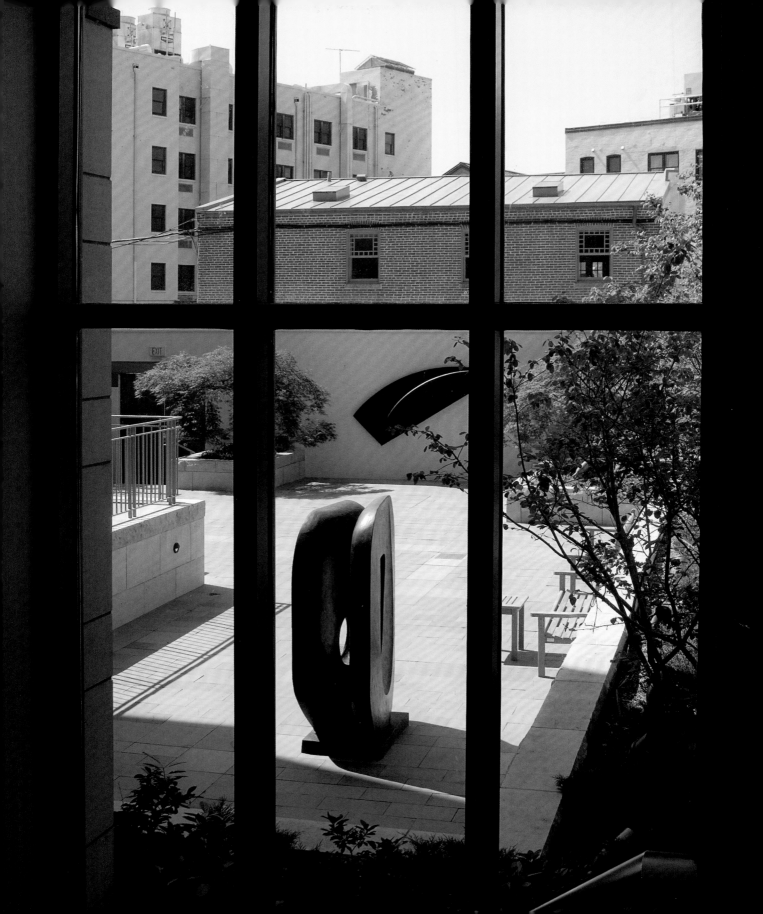

· Foreword

The Phillips Collection marks its ninetieth anniversary in 2011. As part of our extensive celebrations of this milestone, we are publishing this beautiful and accessible catalogue documenting more than one hundred of the most splendid works in the collection. These are among the most beloved objects that attract our visitors to the intimate galleries of the museum. Our selection includes impressionist and post-impressionist masterworks by Pierre Bonnard, Paul Cézanne, Edgar Degas, Pierre-Auguste Renoir, and Edouard Vuillard. We also feature work by the twentieth-century modernists Duncan Phillips vigorously championed, among them Georges Braque, Wassily Kandinsky, Paul Klee, Oskar Kokoschka, Henri Matisse, Piet Mondrian, and Pablo Picasso. An essential tenet of Phillips's collecting philosophy was his profound admiration for American art, from nineteenth-century giants such as Thomas Eakins, Childe Hassam, Winslow Homer, Albert Pinkham Ryder, and James Abbott McNeill Whistler to the important figures of twentieth-century American modernism, for example Milton Avery, Stuart Davis, Arthur Dove, Edward Hopper, Georgia O'Keeffe, and Charles Sheeler. Key works that have emerged as icons of the collection are included: Renoir's *Luncheon of the Boating Party*, purchased within two years of the collection opening to the public in 1921; Jacob Lawrence's iconic *The Migration Series*, a series of panels painted in 1940–1941; and Mark Rothko's luminous canvases of the 1950s. It was Phillips who arranged four of Rothko's paintings in a discrete sanctuary-like space, a setting that Rothko himself saw and that inspired his subsequent installation projects. Phillips was a pioneer in many ways, and our anniversary is celebrating many of these "firsts." In 1948, The Phillips Collection was the first museum to dedicate a room to the work of Paul Klee. The Phillips was the first to acquire work by Avery, Bonnard, Braque, Dove, Kenneth Noland, O'Keeffe, Alfonso Ossorio, and Nicolas de Staël, among many others. The Phillips was the first American museum to offer monographic exhibitions to Bonnard, Marc

Chagall, Howard Hodgkin, Henry Moore, Giorgio Morandi, and Chaim Soutine. Some of Duncan Phillips's selections were surprising in his lifetime and remain unusual today. His approach was neither art-historical nor academic, and his aim was never to amass a comprehensive collection. Rather, he was motivated by a desire to capture the artist's voice, to follow artists outside the mainstream, and to offer support to young artists at the moment they most needed it.

Each work shown in this book is accompanied by a thoughtful commentary. In addition to the entries, we take this opportunity to reprint Robert Hughes's appreciation of The Phillips Collection, first published in 1989; a revised version of chief curator Eliza Rathbone's 2002 essay, "Seeing Beautifully: A Vision of the Whole"; as well as a reduced version of associate curator of research Susan Behrends Frank's 2010 essay, "Duncan Phillips and The Phillips Collection: Champion of American Art," published in the catalogue that accompanied the major international touring exhibition *American Art 1850– 1960: Masterworks of The Phillips Collection in Washington*. I wish to thank all the other authors: Klaus Ottmann, director of the Center for the Study of Modern Art and curator at large; Vesela Sretenovic, curator of modern and contemporary art; Elsa Smithgall, curator; and Renée Maurer, assistant curator. Additional texts were authored by former Phillips Collection editor in chief Johanna Halford-MacLeod, and by Susan Badder. We are grateful for the editorial guidance of Johanna Halford-MacLeod and Ulrike Mills, and thank Vanessa Mallory Kotz. I also wish to acknowledge the essential contributions of Trish Waters, registrar in charge of rights and reproductions.

The Phillips Collection captivates us because it reflects one individual's vision, his passionate personal dialogue with artists, and his keen enthusiasm for the art of his time. Especially inspiring are Duncan Phillips's open-mindedness and generosity of spirit, points of view that do not always characterize the attitude of the private collector toward his legacy.

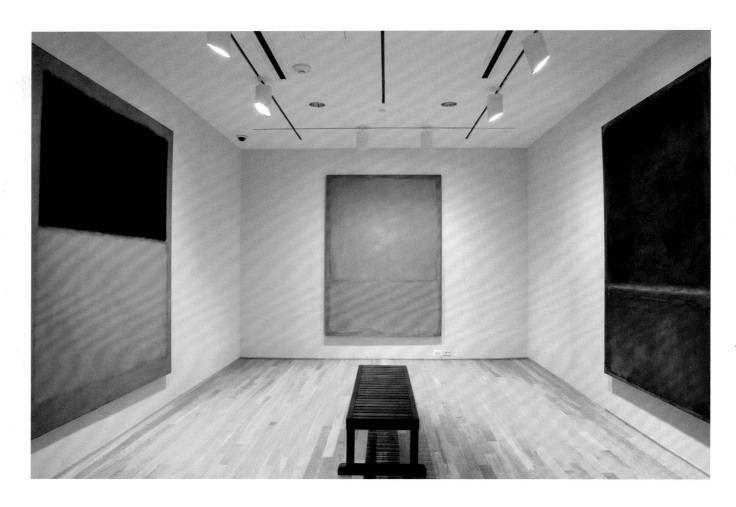

page 6: Hunter Courtyard and Center for the Study of Modern Art with work by Barbara Hepworth and Ellsworth Kelly, aerial view, 2006

above: Rothko Room, photograph Carl Bower, 2006

opposite: Gallery 204 with work by Vincent van Gogh and Linn Meyers, photograph Carl Bower, 2010

Phillips insisted that the collection remain "vital," never static, always open to new arrangements, new installations, and new juxtapositions, and open to growth through "enrichments of new acquisitions." Happily, through exceptionally generous gifts and bequests, as well as occasional purchases with our meager acquisition funds, the collection continues to expand. In 2008, the exhibition *Degas to Diebenkorn, The Phillips Collects* celebrated more than one hundred works acquired in the previous ten years, including outstanding examples by Helen Frankenthaler, Barbara Hepworth, Howard Hodgkin, Hans Hofmann, Ellsworth Kelly, Elizabeth Murray, Susan Rothenberg, Sean Scully, and David Smith. The photography collection continues to grow, with major works by Ansel Adams, Alvin Langdon Coburn, August Sander, Aaron Siskind, Brett Weston, and

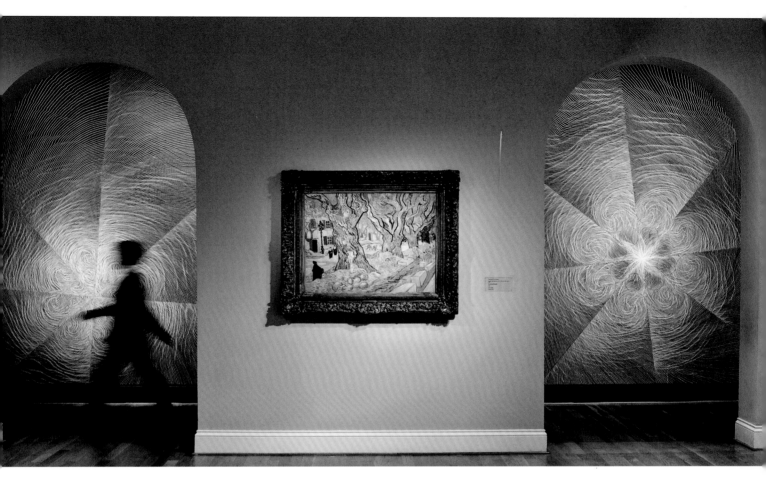

Edward Weston, among others. Works by international contemporary photographers—Marina Abramovic, Thomas Demand, Maria Friberg, Vesna Pavlovic, Nicola Pellegrini, Hiroshi Sugimoto, Frank Thiel, Jane and Louise Wilson, and Catherine Yass, among others—have entered the collection, largely through recent gifts from Heather and Tony Podesta. New additions of sculpture enrich the collection. Two sculptures, Barbara Hepworth's 1965 *Dual Form* and Ellsworth Kelly's 2005 *Untitled*, have transformed the elegant Hunter Courtyard. Ellsworth Kelly's site-specific work hangs on the west wall of this quiet oasis. The highly refined composition of deceptively simple forms was purchased through a substantial gift from Trustee Peggy Hunter in memory of her daughters, Alice Creighton and Pamela Creighton.

David Smith's 1959 *Bouquet of Concaves* was a very generous gift from Joann and Gifford Phillips in 2008, an addition to the collection that has already inspired new scholarship resulting in a major exhibition. A renewed focus on living artists is in fine alignment with Phillips's philosophy and resonates with our current public intellectual engagement, especially at our Center for the Study of Modern Art. Duncan Phillips surely would have been pleased by the aesthetic openness and intellectual vitality of his collection in its ninetieth year. It appears very likely that the one hundredth anniversary will require yet another publication highlighting these new masterworks that continue to transform The Phillips Collection.

Dorothy Kosinski
Director

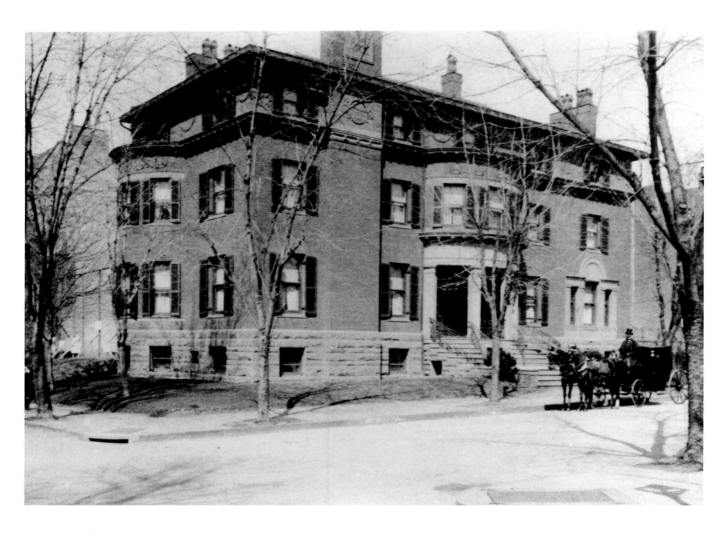

The house at 1600 Twenty-first Street, NW, c. 1900

Art and Intimacy
Robert Hughes

Everyone who loves early modern art loves The Phillips Collection and envies Washington for having it. The neo-Georgian pile at Twenty-first and Q Streets has grown since the Edwardian days when it was the boyhood home of its founder, Duncan Phillips, who died in 1966. Parts were tacked onto it to fit its ever-growing collection in 1907, 1920, 1923, 1960, and 1984. With the 1989 opening of the Goh Annex, it reached the limit of its expansion. And yet the Phillips has never lost its aedicular quality, its gift of intimacy and unhurried ease in the presence of serious art. Nobody ever feels pressured there or cheated by inflated expectation. It was not made for people with a viewing speed of three miles per hour.

Which is a near-miracle, considering what has happened in some of the great encyclopedic museums of America, like the National Gallery in Washington or the Metropolitan in New York. Unable to handle the vast art audience they helped create, big American museums in the 1980s became, in effect, mass media in their own right. The audience is now too big for the art.

But art does not like a mass audience. Only so many eyes can take in the same painting at the same time. There is a level of crowding beyond which one's sense of the object simply dies. Of course, there are plenty of areas in the big American museums where works of art still can be enjoyed in the silence and relative intimacy that is their due. Only on special occasions do they attain the cultural obscenity of the Louvre or the Uffizi in high tourist season. But the miseries of art-as-mass-spectacle are here, and will not go away.

In contrast are the oases, small and well-loved museums whose scale feels right, where the eye is not crowded and the size of the public does not threaten to burst the institutional seams. They evoke, above all, loyalty and affection. In America, one thinks of the Frick, in New York, with its sublime collection whose unchanging nature one no more resents than the fixity of the North Star, and of The Phillips Collection, which is to early modernism what the Frick is to old masters.

Duncan Phillips knew what he wanted: He saw where the big museums were heading. "It is worthwhile," he presciently wrote almost eighty years ago, "to reverse the usual process of popularizing an art gallery. Instead of the academic grandeur of marble halls and stairways and miles of chairless spaces, with low standards and popular attractions to draw the crowds...we plan to try the effect of domestic architecture, of rooms small or at least livable, and of such an intimate, attractive atmosphere as we associate with a beautiful home."

The Phillips Collection has changed since its founder's death: How could it not, without dying, too? It is bigger, by nearly nineteen thousand square feet, and puts more stress on conservation and education. It holds focused historical surveys and one-person shows, samplings rather than full retrospectives. But over all this broods continuity. Duncan Phillips's ghost still stalks the corridors of his museum like a benign, bony wading bird. No one would lightly abandon the values he implanted there.

The style was the man. Duncan Phillips was born into a family of Scots descent, which had made its fortune in Pittsburgh in banking and steel. From his tubular tweeds to his innate belief in the obligations of public service, he was the quintessential eastern WASP. He was brought up in Washington among Tafts and Glovers, and studied English literature at Yale. He was well traveled, rich but not filthy rich, and pomp embarrassed him. He did not collect for "status," because modern art conferred none in Washington seventy years ago, and, in any case, he felt no social insecurities. Still less did he collect for investment, though he had no qualms about selling works out of the collection to trade up.

Like a good Scot, he eschewed the pleasures of the table. When in Paris with his artist wife Marjorie — his equal partner in forming the collection — he would sit down to lunch in temples of belle epoque cooking like the Tour d'Argent and stubbornly order two poached eggs and a morsel of bread pudding. His digestion, he said, had been done in by too many hot dogs at Yale.

But Yale had also formed his ambition—as it would for another great Washington collector who was there in 1907, Paul Mellon. Phillips was struck by the "deplorable ignorance and indifference" to art among the students who would move into America's elite. One graduate student he knew declared at dinner that "Botticelli is a wine, a good deal like Chianti only lighter....He was rudely awakened by a sensitive friend to the fact that Botticelli is not a wine but a cheese." Phillips was horrified, as Alfred Barr also would be, by the lack of art history courses in American schools. (What he would have made of the immense, academized, turgid structure of American art education today is anyone's guess.) He wanted to be a dilettante, in the full and proper sense of the word: not a superficial amateur, but a man who took educated pleasure in every field of culture, especially art.

The clue to this growth lay in the writings of Walter Pater, who was as much a cult figure among American student aesthetes at the turn of the century as John Ruskin had been twenty years before or Clement Greenberg would be in the 1960s. Pater's coiling, elegantly nuanced descriptions of works of art, his craving for the exquisite, and above all his belief that the aesthete, "burning with a hard and gem-like flame," could transcend the grossness of material society, struck deep into the intellectual values of young Duncan Phillips's time and class.

Like many others, including Bernard Berenson and the French critic Henri Focillon, Phillips came to believe that works of art transcend the immediate social and historical conditions of their making, that they form a universal language that can speak to attuned people in any time and place because they are triggers for emotions and feelings that lie deeper than socioeconomic conditioning. Hence their power to please, elevate, stimulate, and provoke reflection. Contemplating them, the viewer becomes a kind of artist.

As Duncan Phillips put it, art is "a joy-giving, life-enhancing influence, assisting people to see beautifully as true artists see." This vision of the "life-enhancing" powers of art was Pater's main legacy to American aesthetes between 1880 and 1914. "Mere" delight—Phillips would never have called it "mere," for it was part of his raison d'être, as it is with all authentic connoisseurs—is out of intellectual fashion today, derided by neo-Marxists and post-structuralists as one of the masks behind which an elite goes about its work of repression.

To art historians who cannot lay eyes on a Matisse still life without spinning lengthy footnotes on the gender-based division of labor in the Nice fruit market in 1931, Duncan Phillips's kind of aestheticism is a fossil. Phillips himself never denied that art reflects society; he knew their reciprocity—as his enthusiasm for Daumier, among others, showed. But he always put disinterested aesthetic awareness before the work of decoding art as a social text. And who could deny that his beliefs have brought more people closer to firsthand art experience than all the socioaesthetic jargon of recent years?

"Life-enhancement" could oppose itself to death and loss. The collection began, in fact, as the Phillips Memorial Art Gallery, a work of *pietas*—a Roman sense of family obligation—to the memory of his father and, especially, his older brother James, who had died at age thirty-four in the Spanish flu epidemic of 1918. Duncan and James had collected pictures jointly until then, and James's death, Duncan wrote later, "forced my hand":

> There came a time when sorrow almost overwhelmed me. Then I turned to my love of painting for the will to live. Art offers two great gifts of emotion—the emotion of recognition and the emotion of escape. Both emotions take us out of the boundaries of self....At my period of crisis I was prompted to create something which would express my awareness of life's returning joys....I would create a collection of pictures—laying every block in its place with a vision of the whole exactly as the artist builds his monument or his decoration.

Though born in grief, the collection would eschew the monumental: It would go in the family house and, symbolically, restore the life that house had lost. It opened in three rooms of the Phillipses' home in 1921. Phillips's taste was daring, highly traditional, and somewhat idiosyncratic, all at once. Not for him the premade collection from the *menu touristique* of accepted values. His memorial to the dead was, above all, a product of reflection.

Duncan Phillips was not a "radical" even in his youth. In 1913, he wrote a review dismissing the New York Armory Show — the first North American exhibition of cubism, fauvism, impressionism, and post-impressionism — as "stupefying in its vulgarity," though later he repented of that, somewhat. Yet one should remember that, although the artists whose work Duncan and Marjorie Phillips collected from the 1920s to the 1950s are long since dead and have become excessively embalmed by history and the market, they were living, problematical creatures with a small audience then.

Few people in 1930 thought of Bonnard as a great painter; even as late as the 1950s there was no shortage of critics writing him off as a *retardataire* impressionist. If the collection now has sixteen Bonnards, it is because Duncan Phillips was almost alone in wanting Americans to see him in depth. But he was no Euro-snob. He stood up for Dove, Marin, Stieglitz, and other American modernists when few private collectors or museums would. His record of sympathy with the American avant-garde was far better than Alfred Barr's. Taste was policy. It was "a cardinal principle," he noted in 1922, "to make the gallery as American as possible, favouring native work whenever it is of really superior quality, as our painting unquestionably is."

Phillips clove to artists — Bonnard, Marin, Stieglitz, Dove — through studio visits and long correspondence. He was not moved by the snobbery that wants to rope in a star painter for the dinner party. The art-star system hardly existed then. Phillips simply wanted to know more about art.

His closest relations were with Arthur Dove, whom he subsidized for some years: There are forty-eight Doves in The Phillips Collection and voluminous letters in the archive. Writing once of ancient Greek vase-painting, he mentioned "craftsmen who were also poets in their various plastic ways and who no doubt more truly resembled our modern artists than the great architects and sculptors of the time of Phidias." He thought of modern art as unpretentious in its essence.

Now that taste has been corrupted to the point where few can distinguish scale from size, and "important" means "unmanageably big," one is apt to lose sight of the fact that most of the paintings that changed art history between 1860 and 1950 would fit over a fireplace. Smallness, intimate address, helped distinguish focused art from the shameless inflation of the academy — as it needs to, once again, today.

Phillips knew this and was grateful to the artists who practiced it. With the new and the young, he was cautiously sympathetic. There being no market hysteria, he could wait, reflect, compare, and eventually admit the newcomer — Morris Louis, Kenneth Noland, Mark Rothko, or Philip Guston — to the company of Bonnard's *The Palm* and Matisse's *Studio, Quai Saint-Michel*. After all, it had taken him nineteen years to decide on his first Cézanne still life.

Lawrence Gowing wrote that "A succession of painters, passing through the capital, have learned in the collection the best lessons of their lives." True: the Phillips has always been an artists' museum. One may doubt whether Morris Louis's or Kenneth Noland's work would have turned out as it did without the radiant example of the Phillips's Bonnards.

When Richard Diebenkorn was a Marine at Quantico, he visited The Phillips Collection so regularly that the powerful orthogonal framing of *Studio, Quai Saint-Michel* became the signature of his own work; so it is fitting that Diebenkorn's superb drawing show opened the Goh Annex forty-five years later.

When art-lovers talk about the paintings that have helped form their sense of quality, one is often struck to find how many hang in the collection. Did Gauguin ever paint a better still life than the Phillips's dusky-red smoked ham, its curve of creamy fat echoed by the sprout-ends of a scatter of pearly onions, floating on its iron table against a deep plane of orange wall? Is there a more audacious gesture anywhere in Bonnard's work than the wide arch of spiky foliage in *The Palm*? Or a Cézanne self-portrait more densely impacted with thought than the one Duncan Phillips bought in 1928 and told his registrar to grab and run with first if there was a fire? How many Matisses carry more messages for future art than his 1916 *Studio, Quai Saint-Michel*? Even those who don't greatly care for Renoir, finding much of his work sugary and repetitious beside the drier pictorial intelligence of a Degas—who is also beautifully represented in the collection—are likely to concur that *Luncheon of the Boating Party*, painted in 1881 and purchased from Durand-Ruel in 1923 for $125,000, is one of the great paintings of the nineteenth century and the summit of Renoir's pictorial achievement.

This, in a sense, was the world's first museum of modern art, founded in 1921, eight years before the Museum of Modern Art opened its first show in a Manhattan brownstone. But only in a sense. The collection never set out to define a canon of modernism. It was much more an act of taste than a pro-

posal about art history. What it stressed—and still insists on—is the continuity between past and present.

Phillips had no patience at all with "revolutionary" myths of the avant-garde. He sometimes thought in terms of evolution but was mildly skeptical of progress in art. The eighteenth-century painter Jean-Siméon Chardin, virtuoso of "the richly harmonious envelopment of objects in space," was the ancestor of Georges Braque's late still lifes of the 1930s and 1940s but not their "primitive" ancestor.

In its first stages, The Phillips Collection consisted largely of paintings by French artists like Chardin, Monet, Monticelli, Decamps, and Fantin-Latour, and American ones like Whistler, Ryder, Childe Hassam, Twachtman, and Luks. The six great Cézannes and three van Goghs, the matchless late Braques and the Matisses, the Bonnards and the hundreds of works by American modernists—Arthur Dove, John Marin, and so on to Mark Rothko and Philip Guston—would come later.

There are many works that seem to have no historical connection to modernism at all—some of them quite extraordinary, like Goya's *The Repentant St. Peter* and the Delacroix portrait of the violinist Paganini, a tallowy wraith whose intensity seems, while you are looking at it, to disclose a whole vista of French romanticism through the dark slot of its surface. Consequently, you never leave the Phillips feeling that a tour of "isms," that schematic labeling of successive

movements on which the mass teaching of modern art has depended for the last fifty years, has been laid out for you. Instead, the clusters of images that come up in room after room have an implied but rarely argued coherence, a sense of "elective affinity" that leads you to ponder what they might have in common and, therefore, what the artists were actually thinking about.

The collection gathered in what Phillips called "units." From John Henry Twachtman to Nicolas de Staël, he liked to have blocks of five or six representative works by an artist. Then, on the wall, one painter could begin a silent *conversazione* with another. You watch the works talking. The place is set up for association and reverie. Its scholarship has always been impeccable, and Phillips himself was one of the best American critics of his day. But the collection is more dedicated to correspondences and sympathies than to hard chains of art-historical cause and effect. And of course the collection gestures outward, to images it does not contain, to the larger museum in our heads.

To think of Goya and Daumier as belonging together is normal. But it is a quite different thing, while looking at Daumier's *The Uprising*, to grasp a connection between its central figure, a worker in a white shirt shaking his upraised fist, and the white-shirted Madrileño defying the French muskets in Goya's *Third of May*.

None but a fool likes everything, and there were whole strands of modernism to which Duncan Phillips remained indifferent. He was not greatly moved by cubism, finding it—one might guess—too brown and cerebral. Nevertheless the collection boasts one of Juan Gris's finest works, a 1916 *Still Life with Newspaper*. He ignored most expressionism (too convulsive) and to Dada and surrealism he was quite indifferent, though he bought one Miró, *The Red Sun*, and accepted one great Schwitters as a gift from the estate of Katherine Dreier. Marcel Duchamp, the father of conceptual art and enemy of the "retinal," could safely be left to the Arensbergs in Philadelphia.

Phillips was in fact the compleat optical collector. He craved color sensation, the delight and radiance and sensory intelligence that is broadcast by an art based on color. Color healed; it consoled; it gave access to Eden. He could not understand—except on the plane of theory—why art should be expected to do anything else.

It had always been so for him, ever since childhood. When Duncan Phillips was four, his parents took him to Europe. In Paris, at the circus, he was terrified into hysterics by the sight of a clown tossing dolls—which the little American boy thought were live babies—into the air. His terror lasted all the way back to the hotel and was only assuaged, Marjorie Phillips wrote in her memoir of her husband, by the sight of a vase of simple flowers in the lobby: blue cornflowers, red poppies, yellow buttercups. "He later remembered how he could not let the bouquet out of his sight and always thought that was his first real aesthetic experience of color." You might say that Phillips's lifetime attachment to color began with a therapeutic instant, one that could be recaptured over and over again, almost at will, in the presence of painting.

He came to see the significance of modern art largely as a narrative of color, of agreeable sense-impression laden with thought. He was not "a modernist," but he immersed himself in modernity as the living form of a tradition that, as he saw it, had begun in cinquecento Venice, among the mysterious reveries of Giorgione: an art of delicately managed emotion, rising from the intersection of culture and nature, in the pastoral mode. (The ideal opener for The Phillips Collection would have been Giorgione's *Tempest*.)

He hated the laborious or sleeked image: Art needed to be fresh in its perception, direct in its touch. He wanted "works which add to my well-being....For me, an artist's unique personality must transcend any imposed pattern which otherwise becomes an academic stencil adaptable to mass production." On Twenty-first Street today, his well-being is still ours.

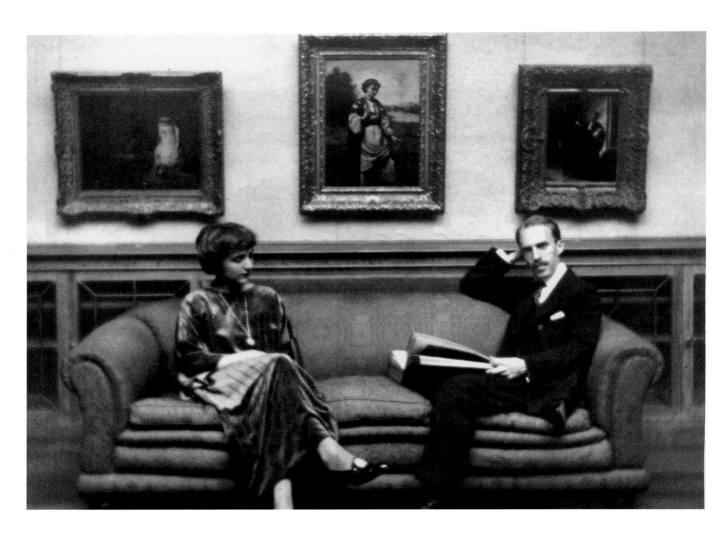

Marjorie and Duncan Phillips in the Main Gallery,
c. 1922, photograph Clara E. Sipprel

Seeing Beautifully:
A Vision of the Whole

Eliza E. Rathbone

*Art offers two great gifts of emotion—the emotion of
recognition and the emotion of escape. Both emotions
take us out of the boundaries of self....At my period of
crisis I was prompted to create something which would
express my awareness of life's returning joys and my
potential escape into the land of artists' dreams. I would
create a collection of pictures—laying every block in its
place with a vision of the whole exactly as the artist
builds his monument or his decoration.*

These words written by Duncan Phillips in 1926 express his
intense passion for art and his remarkable prescience in envi-
sioning the collection he would create. "Laying every block in
its place with a vision of the whole" was a project of extraordi-
nary ambition that would take him a lifetime to achieve.

Every collector's achievement results from both intention
and opportunity. When Phillips decided to create a museum of
modern art and its sources, he set for himself the task of defin-
ing modern art and its origins in the art of the past. The image
of building "his monument or his decoration," of "laying every
block in its place," suggests working from the bottom up or
starting with nineteenth-century "sources" and moving for-
ward into the present. But Phillips's method was more akin to
that of a painter than a stonemason. In fact, his fifty-year odys-
sey in collecting echoes the style of a late work by Paul Cé-
zanne: just as each stroke of color perfectly coheres into a uni-
fied whole, so Phillips retained his vision of the whole even as
each piece—old master or modern, American or European—
came into his collection. Many of the important source works
were not acquired until the 1940s or 1950s, decades when he
also continued his adventurous and active buying of contem-
porary art. The result is an exceptionally unified collection that
perfectly reflects the evolution of Phillips's eye and taste, a
collection in which the whole is greater than the sum of its parts.

Phillips was convinced that the collector should de-
velop his own individual taste in art—to know which artists
he admires and why. As early as 1907, while still an under-
graduate at Yale and an editor of the *Yale Literary Magazine*,
Phillips wrote an article expressing these views with great
conviction and stating, "A man may succeed in memorizing a
wide amount of book knowledge—yet if he is without the
ability to understand, appreciate and possess opinions of his
own, he is not cultured." He continued with disparaging
words about millionaires who buy collections through deal-
ers, praising by contrast "the self-educated, hungry souled
clerk who spends his half-holidays wandering blissfully
through the galleries." Phillips took seriously the process of
self-education. He read the leading critics of his day, Frank
Jewett Mather, Roger Fry, and Clive Bell. Fry and Bell, who in-
troduced post impressionism to England and were deeply
affected by it, provided a framework for Phillips's consider-
ation of the roots of modern art. He pored over Roger Fry's
collected essays in *Vision and Design* (1920), underlining
lengthy passages, and consumed Bell's *Art* (1914), scribbling
his own impassioned and engaged responses in the book's
margins. Testimony to his deep absorption of Bell's ideas about
art, aesthetics, and "significant form," his notes often begin
with comments such as "I heartily agree" and "Quite true!"

Phillips's urge to use his own literary skills to explore
and express his ideas about art eventually led him to produce
more than two hundred articles and essays and seven books.
He kept more than thirty journals and wrote some two hundred
unpublished manuscripts, which constitute a remarkable
record of his perceptions and the evolution of his collector's
eye. But even as he studied the words of critics, Phillips under-
stood early on the value of learning from artists how to look at
art. He sought out the advice of American painters Arthur B.
Davies and Augustus Vincent Tack, both of whom became
close friends and advisers on looking at painting. He and his

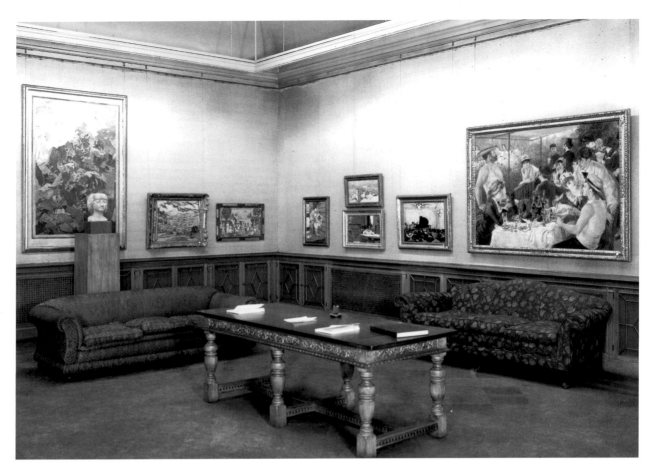

wife, Marjorie, made visits to many studios, always delighting in engaging directly with artists.

Just as Phillips was clear about his own independence of judgment and spirit, he believed in artists who were similarly inclined. As he put it, "My own special function is to find the independent artist and to stand sponsor for him against the herd mind whether it tyrannizes inside or outside of his own profession." Phillips saw a work of art as an "intimate personal message" and in this spirit determined to provide the works he collected with an intimate and personal atmosphere for their contemplation. By the mid-1920s, he had formulated his views about the appropriate setting for his collection, stating: "Instead of the academic grandeur of marble halls and stairways and miles of chairless spaces, with low standards and popular attractions to draw the crowds and to counteract the overawing effect of the formal institutional building, we plan to try the effect of domestic architecture, or rooms small or at least livable, and of such an intimate, attractive atmosphere as we

associate with a beautiful home. To a place like that, I believe people would be inclined to return once they have found it and to linger as long as they can for art's special sort of pleasure." To this day, the galleries of The Phillips Collection have preserved their domestic scale, providing an understated setting for a collection of unique character and exceptional distinction.

Phillips's ambitions for the works of art he would collect were far from modest. As early as 1923, he envisioned "an American Prado." That same year the museum had become the proud possessor of Pierre-Auguste Renoir's *Luncheon of the Boating Party*, a statement to the world of Phillips's lofty aspirations. His excitement is palpable in the letter he wrote to his treasurer announcing that the gallery was to be "the possessor of one of the greatest paintings in the world." He called the painting "the masterpiece by Renoir and finer than any Rubens —as fine as any Titian or Giorgione. Its fame is tremendous and people will travel thousands of miles to our house to see it….Such a picture creates a sensation wherever it goes." In 1911

and 1912 Phillips had made trips to Europe, where he was transported by Renoir's work, warming to its "thrilling vitality" and "shimmering richness." With this single brilliant purchase, he put his fledgling collection on the map and set a course for the future. Now he was ready to state, "I could get lesser examples, which would give great satisfaction, but for such an American Prado as I am planning, there must be nothing but the best." To this day, the Renoir, beyond all other works in the collection, draws visitors to the house at 1600 Twenty-first Street and amazes those who did not anticipate finding it there.

The 1920s was a decade of active buying and significant acquisitions. Among nineteenth-century French paintings, Phillips showed at this time a marked preference for landscape. Even before the museum opened, he had acquired Claude Monet's *Road to Vétheuil*. In the mid-1920s he acquired Alfred Sisley's *Snow at Louveciennes*; two superb landscapes by Gustave Courbet, *The Mediterranean* and *Rocks at Mouthier*; and Cézanne's *Mont Sainte-Victoire*. It would take him thirty years to complete the extraordinary "unit" of works by Cézanne in the collection, culminating in 1955 with the acquisition of *The Garden at Les Lauves*, a late work for which he may not have been ready in the 1920s.

Honoré Daumier's *The Uprising*, acquired in 1925, signaled Phillips's deep response to works that address the human condition. One of Phillips's most prized purchases, it was the largest of seven paintings by the artist that Phillips acquired, making his representation of Daumier as a painter among the finest in America.

Throughout the 1920s, after the museum opened to the public in 1921, the principal space for the exhibition of paintings was the main gallery, a skylit room designed by McKim, Mead, and White, in which Phillips mounted frequently changing installations from his collection. In hanging works by artists of various schools in close proximity to each other, Phillips discovered unexpected relationships and "conversations." Such insights must have had a formative influence on the development of his collection and his highly imaginative and flexible approach to installing it. Through juxtapositions, he hoped to stimulate the eye of the visitor. As he put it: "I avoid the usual period rooms—the chronological sequence....My arrangements are for the purpose of contrast and analogy. I bring together congenial spirits among the artists from different parts of the world and from different periods of time and trace their common descent from old masters who anticipated modern ideas."

Among those "old masters" were Jean-Siméon Chardin and El Greco, and Phillips was fortunate to find suitable works by both artists early in the development of his collection. He could hardly have found a more appropriate painting by Chardin than *A Bowl of Plums* to illustrate the great debt of nineteenth-century still life to the eighteenth-century master, and El Greco's work was widely recognized at this time as anticipating the modern. Phillips would have been aware of Roger Fry's report on the acquisition of a work by El Greco by the National Gallery in London in 1920, about which Fry wrote: "Mr. Holmes has risked a good deal in acquiring for the nation the new El Greco.... With [it] he has given the British public an electric shock. People gather in crowds in front of it, they argue and discuss and lose their tempers....It is really about the picture that people get excited. And what is more they talk about it as they might about some contemporary picture....That the artists are excited— never more so—is no wonder, for here is an old master who is not merely modern, but actually appears a good many steps ahead of us, turning back to show us the way."

Later in the 1920s, Phillips wrote an essay about El Greco, Cézanne, and Pablo Picasso, in which he named El Greco as an important antecedent to Cézanne. He admired El Greco for his "art of building forms in space, a science of projecting and receding planes, a movement of those lines which had

Main Gallery, 1963, with works by Bradley Walker
Tomlin, Nicolas de Staël, Henri Matisse, and
others

emotional force and meaning in them, an enlargement of the unit of design until every mark of the brush, every modulation of color, and every swirl of line repeated one insistent rhythm." He found the final phase of this idea in Picasso. In the end, he felt that "Cézanne would not have altogether approved of his disciple Picasso. At least in his ripe maturity he was too sober a classicist to have tolerated fanaticism when it frankly threatened the sanctity of his museums and traditions and implied infidelity to his beloved Nature. Of the three baroque painters only Greco and Picasso are of the same Gothic family." Bearing out his aesthetic judgments, Phillips often installed El Greco's *Repentant St. Peter* and Picasso's *Blue Room* near each other in his galleries.

Nonetheless, Phillips's excitement over analogies would not produce a perfect work to compare and contrast with El Greco's *St. Peter* until a *St. Peter* by Francisco de Goya came on the market in 1936. The chance availability of this painting created an art historian's dream of comparing and contrasting the same subject in the hands of two distinctly different harbingers of the modern.

To obtain the work, Phillips traded a Tahitian landscape by Paul Gauguin. This was neither the first nor the last time he parted with one acquisition to make another. As he made difficult choices, he honed his collection, seeking internal relationships and moving toward securing greater examples of work by the artists he admired. Gauguin's *Ham*, for example — in many ways an atypical work, which Phillips had the good fortune to acquire in 1951 from New York dealer Paul Rosenberg — is one of the artist's greatest still-life paintings and far superior to the Tahitian landscape that Phillips let go. Phillips recognized the still life's quality and wrote to Rosenberg, "In spite of the fact that we cannot really afford an expensive picture at this time the Gauguin *Le Jambon* has such a resemblance to the Collection and is so much needed as a source of subsequent painting that we cannot resist it." He similarly gave up two paintings by Matisse to obtain Georges Rouault's *Verlaine*, a superb example by an artist Phillips greatly admired. This could be viewed as a mistake were it not for the two works by Matisse that Phillips retained, Matisse's great *Studio, Quai Saint-Michel* of 1916 and *Interior with Egyptian Curtain* of 1948, both major landmarks in the artist's oeuvre.

From first to last, Phillips felt an intense response to the role of color in works of art. In the 1920s he discovered an astonishing colorist in the French painter Pierre Bonnard, initiating a love of the artist's work that would continue all his life. In him Phillips recognized an heir to Renoir. He wrote, "Bonnard is the supreme sensitivity, the music-maker of color...." While other major institutions such as the Museum of Modern Art viewed Bonnard as a latter-day impressionist favoring Picasso and Matisse, Phillips chose Bonnard's work to collect in depth and went on to acquire a group of paintings that remains unrivaled in America. His enthusiasm for Bonnard's work was consistent with one of his first loves in American art, the paintings of Maurice Prendergast. Finding in both artists an individual approach to color, he saw in them an instinct for the decorative that he greatly admired.

Often it appeared that Phillips's engagement in collecting contemporary art gave insight into his choice of works by earlier masters. Indeed, living with Bonnard's original and brilliant chromatic harmonies and splayed compositions may have led to Phillips's eventual acquisition in the 1940s of the daring late work by Edgar Degas, *Dancers at the Barre*, in which the intense vibration of orange-red tonalities and the modulated blue-green of the dancers' skirts combine with a dynamic composition. Phillips acquired all the paintings in his collection by Degas — with the exception of a painting of a ballet rehearsal, which he gave to Yale University — in the 1940s, a time when he was keenly engaged in contemporary acquisitions. Works by Eugène Delacroix and Jean-Auguste-Dominique Ingres, key sources for Degas himself, were also purchased in the 1940s.

Similarly, paintings by Nicolas de Staël, with their patches of color and abstract harmonies, preceded Phillips's purchase of Cézanne's *Garden at Les Lauves*, a work in which he saw an immediate correspondence.

Having opened the collection to the public in the fall of 1921 with approximately two hundred works that he had acquired between 1916 and 1921, Phillips had by 1930 obtained approximately three hundred more works for his growing museum. So he could turn the entire house on Twenty-first Street over to his art gallery, Phillips decided to build a house for himself and his family on Foxhall Road, farther from the center of Washington. In 1930 he celebrated the opening of the house as his museum by making a major purchase, Vincent van Gogh's *Entrance to the Public Gardens in Arles*, the first painting by Van Gogh to enter his collection. An article in the Washington *Sunday Star* announced the opening of the entire house and the first opportunity for Washingtonians to see the painting by Van

Gogh, which had also been shown the year before at the opening exhibition of the Museum of Modern Art in New York.

That Van Gogh's *Public Gardens* was shown at both museums so close in time is hardly surprising. The two collections had remarkably similar missions. When the Museum of Modern Art opened in 1929, its statement of purpose echoed Phillips's in describing its intention as being "first of all to establish a collection of the immediate ancestors of the modern movement," whom it identified as the major figures of post-impressionism —Cézanne, Georges Seurat, Gauguin, and Van Gogh. Because Phillips had been working with these ideas for the better part of a decade, he was a natural choice as a founding member of the Museum of Modern Art's board of trustees. Phillips was also appointed to the first board of trustees of the National Gallery of Art in Washington, which opened in 1941. Unlike Phillips, however, the National Gallery would not begin to accept for exhibition the works of living artists until 1965. By this time, Phillips

had already been collecting contemporary art for four decades.

Given Phillips's reputation in the art world, it was natural that Katherine Dreier, one of the most avant-garde collectors in America and founder of the Société Anonyme, should hold him in high esteem. In 1953 The Phillips Collection received a gift of seventeen works from Dreier's estate. When Marcel Duchamp, the executor of Dreier's estate, offered Phillips an extensive list of works, Phillips stated his "preference to accept only such works as relate in one way or another to the whole scope and yet the very personal taste of my collection." The choices Phillips made reveal the extent to which his personal taste and vision for his collection could not be swayed, even by an offer of major works by famous artists. He rejected, for example, a sculpture by Constantin Brancusi and allowed Alfred Barr to persuade him to let Duchamp's *Small Glass* go to the Museum of Modern Art. But the works that Phillips selected by Franz Marc, Wassily Kandinsky, Kurt Schwitters, Piet Mondrian, Alexander Archipenko, Georges Braque, and Alexander Calder, among others, are superb examples by these artists, which strengthened his collection immeasurably.

Serendipity always plays a part in collecting, and Phillips gained some great acquisitions through unexpected friendships and connections, including two additional paintings by Van Gogh, *The Road Menders* and *House at Auvers*, purchased from the collection of a longtime friend, Elizabeth Hudson. This resulted in an ideal group of paintings by Van Gogh, including a work from each location of the artist's mature life—Arles, Saint-Rémy, and Auvers.

While some purchases were the result of unforeseen opportunity, Phillips also very deliberately singled out certain artists whose work he wished to collect in depth. In his initial plans for his museum, he had envisioned individual rooms devoted to a single artist, but over time only two artists, Paul Klee and Mark Rothko, claimed such spaces. Enchanted by Klee's intensely personal imagination, Phillips assembled between 1938 and 1948 thirteen works that chronicle the artist's production from 1924 to

Alberto Giacometti: A Loan Exhibition, February 7–
March 18, 1963, in the galleries of the first floor
of the Annex

1938, displayed in a room on the second floor of the house. There, one entered a world of Klee's own measure and dimension.

In the 1950s Phillips explored the work of many new and emerging talents, both American and European, including de Staël and Pierre Soulages, as well as Willem de Kooning, Bradley Walker Tomlin, Mark Tobey, Kenzo Okada, and Rothko. The large-size canvases often favored by these artists, together with the increasing growth of the collection as a whole, spurred Phillips to initiate the construction of another building that would be joined to the original house by a two-story bridge. The Annex, designed by Frederick Rhinelander King with a good deal of in-put from the Phillipses themselves, opened to the public in 1960. Its galleries were planned to echo the scale and feeling of the original house, and a room was set aside on the first floor for Rothko's paintings. Phillips had the benefit of conversations and visits with the artist himself, and the close understanding that developed between them led to the creation of one of the most successful rooms devoted exclusively to Rothko's work. By this time, each artist that Phillips took on contributed a voice that could participate in the visual "conversations" already estab-lished in the collection. Phillips's strong response to Rothko's work seems adumbrated by a host of works in the collection — from William Merritt Chase's *Hide and Seek*, with its daring void in the center of the composition, to Bonnard's finely tuned color harmonies, echoed in Rothko's more brooding and emotive work. Likewise, the work of American Richard Diebenkorn entered a collection where the artist had spent many hours absorbing the compositional inventions of Edouard Vuillard and the sober monumentality of Matisse's *Studio, Quai Saint-Michel*.

By careful selection, Phillips achieved to a rare degree the unity in diversity that he sought for his collection. In his "experi-ment station," he combined the independence of the private collector with the ideal of serving the public. To his youthful ro-manticism, he brought an understanding of formalist concerns, forging a profound appreciation of the strengths of both. His

collection had been "lived with, worked with, and loved." As a collector, writer, and museum director, Phillips's most earnest purpose was to share his own pleasure in the life-enhancing power of art. As he explained it late in life, with characteristic modesty:

> Pictures send us back to life and to other arts with the ability to see beauty all about us as we go on our accustomed ways. Such a quickening of perception is surely worth cultivating. I have devoted myself to the lifelong task of interpreting the painters to the public and of gradually doing my bit to train the public to see beautifully.

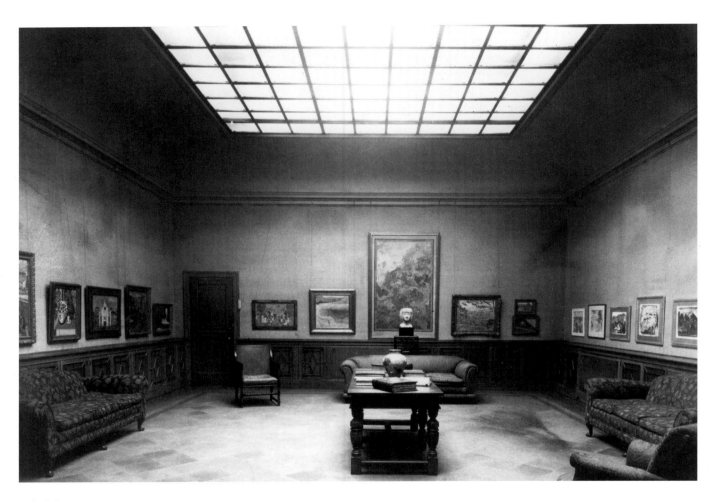

Main Gallery, 1927

Duncan Phillips:
Champion of American Art
Susan Behrends Frank

From the time it first opened in 1921, The Phillips Collection (then called the Phillips Memorial Gallery) was a unique institution and its founder, Duncan Phillips, a man with rare vision. Although New York in the 1920s was the commercial center of the American art world, no museums committed to showing or acquiring the work of contemporary American art existed there prior to the Museum of Modern Art, opening in 1929, and the Whitney Museum of American Art, opening in 1931. Only in Washington, DC, at The Phillips Collection, could American artists find a public collection that was prepared to exhibit and acquire their work.

No other art museum in the country in the 1920s was willing to make the brave leap away from representational painting and focus on modernism and abstraction. Even after the Museum of Modern Art and the Whitney became active in the 1930s, the Phillips was alone in championing and exhibiting new American painting together with contemporary European art, not chronologically, but by artistic temperament. It was an unorthodox position, directly counter to standard museum practice, but it gave American painters equal status with other artists, which neither the Museum of Modern Art nor the Whitney was willing or able to do. While Phillips's high-profile acquisitions in the 1920s of European masterworks, such as El Greco's *The Repentant St. Peter* (c. 1600–1605 or later), Honoré Daumier's *The Uprising* (1848 or later), and Pierre-Auguste Renoir's *Luncheon of the Boating Party* (1880–1881) gave his newly launched museum national and international prominence, he never lost sight of his goal to "show American painting...as part of the main channel of all artistic progress."

For nearly fifty years, from his first published art criticism in the early 1910s to his death in 1966, Phillips promoted the work of American artists. From the outset of his career, he expressed nativist pride and confidence in their work. He was enthusiastic about American art of the recent past and the present and adamantly opposed to what he viewed as artistic fads, as well as the conservatism of the Academy, which, he believed, standardized and stultified an artist's creative response.

The birth of the modernist spirit in American painting began with the urban realists who flocked to Robert Henri at the New York School of Art after the turn of the century, individuals such as George Bellows, Guy Pène du Bois, William Glackens, Ernest Lawson, Rockwell Kent, George Luks, and John Sloan. Asserting their independence from the National Academy of Design, they championed independence from artistic cliques, exhibition restrictions, and mainstream aesthetic styles that featured only pastoral interpretations of the American countryside and pretty views of the city. They focused, instead, on the gritty side of the industrialized city and its immigrant neighborhoods, adopting a style derived from the flamboyant brushwork and darker palette of Frans Hals and Diego Velázquez. Phillips found the work of these contemporary realists, called the "Ashcan School" artists, highly appealing. In 1912 he characterized the Henri circle's "true" depictions of the city as "moments vividly experienced." By the time he opened his museum to the public, Phillips had assembled a significant number of works by the American impressionists, as well as the urban realists around Henri, and could lay claim to being the first to acquire a painting by Sloan, *Clown Making Up* (1909), for a museum collection.

Phillips was the second son of a Pittsburgh glass manufacturer and an heir to the Laughlin Steel Company. He grew up comfortably in Washington, where his parents had retired in 1896 when he was ten years old, moving easily among the city's political and social elite. Establishing the museum as a living memorial to his recently deceased father and brother, Phillips was thirty-four years old when the Phillips Memorial Art Gallery opened to the public in October 1921. By then Phillips had assembled 237 works, the nucleus of a growing collec-

tion of which three-fourths (188) were paintings by fifty-eight different American artists. At his death in 1966, the museum's permanent collection consisted of nearly 2,000 works, of which 1,400 were American.

As Phillips's understanding of modernism deepened, he began to refine his collection, emphasizing works that acted as links between the past and the present. He believed the modern spirit in American painting could be found in the work of George Inness, Winslow Homer, Thomas Eakins, and Albert Pinkham Ryder, the visionary master of nature as rhythmic abstract form. James Abbott McNeill Whistler was, for Phillips, the self-conscious stylist whose portraits had "Venetian chivalry and romantic charm." Maurice Prendergast, "the embroiderer of bright bold patterns," and John Henry Twachtman, the "spiritualized impressionist," were two of Phillips's favorites when the museum opened.

In his fledgling museum, Phillips focused his "eye" on twentieth-century American art that was often abstract and increasingly expressionist. This was a highly uncommon and unpopular position within the American art establishment after World War I and placed Phillips outside the mainstream art community. He emphasized an institutional commitment, as no other museum director was willing to do, "to stimulate contemporary artists by establishing personal contact and friendly relations, to win their confidence…."

Phillips's nascent appreciation for abstraction was initially grounded in the American impressionists Childe Hassam, Prendergast, and Twachtman, whose work he collected through 1922. Their emphasis on design, pattern, color relationships, and spatial flatness prepared Phillips for a new generation of American modernists. In 1922, Augustus Vincent Tack, Phillips's close friend, mentor, and associate, developed what he described as abstract, decorative "compositions of form and color based on essential rhythm." Phillips was the first to appreciate Tack's venture into abstraction, quickly acquiring his breakthrough

pictures, *Storm* (c. 1922–1923) and *The Voice of Many Waters* (c. 1923–1924), and became Tack's most outspoken patron, championing his abstractions for the next forty years, which Phillips believed were the first true blending of Eastern and Western art in America. He connected Tack to Twachtman, who was Tack's teacher in the 1890s, recognizing that these two artists of different generations shared a sense of universal rhythm in nature outside any temporal moment.

As Phillips's aesthetic sensibility became more sophisticated, he bought work by other advanced American artists. He began visiting galleries in New York known for carrying the newest American painting, like the Bourgeois Gallery and Daniel Gallery. Because these dealers knew that Phillips was establishing a collection of the best contemporary American painting, they offered the neophyte director their advice and encouragement. The dealer Charles Daniel wrote to Phillips in 1924 that no complete collection of American art should omit Marsden Hartley, Charles Sheeler, or John Marin. Phillips already had an early landscape by Hartley in his collection but added Sheeler's *Skyscrapers* in 1925, a work he valued for the "emotional essence" in its distorted view of the office canyons of New York. Marin's work entered the collection the following year. Hartley's late Maine compositions, for example *Off the Banks at Night* (1942), which shared the romantic, visionary tradition of Homer and Ryder, found a home at the Phillips. The newest pictures by Rockwell Kent, a Henri student whose realist canvases Phillips first acquired in 1918, also caught the collector's eye in the mid-1920s.

Determined by 1925 to introduce Washingtonians to the most avant-garde trends, Phillips opened the "Little Gallery," a second, smaller gallery in his home. Here he freely explored aspects of American art in a more focused way, separate from the larger Main Gallery. Phillips chose artists for these Little Gallery exhibitions whom he believed "comprised the rich ore of American painting" up to that time, including not

only the great Homer, but also contemporary realist painters such as Sloan, Sheeler, and Edward Hopper. In his book *A Collection in the Making* (December 1926), Phillips was the first to write about Hopper's contrasting content, recognizing how Hopper's realism, filled with the "boredom of the solitary" figure and the psychological isolation of modern life, "defies our preconceptions of the picturesque."

Neither the witty antics of Dada with its machine aesthetic, nor the cerebral art of analytical cubism held any fascination for Phillips. His romantic nature preferred an art that contained an emotional or spiritual sense and a personal vision. It was an aesthetic that fit comfortably with Alfred Stieglitz, the avant-garde photographer and dealer who had been a primary supporter of European modernism in prewar America. By 1917 Stieglitz had soured on what he saw as commercialization and lack of emotional depth in some European movements and vowed to support only those American artists who had a spiritual element in their work. After the war, Stieglitz and his colleagues promoted a renaissance of American art based on emotional intensity and a connection to nature that revealed the artist's soul. Such an American art, they believed, could only spring from local experience and native surroundings; it was to be an American art "without that damned French flavor," as Stieglitz wrote to Paul Rosenfeld. The Ameri-

cans that Stieglitz singled out were Arthur Dove, Hartley, Marin, Charles Demuth, and Georgia O'Keeffe, along with himself and the photographer Paul Strand. "American," "soil," and "spirit" were the words most often used by the Stieglitz circle to define their aesthetic position. It was directly antithetical to that taken by avant-garde European artists such as Marcel Duchamp and Francis Picabia, who had come to New York in the 1910s and celebrated American advances in technology and industry as positive influences on art.

As his ideas matured, Phillips was drawn to the artists of the Stieglitz Circle. He encountered the work of Dove and O'Keeffe at Stieglitz's New York gallery in February 1926. Their freshness of vision proved irresistible. Phillips purchased two pictures by each, *Golden Storm* (1925) and *Waterfall* (1925) by Dove, and *My Shanty, Lake George* (1922) and one other work by O'Keeffe, which he later exchanged for *Pattern of Leaves* (1923)—the first works by each to enter a museum.

Just a month after discovering Dove and O'Keeffe in 1926, Phillips became Marin's most ardent supporter, acquiring nine of the artist's watercolors within a year, which prompted Stieglitz to playfully diagnose Phillips with "Marinitis." Determined that his artists should have a primary position in Phillips's museum enterprise, Stieglitz wrote the young director in late 1926, "I feel that you will not only have to have a large

group of Marins but undoubtedly groups of Doves and O'Keeffe, Hartley, not to speak of my own photographs, if you really want your gallery to reflect a growth of something which is typically American and not a reflection of France or Europe." Phillips needed no encouragement as he had already decided in favor of these artists on his own.

Presenting his new discoveries became a priority for Phillips. In 1926–1927, he constructed a season of modernist exhibitions "carefully planned to give the people of Washington a chance they might not otherwise have had to see what is going on among more adventurous artists of America...." *Nine Americans* focused on cubist-derived painters of "volume" and "colored forms in space," and was followed by an *Exhibition of Eleven Americans* that featured artists Phillips found to be primarily "expressionist" because they shared a desire "to create a fresh and rhythmical language of form and color which will convey their emotions." New acquisitions by Dove and O'Keeffe were prominently on view in *Eleven Americans* alongside a Tierra del Fuego picture by Kent, a brilliantly colored midday landscape by Max Weber, and decorative abstractions by Tack. Both exhibitions were Phillips's way of familiarizing the "open-minded visitor" with the new and unfamiliar visual language of abstraction. Collecting was an adventure for Phillips filled with the exhilaration that came with finding new talent.

No installation, however, was as bold and revealing of Phillips's aesthetic philosophy and commitment to the new American painting than the one he crafted for the Main Gallery in early 1927. Focusing on artists who showed an expressionist intensity in their work, Phillips organized the show around the formal elements of line, color, mass, space, and light, rather than subject matter. He gave special emphasis to the work of Pierre Bonnard and Marin, both new to the collection, explaining that "I have chosen them for special emphasis because they are the two most fascinating temperaments in contemporary art." Twelve watercolors by Marin faced paintings by

Bonnard and other French moderns such as Edouard Vuillard and Henri Matisse. On January 15, 1927, Phillips wrote to Alfred Barr, then teaching at Wellesley College but soon to become director of the Museum of Modern Art, of his intention to use Marin's watercolors to "give Washington a bracing shock." The artist John Graham was encouraged to visit the collection with his friends to see a "simply thrilling" whole "wall of Marin" along with "another wall of French Moderns, including new works by Matisse, Bonnard, [Maurice] Utrillo and [André Dunoyer de] Segonzac." Anchoring the center of the end wall was Tack's abstract panel, *The Voice of Many Waters*.

About this time Phillips began referring to his museum as "the experiment station," where new artists were "being tested by the great things in the Collection." The collection was being "molded," as he wrote, "in full view of the public" in an "unorthodox institution" that was willing to make mistakes and "learn from them in its consecrated task of searching for talent." Calling the museum "the experiment station" was a way for Phillips to capture the spirited life that his inventive exhibitions and new acquisitions gave to his still young and developing museum.

Never concerned with creating a comprehensive collection, Phillips felt a commitment from the beginning to "purchase many examples of the work of artists I especially admire and delight to honor...instead of having one example of each of the standardized celebrities," and this differentiated the Phillips from all other institutions. He was not dissuaded by mainstream criticism from pursuing artists he believed in. Phillips was ahead of his time and often the first to acquire work by artists as varied as John Kane, Horace Pippin, Allan Rohan Crite, and Jacob Lawrence, the latter today perhaps the single artist most closely identified with the black experience in America. An early and articulate proponent of our national heritage as "a fusion of various sensitivities, a unification of differences," Phillips accepted a broad range of styles, including work by

immigrants Rufino Tamayo, Yasuo Kuniyoshi, and Peppino Mangravite. The place of these independent artists within The Phillips Collection, alongside other equally diverse American painters between the wars, was a clear manifestation of Phillips's belief, expressed as early as 1914, that a renaissance of American painting would grow out of diversity.

Phillips's philosophy of collecting his favorite artists in depth led him to foster relationships with certain individuals over the years. He gave financial support to American artists exclusively, paying stipends and initiating commissions in order to give encouragement or assistance in rough economic times. The list includes Stuart Davis, Dove, Graham, Morris Graves, Kent, Karl Knaths, Ernest Lawson, Marin, Tack, and Harold Weston. Many, like Knaths, Marin, Tack, and Weston, became particularly good friends.

Phillips never lost his enthusiasm for young artists, continuing the search for new talent and works of quality and distinction in the 1940s, 1950s, and 1960s with the same adventurous spirit as before. His romantic nature favored the poetic and lyrical side of postwar painting that seemed alive with light and movement. This included the more colorful gestural abstractions of Philip Guston, Bradley Walker Tomlin, Joan Mitchell, and Sam Francis, which Phillips could relate to the great modern colorists in the collection, for example Bonnard and Matisse, among others. Around 1954 Phillips also became aware of Kenzo Okada, a Japanese-American artist working in an abstract expressionist manner.

Of all the artists of the New York School, it was through Mark Rothko that Phillips had his most serious engagement with postwar American painting. Acquiring his first Rothko paintings in 1957, Phillips held a one-person show at the museum for the artist in 1960. As he learned more about Rothko's intentions, Phillips came to understand the artist's desire to have his work exhibited on its own in small spaces. The Phillips Collection's Rothko Room, established in 1960, is the first permanent hanging of Rothko's work as a separate group, one of only three such permanent public environments of the artist's work in the world. It remains a signature feature of the museum today.

Phillips's commitment to an ahistorical installation of his collection, where, as he wrote, the "rivers of artistic purpose" would be revealed across time and geography, made it attractive to artists who not only wanted their work represented in the collection, but who also valued it as a place to study the many faces of modern art. From the outset Phillips envisioned his museum as a place to inspire working artists, often referring to it as an "American Prado." That idea encapsulated Phillips's hope that the museum that carried his name would ultimately influence artists themselves, "I hope that our Gallery will furnish inspiration to creative artists, either starting or sustaining them on their thrilling quest." Phillips aimed high in his determination to open the door wide to the modern experience and provide contemporary American artists with a historical proving ground, similar to the great Spanish museum that had permitted Edouard Manet to learn from Fran-

cisco José de Goya, Velázquez, and El Greco. Marin, on his many visits to the Phillips, was captivated by artists as diverse as Edgar Degas and Goya. O'Keeffe, who visited the Phillips only once, shortly after Phillips purchased her work in 1926, was thrilled to see her paintings and those by Dove incorporated into a collection that included the work of European masters of the modern spirit, such as Gustave Courbet, Daumier, Renoir, and El Greco.

It was, however, the generation of American artists who came to maturity after World War II on which The Phillips Collection's in-depth assemblage of American and European modern painting had its deepest impact. Richard Diebenkorn, for example, while stationed near Washington as a Marine during World War II, spent most weekends at the Phillips. He spoke reverently of the collection and its influence on him, "It wasn't, of course, like a museum at all....it was a refuge, a sanctuary for me to absorb everything on those walls." Along with the Doves and the Marins, it was Matisse's *Studio, Quai Saint-Michel* (1916) that held the greatest fascination for Diebenkorn, "the painting has been stuck in my head ever since I first laid eyes on it there [at the Phillips]. I've discovered pieces of that painting coming out in my own over the years."

Guston soaked up the expressive color in the Bonnards at the Phillips. Gene Davis, known for his canvases of intensely colored vertical stripes, recalled that "the Phillips Gallery loomed as a kind of artistic cathedral for an art-hungry young painter." Davis spent time at the Phillips in the 1940s even before he began to paint, and was particularly mesmerized by the Klee Room. Kenneth Noland, too, thought of the Phillips as a special sanctuary. He spent long hours in the Klee Room and remarked years later of the importance the collection, including the work of Americans such as Tack and Dove, had on him in those formative years. It was only at the Phillips that an artist could find so many examples by such a range of painters, European masters alongside America's "old masters" and mod-

ernist inventors between the wars, all presented in intimately scaled galleries perfectly suited to close looking.

Duncan Phillips built a collection of American painting that was substantially different from that of his contemporaries. As he was interested in the relationships between works of art, not their separations or differences, he looked for artists he believed were connected to the great American and European traditions. The idea of the connectedness of art between centuries and countries was always a guiding principle. Phillips often brought together in the galleries the landscapes of the American painters Twachtman and Lawson with work by Claude Monet and Cézanne. The contemporary still lifes of Georges Braque and Matisse stood alongside works by Hartley, Walt Kuhn, Knaths, Man Ray, and O'Keeffe. Phillips was attracted to artists whose work was linked to nature and its rhythms, sensibilities attuned to universal rhythms in the natural world, which he once described as capturing "the cosmic *unconsciously*." When Phillips acquired his first work by Rothko, *Green and Maroon* (1953), in 1957, he immediately hung it on a wall with works by Tack and Okada in *Abstract Expressionists from the Collection*. This captured Phillips's ideal of bringing together Eastern and Western aesthetics into a fully realized vision of American abstraction as a transcendent, spiritualized experience of pure form and color.

Throughout his life, Phillips wrote about American art and artists; he exhibited their work in his museum; and, most significantly, he gave American artists his patronage and encouragement. In 1929 he wrote that "the true artist needs a friend and a true patron of art who has nothing better to give the world than the helping hand he extends to the lonely, lofty spirits...." It was the maxim that guided him in his lifelong quest to assemble a collection of the best of American painting for all to see and enjoy.

Master Paintings

Milton Avery
b. 1883, Sand Back, New York, d. 1963,
New York City

Girl Writing, 1941
Oil on canvas, 48 × 31 ¾ (121.9 × 80.6)
Acquired 1943

Black Sea, 1959
Oil on canvas, 50 × 67 ¾ (127 × 172)
Acquired 1965

Milton Avery had a genius for paring his work down to essentials. Whether depicting friends, family, objects, or favorite places in the mountains or by the sea, he distilled the essence of his subject to create paintings that arrest us with their luminous color and gentle power. A quiet man for whom, as his wife put it, "drawing was as natural as breathing," he lived most of his adult life with his wife and daughter in New York, escaping during the summer to the mountains of New York or Vermont or to the seaside of Cape Ann or Provincetown. Often focusing on uneventful scenes of family life, Avery could make a casual sketch of his daughter March seated on a piano stool at the drafting table in their apartment into a monumental painting. *Girl Writing* centers on the figure herself, elbow bent and resting on the table to support her forehead, her legs below double-crossed in a pose of utmost concentration. Avery takes certain liberties, turning her simple waisted dress into a bold white shape, her hair black, her face pink, and her socks red. Showing his natural inclination to take away rather than to add, he decorates her socks by incising them with stripes. On the table in the far corner sprigs of flowers in a bouquet of spindly lines and dabs of white offer a perfect counterpoint and depth to this flattened pictorial space. While Avery has eliminated table legs altogether, allowing the broad plane of the table to jut out from the wall, it does not float so much as support with

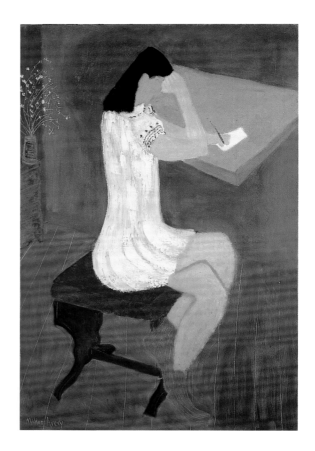

undeniable pictorial weight the painting's central subject. Using distortion and emphasis for the sake of pictorial expression, Avery deftly apportions the quantity and intensity of each color to balance and energize the composition as a whole.

The Phillips Collection was the first museum to purchase a painting by Avery (in 1929) and the first to present an exhibition of his work, but it was not until the 1940s—Avery's most prolific decade—that Phillips began acquiring Avery's work consistently, building a collection of eleven paintings and one work on paper.

During the 1950s Avery often worked on a larger scale while at the same time further reducing the elements of his composition. *Black Sea*, an iconic painting of 1959, consists of an expanse of golden sand, a ripple of white surf and a wedge of black suggesting an infinite sea beyond. Avery's close friendship at the time with Mark Rothko and Adolph Gottlieb may be reflected in this work, but Rothko gave all the praise to his mentor in his memorial address of 1965, in which he said of Avery's work, "the poetry penetrated every pore of the canvas to the very last touch of the brush. For Avery was a great poet-inventor who had invented sonorities never seen nor heard before. From these we have learned much and will learn more for a long time to come." ER

Francis Bacon

b. 1909, Dublin, d. 1992, Madrid

Study of a Figure in a Landscape, 1952
Oil on canvas, 78 × 54 ¼ (198.1 × 137.7)
Acquired 1955

Francis Bacon spent his tumultuous youth in Ireland and England. When his homosexuality was discovered, he was thrown out of his parents' home. Aged sixteen, he left for London, then lived for a couple of years in the bohemian worlds of Berlin and Paris. He started to draw and paint in watercolors around 1926 but had no formal training as an artist. Bacon moved back to London in 1929 and began to paint, inspired by seeing Pablo Picasso's exhibition in Paris in 1928. Later notable inspirations were the works of Diego Velázquez, surrealism, film, and the poetry of T. S. Eliot.

Bacon's main subjects are male figures, often screaming or in violent sexual grapples, against stark backgrounds. Painted with clinical detachment and hung framed and under glass, they provoke anxiety. In *Study of a Figure in a Landscape*, an austere and quiet painting, a man squats in a field, high on the picture plane and close to the horizon line. Vulnerably naked, he is an animal, simultaneously wild and tame, blurred, almost camouflaged as a shadow. The only heavily painted element in the painting and its focal point, demarcated by

stippled verticals and horizontals, the figure looks as though it has been cut out of a grainy photograph and pasted onto the background, a tawny field of long, waving grass. The disjuncture between figure and background is typical of Bacon, who often used films and photographs as sources. In this case, the source for the figure was a photograph from Eadweard Muybridge's *Human Figure in Motion* (c. 1885). The realistic treatment of the figure contrasts with the painting of the dreamlike setting, inspired by the artist's trips in 1950 and 1952 to South Africa, where he visited the Kruger National Park. Blades of long grass are rendered individually as lime or black strokes of lean paint, black smudges suggest a background of scrubby trees, and a sky is rendered as a pastel-like rub of brilliant blue.

Study of a Figure in a Landscape, a particularly delicate painting in Bacon's oeuvre, continues the landscape theme of the English paintings in The Phillips Collection. After acquiring it Duncan Phillips, who greatly admired the artist's technical skill, considered buying another work by Bacon, a portrait of a cardinal, but, finding it too alien, he ultimately decided against it. JHM

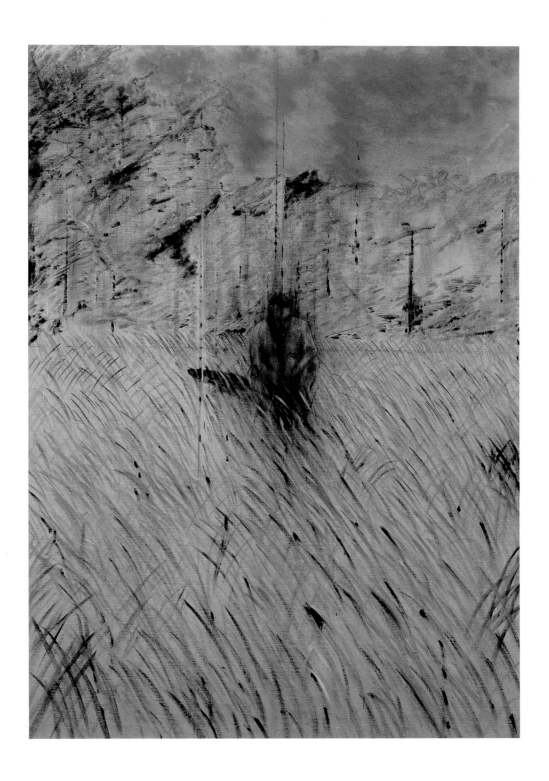

Pierre Bonnard

b. 1867, Fontenay-aux-Roses, France, d. 1947,
Le Cannet, France

The Open Window, 1921
Oil on canvas, 46 ½ × 37 ¾ (118 × 96)
Acquired 1930

The Palm, 1926
Oil on canvas, 45 × 57 ⅞ (114.3 × 147)
Acquired 1928

At the start of his career Pierre Bonnard, along with his friend Edouard Vuillard, belonged to the Nabis, a group of painters who embraced the symbolist theories of Paul Gauguin, Japanese art, and the poetry of Stéphane Mallarmé. Where Gauguin looked to distant civilizations and lost Edens for meaningful symbols, Bonnard found paradise at home. Unlike the impressionists, to whose work Bonnard's has a superficial resemblance, he worked from memory rather than from the motif, which accounts for the dreamlike quality of his paintings.

Bonnard's quiet and private life is mirrored in his work. His primary subject was the domestic interior and its psychological charge, and in many of his interiors a sense of longing is concentrated in open windows and the world beyond seen through them. In *The Open Window*, ravishing color and shimmering, pearly light transfigure a room in his house in Normandy. In fact, Bonnard shows very little of the room. The focal point of the painting is the void at its center, the blue sky, green foliage, and violet shadow outside, framed invitingly by the window casing, walls, and a dark, guillotine-like slice of window blind. The contrast between the exterior blues and greens and the interior red oranges is so dazzling that it takes a moment before a black cat and a woman become visible at the lower right corner of the canvas. In Bonnard's paintings, dogs and cats are essential threads in the weave of human life. They insinuate themselves into his paintings, almost indecipherable calligraphic marks, peripheral presences. A recurrent human figure is his wife, Marthe de Méligny. Marthe, whose real name was Maria Boursin, became his mistress in 1893 and was his wife from 1925 until her death in 1942. Their claustrophobic relationship was complicated by Bonnard's infidelity. The blond woman in *The Open Window* may be Renée Monchaty, with whom he fell in love around 1917 and who committed suicide in 1923, when Bonnard left her to return to Marthe.

Bonnard used color both expressively and scientifically, setting the mood of a scene, and, at the same time, accurately describing the way the eye encounters particular effects of light. In *The Palm*, the landscape, with its decorative, tightly woven, abstract pattern of rooftops through a frame of palm fronds, is a vista Bonnard could see from his home on the French Riviera. The artist was keenly observant of the tricks that light plays and the way the eye apprehends the world as opposed to the way one actively looks at pictures. In *The Palm* Bonnard places the painting's human subject at the bottom of the picture: one focuses first on the light-filled view in the center of the composition, not immediately noticing the drama quietly taking place in the foreground shade. There, the half-figure of a woman looks out at the viewer, an apple in her hand, which seems almost to cross the frame of the painting

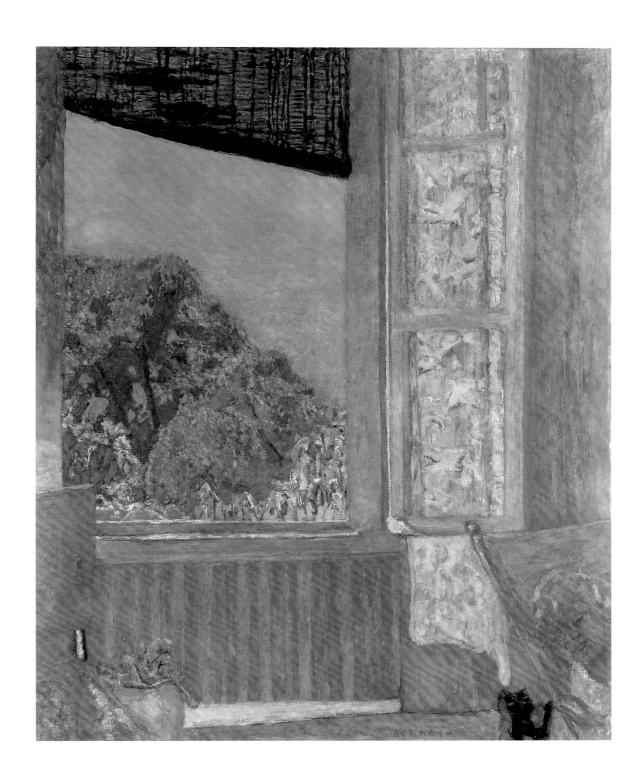

into the viewer's space. Is she Eve offering the apple? Is she an allegory of nature? Or, do the palm fronds signify victory? If so, perhaps Bonnard is saying that the model is beauty herself, Venus Victrix on Mount Ida, to whom Paris has just awarded the golden apple.

It is difficult to overstate the importance to The Phillips Collection of Phillips's encounter with Bonnard's work in 1925. Overwhelmed by the artist's use of color, Phillips saw in his paintings a modern continuation of the sensualist tradition of Titian and Pierre-Auguste Renoir. For Phillips, as for Bonnard, the intimate domestic interior was paramount. Phillips's vision for his museum, as a series of small intimate domestic spaces where the visitor could linger at ease in the contemplation of great works of art, seemed to find an echo in Bonnard's obvious pleasure in everyday life at home. When Phillips said, "With us Bonnard is at home," the sentiment could clearly be reversed. With Bonnard, Phillips was at home. JHM

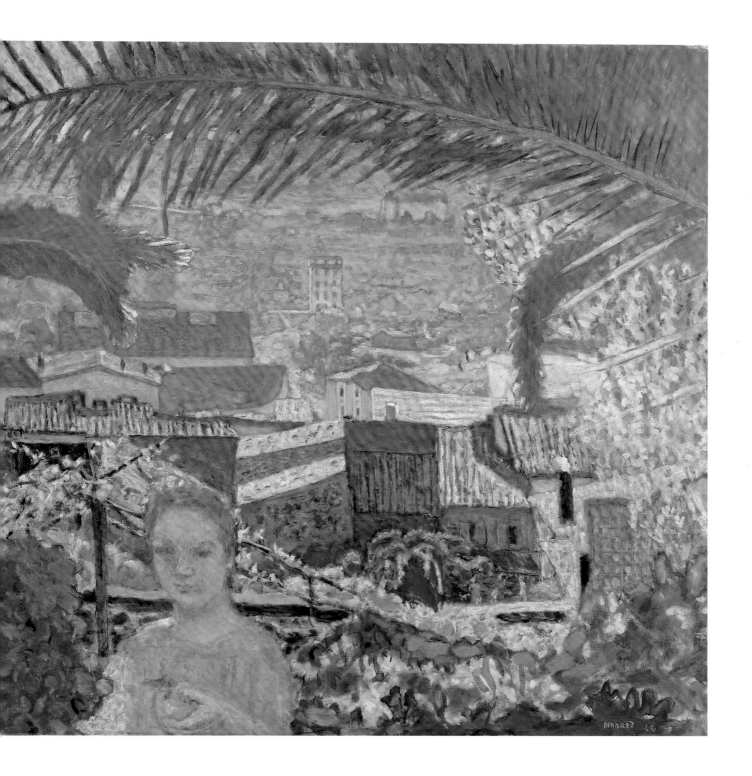

Georges Braque

b. 1882, Argenteuil-sur-Seine, France, d. 1963, Paris

The Round Table, 1929
Oil, sand, and charcoal on canvas, 57 ⅜ × 44 ¾
(145.6 × 113.8)
Acquired 1934

The Washstand, 1944
Oil on canvas, 63 ⅞ × 25 ⅛ (162.4 × 63.8)
Acquired 1948

With one exception, the thirteen paintings by Georges Braque in The Phillips Collection date from the years following the end of the pioneering cubist examinations of space and form he undertook with Pablo Picasso. Called up at the beginning of World War I and seriously wounded in 1915, Braque returned to painting in 1917, at which time he and Picasso were no longer "two climbers roped together," as Braque described their earlier partnership. Braque continued to use the pictorial language and images of cubism but in ways that made the subjects of his paintings intelligible. Although appalled by the first manifestations of cubism, Duncan Phillips developed an understanding of the style by the end of the 1920s, in large part because Braque's seductive paintings so changed the look of cubism. During the 1920s, his paintings became majestic and grave, which led Phillips to see in them supremely French "qualities of taste, logic and balance."

The Round Table is one of many still lifes that Braque set on a round pedestal table during the 1920s. He shows the table in a corner, its top tilted almost parallel to the picture plane and cluttered with objects. Throughout the painting, ambiguous spatial relationships cause the eye to shift as it moves over the canvas. Contrary to the laws of conventional perspective, the lines of the dado remain at a uniform height as they converge on the corner of the room. Abstracted pages or sheets of paper on the table seem to be interleaved with the planes of the corner. One half of the guitar appears three-dimensional, while the other half is two-dimensional. The knife—a staple of the still-life tradition in which it signified the painter's power as an illusionist—has its handle turned toward the viewer and is painted in two dimensions only. As a further reminder that paintings are artifice and canvas is flat, Braque paints the table to look as though it is cut out of wood-grained paper. He treats the dado, too, as though it is a fictive element, the creation of a house painter-decorator (a trade Braque learned from his father). The subject of The Round Table is an abstraction, the nature of painting, which Braque realized in a composition that shares the quiet, reserved quality of works by Jean-Siméon Chardin. Braque counters the unstable relationships between the objects in his painting with a centered and quartered composition that is powerfully, reassuringly, thoughtfully static. Painted with a light-filled palette of sensual, soft, pale viridian green, red orange, cobalt blue, and lemon yellow, as well as his signature blacks and whites, The Round Table invites the viewer's gaze to linger.

Braque and his wife lived in Paris during World War II. Painted during the war, The Washstand has none of the exuberance of The Round Table. The stacked column of melting forms including the sponge, brush, and bidet or stool rises

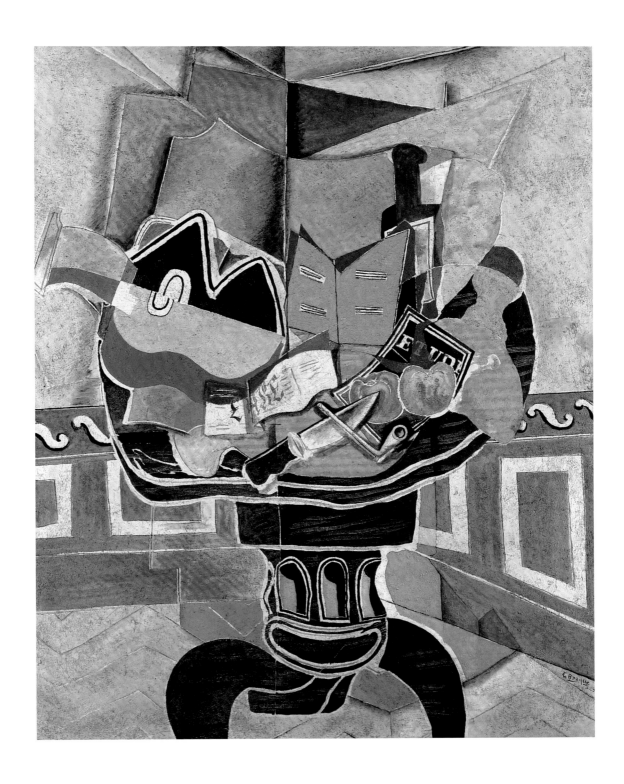

within a tight framework of verticals and horizontals. *The Washstand*'s drab colors, restricted space, and gray, viewless window seem to reflect the austerity and deprivations of wartime life. Only in the checkered blue and white cloth, the marbling below the window, the curve of wrought iron outside, and the stripes of the radiator are there hints of ornamental energy. Ablutions, in this painting, are a necessary ritual, hygienic rather than pleasurable. Braque's concentration on bathroom and kitchen still lifes at this period was due at least in part to the fact that these were the only rooms that he and his wife were able to keep warm. JHM

Charles Burchfield

b. 1893, Ashtabula Harbor, Ohio, d. 1967,
West Seneca, New York

Moonlight over the Arbor, 1916

Watercolor and gouache over graphite on paper,
19 ¼ × 13 ½ (48.9 × 34.3)
Acquired 1933

Charles Ephraim Burchfield was born in 1893 in Ashtabula Harbor, Ohio, a small town on Lake Eerie whose main distinction is that before the American Civil War it was the last stop on the Underground Railroad, which brought African-American slaves to its port so that they could be carried by boat to freedom on the Canadian side of the lake.

Burchfield enrolled in the Cleveland School of Art and in 1916 received a scholarship to study at the National Academy of Design in New York, but he left after just one day. He soon returned to Salem, Ohio, where his family had moved in 1898 after his father's death. There, he began painting the surrounding woods and meadows. As a twenty-one-year-old, Burchfield wrote in his journal, "I hereby dedicate my life and soul to the study and love of nature, with the purpose to bring it before the mass of uninterested public."

Like much of his early work, his depiction of a full moon above a shady alcove of trees and plants in *Moonlight over the Arbor* is stylized and expressed with simple lines and colors, not unlike the woodblock prints by the American arts and crafts artist and educator Arthur Wesley Dow that were in turn informed by nineteenth-century Japanese printmaking. Artists as varied as Paul Gauguin, James Abbott McNeill Whistler, and John La Farge have drawn on the aestheticized depiction of nature in Eastern art, and Burchfield was no exception. Burchfield's preferred medium was watercolor, however, which he valued for its "natural quality" and its responsiveness to change. In these early works he usually drew the outlines of his compositions with pencil and then filled them in with washes of watercolor.

Moonlight over the Arbor shows his familiarity with Japanese art as well as a remarkable virtuosity in creating patterns and rhythms with color—a skill he would explore by teaching camouflage painting during his service in the U.S. Army between 1917 and 1918, and again when he became head of design for the wallpaper company M. H. Birge and Sons in 1925. KO

Paul Cézanne

b. 1839, Aix-en-Provence, France, d. 1906,
Aix-en-Provence

Self-Portrait, 1878–1880
Oil on canvas, 23 ¾ × 18 ½ (60.4 × 47)
Acquired 1928

Mont Sainte-Victoire, 1886–1887
Oil on canvas, 23 ½ × 28 ½ (59.6 × 72.3)
Acquired 1925

The Garden at Les Lauves, c. 1906
Oil on canvas, 25 ¾ × 31 ⅞ (65.4 × 80.9)
Acquired 1955

Coming to terms with the art of Paul Cézanne led Duncan Phillips to understand modern art. The collector considered the painter a fool in 1912, but later saw in him the link between El Greco and Pablo Picasso. Between 1925 and 1955, Phillips bought seven works by Cézanne that are now in The Phillips Collection (six oils and a lithograph). All date from the last three decades of the artist's life.

Cézanne painted scores of self-portraits, many of them in exactly this pose and on canvases of about the same size, recording his appearance and self-image as well as his progress as a painter. In this powerfully modeled portrait, painted when he was about forty years old and at an age that invites self-appraisal, Cézanne looks at himself unflinchingly, objectively reporting his knobby features and generally lumpen, unrefined, and shaggy appearance. His jacket, loosely and roughly painted, looks, in places, to be of the same fabric as the canvas. Cézanne's hair reaches his collar and his neck hides behind his clothing and his messy beard. A hint of mouth is visible, but mustache and beard conceal most of it. Little skin shows. Cézanne models his ruddy, blotchy face and large, balding head in short unblended brushstrokes, built up to a thick impasto. This literal edifice of paint serves as a defense, behind which his sharp eyes peer out. It is the psychological guardedness of this man (who is otherwise completely candid about his ugliness) that makes the painting so compelling. Vigorously and freely painted in a dark and limited palette, his work has more in common with the old masters than with impressionism. The Phillips Collection's painting was the first self-portrait by Cézanne to enter an American museum. Phillips was very proud of it, describing "that head of an old lion of a man, the pride and loneliness of him so directly conveyed by purely plastic means." He was almost exactly the same age when he bought the painting as Cézanne was when he painted it. History shows that, at forty, both were just getting started.

One of the many views Cézanne painted of the mountain near his home in Aix-en-Provence, *Mont Sainte-Victoire* appears through a frame of pines and across a great valley. Cézanne may have loved the mountain, but his feeling for it differed from the visceral attachment that Gustave Courbet

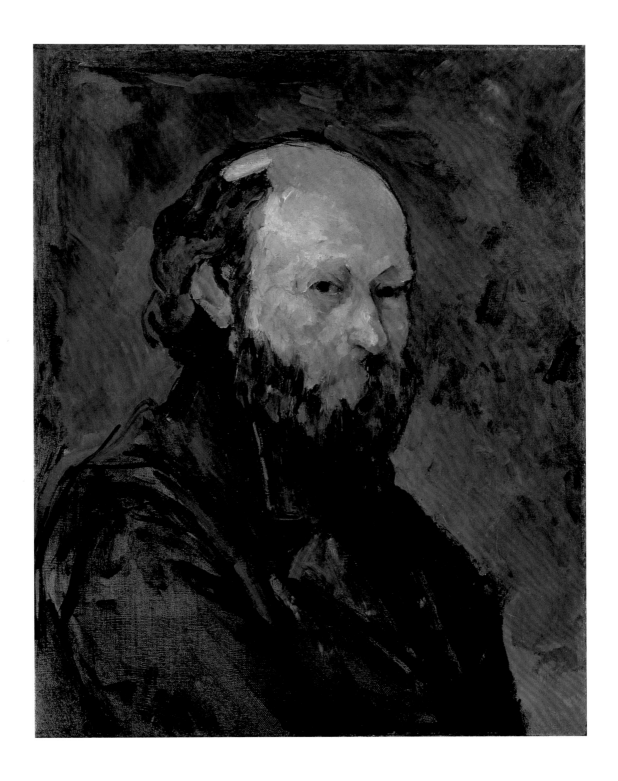

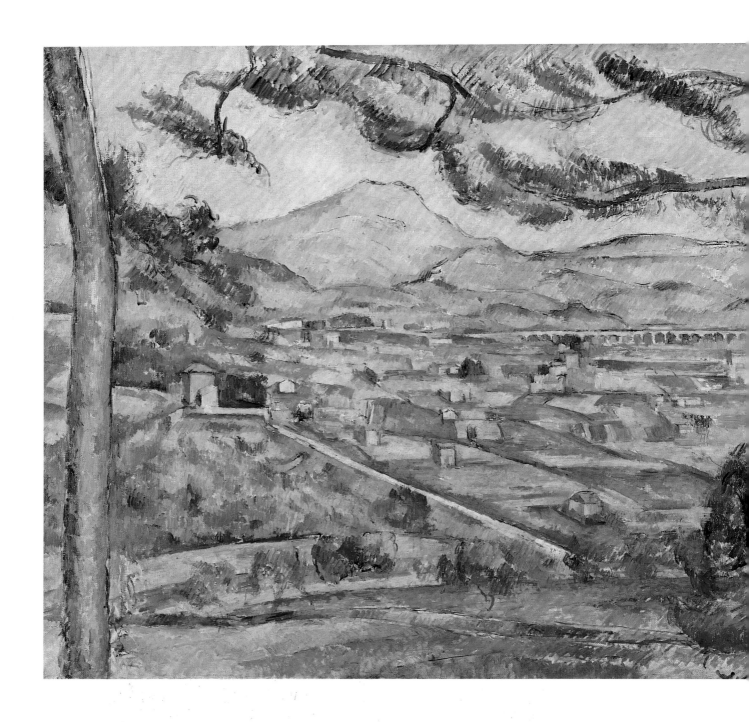

46

felt for his local scenery. For Cézanne, trysts with Mont Sainte-Victoire represented his ambitious struggle to paint landscapes for the ages and create new equivalents to the arcadian scenes of Claude Lorrain and Nicolas Poussin. Cézanne did not work quickly or easily. He painted Mont Sainte-Victoire with deliberation, in short, angled brushstrokes, trying to connect his visual sensations, not to a moment, but to the ongoing facts of the view. He sought to reconcile individual facts in his field of vision with the geography of the whole.

The Garden at Les Lauves, energetically painted very late in the artist's life, depicts a view toward Aix that Cézanne could have seen from the studio he built in 1901 north of the town. Framed by an overhanging branch of a tree that grew outside

his studio, the vividly colored, abstracted view takes in the dark band of the terrace's retaining wall. Beyond it is a middle ground of vegetation, and in the distance the wild sky and perhaps mountains. Unpainted patches of canvas are visible among the slashes of color, leading scholars to speculate that this may be an unfinished work. However, the artist wrote in 1905 that he found "the color sensations which give us light are the source of abstractions which do not allow me to cover my canvas nor to pursue the delineation of objects where the points of contact are tenuous, delicate; thus my image and picture is incomplete." Phillips thought the work a sketch, recognizing the painting's structure as well as its improvisational quality, and judged it a symbol of great art in the making. JHM

Jean-Siméon Chardin

b. 1699, Paris, d. 1779, Paris

A Bowl of Plums, c. 1728
Oil on canvas, 17 ½ × 22 ⅛ (44.6 × 56.3)
Acquired 1920

Although Jean-Siméon Chardin was a member of the French Academy, he worked almost exclusively on subject matter that ranked very low in the academy's official hierarchy of painting, spending most of his quiet and uneventful life creating luminous still lifes in glowing colors. In the mid-1730s, he gave them up for about a decade to concentrate on interior scenes, which commanded higher prices than still lifes. Chardin's work anticipated modernism in many ways. His originality lay partly in his choice of everyday objects as subject matter. The same cast of objects, typical of a bourgeois household, reappears in his works. The simple forms and humble nature of the objects, in apparently uncontrived arrangements, and Chardin's bold use of empty space give his work an austerity that sets it apart from the extravagance of contemporary rococo painting. A Bowl of Plums is typical of his early paintings. The bowl of fruit and the Delft pitcher are set on an indeterminate surface against a scumbled background and at enough distance to diminish detail, allowing a painterly concentration on essences rather than exact imitation. A Bowl of Plums was one of Duncan Phillips's favorite paintings. He admired it as "personal and poetic in spite of its apparent objectivity." JHM

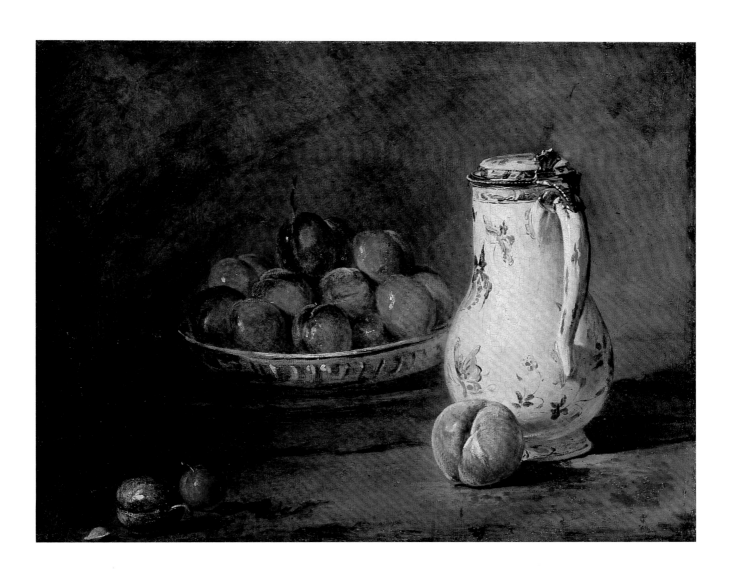

William Merritt Chase

b. 1849, Williamsburg (later Ninevah), Indiana,
d. 1916, New York City

Hide and Seek, 1888
Oil on canvas, 27 ⅝ × 35 ⅞ (70.2 × 91.1)
Acquired 1923

William Merritt Chase trained with a portrait painter in Indianapolis before enrolling in the National Academy of Design in New York in 1869. After a brief sojourn in St. Louis he went to Munich in 1872 to study at the royal academy. The dramatic "dark manner" characteristic of that program was transmitted to him by Karl von Piloty and Wilhelm Leibl, as was the encouragement of quick, bold brushstrokes.

Returning to New York in 1878, Chase joined the faculty of the Art Students League and was instrumental in the establishment of the then-radical Society of American Artists. His Tenth Street Studio functioned as a salon for fellow artists, patrons, and students. Two decades later Chase formalized the Chase School of Art and counted such distinct talents as Alfred Maurer, Charles Demuth, Marsden Hartley, and Georgia O'Keeffe among his pupils.

Chase went abroad frequently and, believing that exposure to the old masters and the new European modernism was critical to an artist's development, often took students with him. Technique was always more important to him than subject matter. An essentially conservative artist, he believed firmly in attention to detail. He drew directly on the canvas with a loaded brush and is recognized for his facile, bravura brushwork, applying the same principles to his work in pastel. He painted prolifically, showed extensively, and won numerous medals and awards. Chase was president of the Society of American Artists from 1885 to 1895, when he withdrew to join The Ten as their eleventh member after the death of John Twachtman.

Hide and Seek can be viewed as transitional in Chase's oeuvre. As the light-filled qualities of impressionism begin to infiltrate his painting, remnants are still evident of the darkness of the Munich school and Spanish masters such as Diego Velázquez. Chase's asymmetrical composition and eccentric point of view betray the influences of photography and Japanese prints. The horizon line is high while the center of the canvas is strangely unencumbered. The objects that frame it are cut off and flatly modeled. Looking over the glistening hair of the girl on the lower left, we traverse the vast, shimmering expanse of brown floor toward the other girl and the promise of light that slips around the Oriental screen, balanced by the luminous blue, but empty chair. The painting speaks eloquently to the magic and mystery of childhood.

A small oil on panel, an undated "postcard" of Florence, Italy, is the only other work by Chase in The Phillips Collection. At the core Chase was a realist, but an extremely elegant one. Perhaps neither as "American" nor as radical as some would like, he is to be respected, in the words of Duncan Phillips, "for his influence on the development of taste in the United States during the period when we were acquiring some of the artistic sagacity of Europe." SB

50

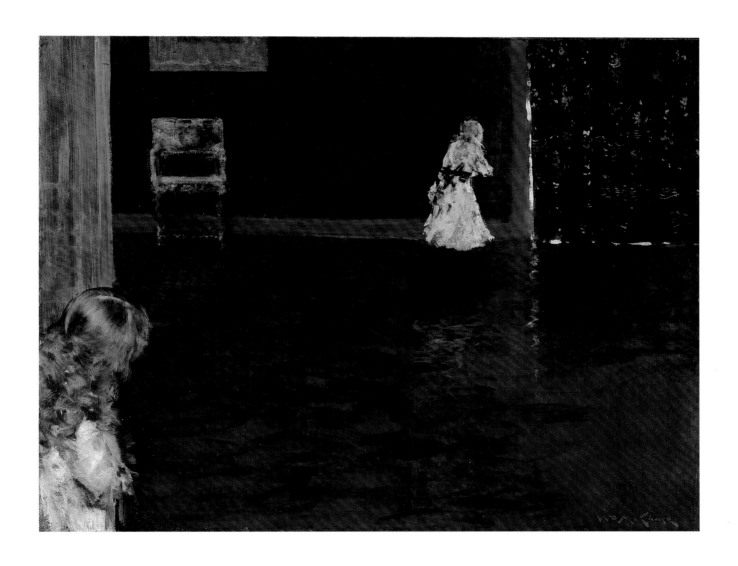

Jean-Baptiste-Camille Corot

b. 1796, Paris, d. 1875, Ville-d'Avray, France

View from the Farnese Gardens, Rome, 1826

Oil on paper mounted on canvas, 9 ⅝ × 15 ¾
(24.5 × 40.1)
Acquired 1942

Jean-Baptiste-Camille Corot painted *View from the Farnese Gardens* during his first stay in Italy from 1825 to 1828. At this time, a Roman sojourn was still considered a necessary stage in an artist's education. While in Italy, Corot worked out of doors. Over the course of seventeen days, he painted three pictures in the Farnese Gardens. He spent the mornings working on The Phillips Collection's painting. The view faces the church of San Sebastiano in Palatino, the building just to the left of the painting's center. At noon, Corot turned east to continue painting the view of the Colosseum (Musée du Louvre, Paris), while later in the afternoon he shifted to a slightly different position in the Farnese Gardens. From this spot, he would work on the view of the Roman Forum, to the north (Louvre, Paris). The Phillips Collection's painting captures the feeling of a sunlit early morning, cool and clear, before the day turned hot. The light falling in the distance and in the middle ground creates strong shadows. In contrast to Corot's empirical treatment of the light is the generalization of the trees in the foreground, holdovers from the studio conventions of historical landscape painting. The artist's mastery of infinitely subtle tonal values is evident throughout the work.

View from the Farnese Gardens is one of four paintings in The Phillips Collection by an artist whom Duncan Phillips regarded as a critical link between past and modern art. JHM

Gustave Courbet

b. 1819, Ornans (Franche-Comté), France,
d. 1877, La Tour de Peilz, Switzerland

Rocks at Mouthier, c. 1855
Oil on canvas, 29 ¾ × 46 (75.5 × 116.8)
Acquired 1925

One of the most important painters in the development of modernism, Gustave Courbet linked his anti-idealist approach to art with his anticlerical and political beliefs. Critics considered his unconventional early works — monumental paintings of peasants and laborers — ugly and offensive. After 1855, when Courbet organized his own exhibition, the Pavilion of Realism, following rejection at the Paris Universal Exposition of the same year, he concentrated on landscapes and hunting scenes, for which he won official recognition. Ever political, Courbet publicly turned down the cross of the Légion d'honneur in 1870. His involvement in the Paris Commune the following year cost him six months in jail. Courbet spent the last four years of his life in Switzerland.

The artist's independent approach to the world did not accommodate the traditional academic hierarchy of subjects. Landscape, particularly that of the Franche-Comté in eastern France, where he grew up, held a primal, almost sacred importance for him. *Rocks at Mouthier* depicts a place in the vicinity of Ornans, Courbet's birthplace. The setting has been identified as the rocks of Hautepierre, a massive outcropping overhanging Mouthier-Haute-Pierre, shown in many of Courbet's works. Its significance to Courbet is suggested by the fact that it is the subject of the painting on the easel in his most famous painting and manifesto of 1854–1855, *The Painter's Studio* (Musée d'Orsay, Paris).

In The Phillips Collection's painting, the steep escarpments and limestone cliffs of Hautepierre dominate the canvas, filling most of it on the right, pushing up to the top, and leaving room for just a sliver of blue sky. On the left, the cliffs fall away, revealing a big sky that fills the upper left quadrant. In the foreground the dark waters of a stream reflect the deep greens of lushly painted trees and vegetation. To the left, a trail leads through the valley before vanishing at the top of a hill. Patches of sunshine illuminate some of the vertical rock faces. In other areas entrances to dark caves are visible. Shadows on the undulating turf that covers the rock formation at the upper right quadrant of the canvas tell of passing clouds, and where the horizontal turf layer meets the planes of the rock turrets, Courbet shows how thin that stratum is. Evidence suggests he took an interest in the ancient geology of his native region. Part of what makes this painting so compelling is the combination of precise scientific observation with a bravura application of paint visible in the treatment of the eroded rock face. Slashing away with his palette knife, Courbet seems almost to have quarried the rock out of paint.

Duncan Phillips bought *Rocks at Mouthier* early in his career as a collector. He recognized the vigor and independence of Courbet's elemental and nonliterary vision, and regarded him as a kind of Walt Whitman of painting. JHM

Honoré Daumier

b. 1808, Marseille, d. 1879, Valmondois, France

The Uprising, 1848 or later
Oil on canvas, 34 ½ × 44 ½ (87.6 × 113)
Acquired 1925

Three Lawyers, 1855–1857
Oil on canvas, 16 × 12 ¾ (40.7 × 32.4)
Acquired 1920

Honoré Daumier was almost unknown as a painter in his lifetime. He made his living as a cartoonist, using his gift for speedy summaries of emotion and gesture, and he is best recognized for his depictions of the plight of the poor and his political caricatures of French society under Louis-Philippe. A painter of considerable power, Daumier was a favorite of Duncan Phillips who relished the artist's ability to convey the drama of everyday life in a universal way. For this, as well as for

Daumier's monumental forms, Phillips considered him the peer of Michelangelo.

The Uprising depicts a moment of revolutionary uproar in the streets that may have been inspired by the revolution of 1848 and the overthrow of Louis-Philippe's July Monarchy, one of many violent episodes in nineteenth-century French political life. The core of the painting is gesture, the defiant raised right fist that is about to punch through the edge of the paint-

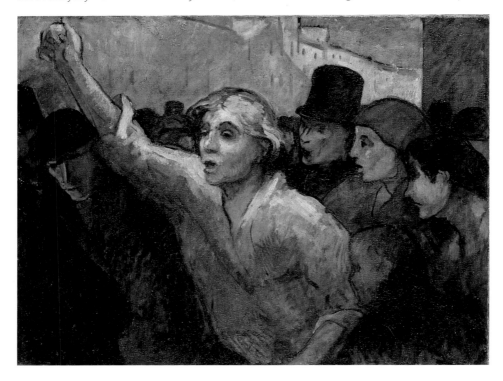

ing. Daumier certainly knew Eugène Delacroix's famous painting of 1830, showing Liberty guiding the people. In it, Liberty raises her right arm in the same gesture. She is clutching the French tricolor flag in one hand and a musket in the other. But unlike Liberty, Daumier's demonstrator is a human being, not an idealized figure standing in for a larger concept. Daumier renders a surging crowd in shorthand, as a compilation of social types: a worker in his cloth cap, a bourgeois in a top hat, a couple of working-class women, and a child. In fact, *The Uprising* suggests menace rather than riot: the man in the top hat could be yelling, but really the crowd just looks on. The energy of the event is concentrated in the man in the white shirt, bathed in light. He stands out from the crowd, which must have struck a chord with Phillips, for whom artistic independence was paramount: "My own special function," he said, "is to find the independent artist and stand sponsor for him."

On stylistic grounds, some scholars believe that Daumier painted *The Uprising* in the second half of the 1850s. Critics generally agree that a later hand retouched parts of the painting and that Daumier left it in a more sketchy form than the extant work. Phillips, who made clear that *The Uprising* was his favorite among Daumier's paintings and referred to it at times as "the greatest picture in the Collection," felt that in its essence, the work revealed Daumier in spite of later additions. "An unfinished masterpiece," said Phillips, "cannot be left out nor underrated if the heart, the mind and the hand of a great artist at his best have been revealed in the essential part of the picture which carries the emotional expression."

Three Lawyers takes up a theme that Daumier treated in countless works on paper. He himself had experienced French justice. He was charged with sedition for lampooning Louis-Philippe and served six months in jail, after which government censorship forced him to focus on middle-class society and manners. He clearly enjoyed mocking the legal profession and obviously felt that the deck was always stacked against society's poor, lowly, and defenseless. No matter what the outcome for the little man, the lawyers in Daumier's images always do fine. Here they are, self-congratulatory, puffed up with self-importance, exchanging clever quips. While in the courtroom they attack each other with obligatory theatricality, outside there is unity and collusion. In the background at the left, a weeping woman, ignored by the lawyers, is a reminder of the human toll of legal action. Phillips noted the beautiful and colorful effects that Daumier extracted from a palette of blacks and whites, comparing him to Diego Velázquez, Gerard ter Borch, and Rembrandt. JHM

Stuart Davis

b. 1894, Philadelphia, d. 1964, New York City

Egg Beater No. 4, 1928
Oil on canvas, 27 ⅛ × 38 ¼ (68.9 × 97.2)
Acquired 1939

Blue Café, 1928
Oil on canvas, 18 ⅛ × 21 ⅝ (46 × 54.9)
Acquired 1930

Stuart Davis grew up in an artistic environment — both his parents worked in the arts. His father, Edward Wyatt Davis, was artistic director of the Philadelphia Press, and his mother, Helen Stuart Foulke Davis, a sculptor. At age fifteen Stuart dropped out of high school and went to New York to study painting at the Robert Henri School of Art. Three years later he exhibited at the infamous 1913 Armory Show, the youngest artist to participate. There he discovered the highly personal abstractions of the

French cubist painter Fernand Léger, which were characterized by bold colors and a simplified treatment of modern subjects. They inspired Davis to develop his own abstract style, which he achieved with his pivotal Egg Beaters series. He worked on the series exclusively for one year, from 1927 to 1928, focusing on the spatial relationships and structural integration of objects, and he later recalled, "I nailed an electric fan, a rubber glove, and an egg beater to a table and used it as my exclusive subject matter for a year." *Egg Beater No. 4* is the last work in the series, and Davis considered it its most successful example. Like the other paintings in the series, it is informed by products and appliances of modern life and the bold graphics of American advertising. Reduced to its most essential shapes and flattened by solid colors, it represents a radical reinterpretation of the still-life genre. It is one of two works that Davis chose to take with him when he moved to Paris later that year. Davis later remarked to curator James Johnson Sweeney, "You may say that everything I have done since has been based on that eggbeater idea."

During his one-and-a-half-year stay in Paris, made possible by the financial support of Juliana Force, the director of the Whitney Studio Club in New York, Davis began painting playfully ebullient street scenes that reveal his instant enthrallment with the bohemian life in Paris. In *Blue Café* the artist combined his considerable experience and skill as a former magazine illustrator with his newly achieved flat, cubist-inspired painting style to capture the timeless yet modern ambience of a Parisian café and street corner. The buildings and street signs are reduced to their most essential elements and are painted in bold pinks, greens, blues, and yellows. *Blue Café* was the first of many paintings by Davis purchased by Duncan Phillips at the urging of the influential Baltimore-based modernist painter John Graham, who made frequent trips to Paris during the 1920s. Phillips valued Davis's Paris paintings for their kinship to Pablo Picasso and acquired three additional works from that period within a year.

Into the solid pink sky above the building Davis drew five parallel lines to symbolize a musical stave and a cleflike number 8, which may be a reference to the American jazz that was sweeping Paris at the time. Davis had been a devotee of jazz, which he likened to modern art, since his student days. KO

Willem de Kooning

b. 1904, Rotterdam, The Netherlands, d. 1997,
Long Island, New York

Asheville, 1948
Oil and enamel on cardboard, 25 ⅝ × 31 ⅞
(64.9 × 80.9)
Acquired 1952

Willem de Kooning was one of the leading figures of abstract expressionism. Trained in fine and applied arts at the Rotterdam Academy, he immigrated to the United States in 1926 and settled in New York. There he befriended many avant-garde artists of the time, for example John Graham, Arshile Gorky, and Stuart Davis. Under the auspices of the WPA Federal Art Project in 1936, De Kooning was able to fully dedicate himself to painting, producing throughout the late 1930s and the 1940s a large body of work, both figurative and abstract.

In the spring of 1948 he had his first solo exhibition at Eagan Gallery in New York, showing black-and-white abstract painting that referred to the chaotic tempo of New York life and the cubist and surrealist styles. That year De Kooning asserted: "I'm not interested in 'abstracting' or taking things out or reducing painting. I paint this way because I can keep putting more and more things in it: drama, anger, pain, love, a figure, a horse, my ideas about space." Later that summer, the artist began to teach at the experimental Black Mountain College in North Carolina. He worked on one painting during his tenure, *Asheville*, the name of the town near the progressive school. With its bold use of color, this work marked a departure from the earlier abstractions. De Kooning painted over and then removed a paper template and built up surfaces numerous times to create a rich texture that resembles collage. Although the painting appears to be spontaneous, chance-driven, or automatic, it reveals the technical mastery of the artist's hand.

While in residence at Black Mountain College, De Kooning found his way under the leadership of the German color theorist Josef Albers, then head of the art department. He struggled with his painting, experimenting with pastels before beginning *Asheville*, on which he would continue to work after returning to New York. De Kooning's wife, Elaine, witnessed the painting's evolution as the "flaming pinks and oranges and yellows would sweep across the paper in ever-changing forms." The result is a composition connected by sinuous black lines made with a liner's brush, a tool he had utilized while working as a sign painter. The skyline in the upper center suggests the Blue Ridge Mountains, and the panel of green at the left evokes pastoral life.

Duncan Phillips expressed an interest in De Kooning's work in 1951, while preparing for the exhibition *Painters of Expressionistic Abstractions*. He wrote to the New York dealer Sidney Janis, voicing his preference for the artist's "pure abstractions in which no figures or parts of figures are to be found." Though *Asheville* hints at the figuration later seen in De Kooning's aggressive series of women, Phillips purchased the painting. It became the first and only acquisition of the artist's work by Phillips for the collection. vs

Edgar Degas

b. 1834, Paris, d. 1917, Paris

Melancholy, late 1860s
Oil on canvas, 7 ½ × 9 ¾ (19 × 24.7)
Acquired 1941

After the Bath, c. 1895
Pastel on paper, 30 ½ × 33 ⅛ (77.5 × 84.3)
Acquired 1949

Dancers at the Barre, c. 1900
Oil on canvas, 51 ¼ × 38 ½ (130.1 × 97.7)
Acquired 1944

Edgar Degas was predominantly a figure painter and a consummate draftsman. An acute observer of modern life, he was a driving force behind the organization of the first impressionist exhibition in 1874 and participated in six of the seven impressionist exhibitions that followed. However, he disliked the label impressionist, and unlike the other impressionists he had little interest in landscape painting and was scornful of *plein-air* painting. Degas was a passionate and discerning collector who bought numerous works by other artists.

Melancholy, Degas's portrait of an unknown woman, dates from early in his career and exemplifies his considerable psychological powers as a portraitist, as well as his understanding of the revelatory nature of gesture. He shows his subject, dressed in red with a white collar, leaning forward out of a red-brown upholstered chair, her arms crossed and hugged to her body, her face in three-quarter profile, resting against the back of the chair. The sitter's pose, in combination with the way the scene is lit from below, suggests that she is staring into a fire. Although it is questionable whether the title of the work dates from Degas's lifetime, the expression on his sitter's face implies introspection, perhaps the kind generated by staring into the flames when feeling miserably cold. Fragmentary and sketchlike qualities (the fire, unseen but implied, the indistinct background with its suggestion of a screen, the unfinished look of the paint surface on the back of the chair) and the Japanese reference of its asymmetrical, diagonal composition contribute to the power of this tiny but concentrated painting.

Degas's oeuvre is full of images of women grooming themselves. In the absence of a male audience, implied or seen, his nudes are unselfconscious in stance and gesture. Degas loved the awkward poses captured by snapshots, and these informed his vision of the private world of women. In *After the Bath*, a woman steps out of her tub and toward a maid with waiting towel. Balancing on her left leg, the bather stabilizes herself by placing her left arm on a chair covered in drapery while she hauls her right leg out of the water, rump in the air. The intimacy of the scene is accentuated by its composition, the simple setting—a tub, a couple of chairs, a screen, and some fabrics—sumptuously rendered in orange, pink, and gold set off by intense blues, surrounding the figure like the entrance to a grotto.

Ballet, itself an art of the body, with its stress on line, was a perfect subject for an artist with Degas's preoccupation with drawing the human figure. Degas drew and redrew the dancers' poses and then, choreographing his own paintings, combined the poses into paintings. He painted ballet subjects throughout his career, depicting dancers exhausted and slumped in awkward stances as often as practicing within the prosaic settings of rehearsal halls and waiting rooms. *Dancers at the Barre*, which dates from late in the artist's career, was in his studio at his death. It is one of the latest representations by Degas of the motif of a dancer with her leg up on a practice bar, a subject that appeared as early as the mid-1870s. Like many of

Degas's treatments of ballet, *Dancers at the Barre* captures the inherent formal strangeness of its poses, as the individual dancers fuse into a group. In this painting, the two dancers are seen from behind as conjoined twins, their blue dresses forming one shared skirt, as, facing away from one another, they stretch opposite legs on the bar. The straining muscles visible in the back of the red-haired dancer and the strong diagonal thrust of the composition, seen in the rising floor and the pointing left foot of the dancer on the left, counter the apparent stillness of the poses. The large painting's size is matched by the intensity of its strong complementary oranges and blues, its freedom of execution, and the monumentality of its

bold composition in which spatial concerns are subordinated entirely to those of form. *Dancers at the Barre* is an example of Degas's increasingly expressive use of medium and color late in his career.

Degas is one of the artists whose work Duncan Phillips collected in depth. He recognized the impressionist qualities of Degas's works, but he also saw and admired those that distin-guished Degas from the group: a stress on line, which Phillips likened to that of Hans Holbein and Sandro Botticelli, and a use of formal compositions that Phillips thought echoed Japanese works. Phillips was also particularly sensitive to Degas's color-ful and expressive style. JHM

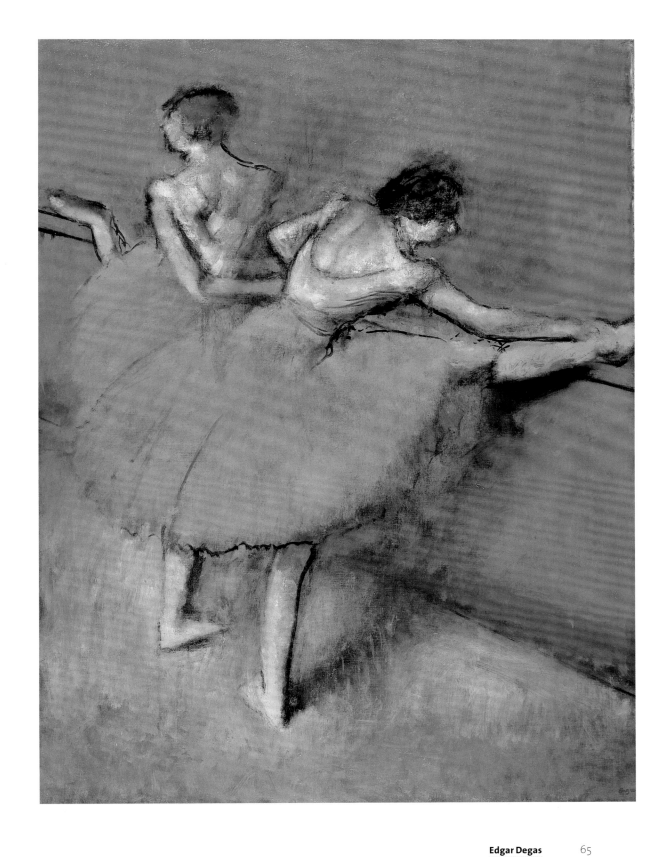

Eugène Delacroix
b. 1798, Charenton-Saint-Maurice, France, d. 1863,
Paris

Paganini, 1831
Oil on cardboard on wood panel, 17 ⅝ × 11 ⅞
(44.7 × 30.1)
Acquired 1922

Eugène Delacroix heard the legendary Italian violinist and composer Nicolò Paganini play at the Paris Opera on March 9, 1831, and painted the small, full-length portrait of the virtuoso a short time later. Contemporary accounts, confirmed by Delacroix's painting, make clear that Paganini's appearance was strange, if not repellent. He was tall and thin, cadaverously pale, with missing teeth and shoulder-length black hair. In performance, however, he charmed, and his presence was electrifying. It was noted that he played with his right foot thrust forward beating time, while his garments flapped around his skinny frame. Delacroix's portrait of Paganini, the only one he painted of a contemporary celebrity outside his circle, shows the violinist in concert and is executed with an energy and brilliance that match the playing of its subject. The black-clad figure of Paganini is barely distinguished from the dark background, as he stands with his weight on his left foot, his right leg forward and bent at the knee. Light falls only on his face, with closed eyes, his all-important hands, and his shirt front. The line of the bow shines against the violin, itself barely discernible against the surrounding darkness. Delacroix, who was a great music lover and played the violin, wrote in his journal his thoughts about the relationship between music and painting, comparing painted sketches and musical improvisations, and likened the act of painting to playing the violin. His portrait of the virtuoso, rough and sketch-like in its gestural brushstrokes and finish, is a perfect painterly equivalent of Paganini's performance style and a distillation of the romantic concept of genius.

Duncan Phillips bought three paintings by Delacroix and a charcoal-and-watercolor drawing. Early on, Phillips admired Delacroix for his liberating effect on French art and for his expressive drawing and emotion-laden color, but objected to his dependence on literary sources. For this reason Phillips, who called the *Paganini* a "tiny soul-portrait," considered it not to be a typical work by Delacroix. JHM

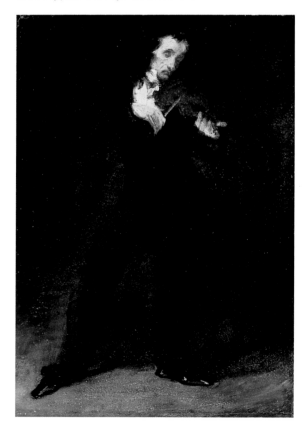

Richard Diebenkorn

b. 1922, Portland, Oregon, d. 1993, Berkeley,
California

Girl with Plant, 1960
Oil on canvas, 80 × 69 ½ (203.2 × 176.5)
Acquired 1961

Ocean Park No. 38, 1971
Oil on canvas, 100 × 81 (254.5 × 205.7)
Acquired 1999

Whether painting in a style that appears abstract or representational, Richard Diebenkorn sought new ground between the two, alternately emphasizing one or the other during his long and prolific career. His representational paintings are abstract and his abstractions are full of observation and reference to the visible world, including specific places and aerial views. More than a decade younger than most of the abstract expressionists of the New York school, Diebenkorn, living on the West Coast, was inspired by the work of Willem de Kooning, Mark Rothko, Jackson Pollock, and Clyfford Still, but also by the art of Edward Hopper, painter of quintessentially American places. Moreover, he was deeply moved by his own visual experience. The landscape and light of the western part of the United States permeate his work, which even in its most abstract iteration evokes a sense of place.

Perhaps more than any other artist of the second half of the twentieth century, Diebenkorn is inextricably woven into the history and fabric of The Phillips Collection. The Phillips Collection was the first East Coast museum to show and acquire his work. Introduced to Duncan Phillips by his nephew Gifford Phillips during the 1950s, Diebenkorn's work instantly struck a chord, not least because the artist had come to know and love this museum while posted as a Marine at Quantico, Virginia, in 1944. By his own admission, he was profoundly influenced by what he saw, particularly by Pierre Bonnard's *The Open Window* (1921) and Henri Matisse's monumental painting *Studio, Quai Saint-Michel* (1916), which, he maintained, stayed with him ever after. Today the museum's holdings are richly representative of Diebenkorn's achievement, spanning most of the artist's location-named periods from the critical early years in Albuquerque, New Mexico, to his last major series of works done in Ocean Park, a section of Santa Monica, California. Including in its holdings five paintings and six works on paper, the museum has also presented four important exhibitions of the artist's work.

Girl with Plant comes from the artist's figurative period when he was living in the Bay Area from 1955 to 1966. The second work by Diebenkorn to enter the collection, it was purchased by Phillips in 1961, soon after it was painted. Not in any way a portrait of a girl in a room, instead her figure seen from behind becomes a part of the painted composition, not unlike that of Madame Vuillard in *The Newspaper*, which Diebenkorn could have seen at The Phillips Collection. Diebenkorn's girl is absorbed in an activity unknown to us while offering dimension to an otherwise flat pictorial space. In this large-scale work that echoes Matisse's architectural structuring of his 1916 composition, the artist trades in the muted gray of a Paris sky for one of intense blue outside the window, chromatically matched by the golden yellow of the interior of the room, the two combining to evoke the sensation of California light.

Highly structured in composition and reductive in its approach to its subject, this painting also exhibits the layered execution that allows the painting process to show through, an approach that became a hallmark of the artist's style.

Collapsing space into a flat, painted surface that evokes a specific place and particular light characterizes the much more abstract Ocean Park series that the artist began in 1966, after moving to this neighborhood bordering on Venice, California. Here his spacious studio prompted a rich outpouring of painting, works on paper, and prints that constitute a great late period of Diebenkorn's work. Large in dimension and vertical in format, *Ocean Park No. 38* is characteristic of this monumental series of paintings that for all their apparent abstraction have also developed from embedded impressions of the light of southern California and the architecture and view from the artist's studio. With their scraped and thinly painted, smudged and scumbled layers of color, yet crystalline and clear sense of light and form, these paintings culminate Diebenkorn's formal and chromatic explorations to result in works both sensuous and classically serene. ER

Arthur G. Dove

b. 1880, Canandaigua, New York, d. 1946,
Huntington, New York

Morning Sun, 1935
Oil on canvas, 20 × 28 (50.8 × 71.1)
Acquired 1935

Me and the Moon, 1937
Wax emulsion on canvas, 18 × 26 (45. 7 × 66)
Acquired 1939

Throughout his career, Arthur Dove sought to record his sensations through an abstract language of color and form. His mature paintings, *Morning Sun* and *Me and the Moon*, are the result of his experimentation with two of his favorite motifs, the sun and the moon. As an artist seeking to express his subjective experience, Dove saw no need for "making things look like nature." Working at the forefront of abstraction, he rejected the longstanding tradition of art as a literal record of the outward appearance of things. In these paintings, made two decades

after his breakthrough abstractions of 1910, Dove captured his remembered "sensations" of a sun-filled day and moon-lit night through the organic rhythms of color, line, and form. Both works were painted during Dove's years in Geneva, New York, where he had moved in 1933 to settle the family estate.

In *Morning Sun*, a radiating sun spreads over a resplendent, furrowed field. Positioned low in the picture plane, the undulating field rises up dramatically before reaching the curved horizon line and lifting up toward the glowing sun. In

the distant hillside, irregular, round, treelike shapes swell out-ward, pulsating with life. A strong, seemingly magnetic pull draws the viewer's eye up through the sun's rays to the black spot on its upper crust. Sensitive to the cyclical changes in his environment, Dove must have been captivated by this specific condition of light, which recurs only about every eleven years when powerful magnetic forces come into contact with the sun. *Morning Sun* announces the vitality ushered in by the break of dawn. Growing up on the family farm in Geneva, Dove cultivated a love of the land that is evoked in this painting. Georgia O'Keeffe once said, "Dove is the only American painter who is of the earth." Critic Paul Rosenfeld echoed this sentiment when he spoke of the work of both Dove and O'Keeffe as em-bodying the "direct sensuous feeling of the earth."

In 1937, Dove traded his farmhouse on the family prop-erty for vast third-floor quarters in a commercial high-rise in Geneva known as the Dove Block. Built by his father, the building was situated on Geneva's main street and afforded Dove pan-oramic views from its ten-foot windows on three sides. It was here that he painted *Me and the Moon*, a lyrical nocturne suf-fused with the incandescent glow of the full moon. A music lover who enjoyed singing, dancing, and playing the mandolin, piano, and drums, Dove likely titled the work after a popular Bing Crosby single he had heard on the radio. Dove readily embraced the idea of art as a pictorial equivalent to music—what he called "music for the eyes." This notion gained currency among the circle of Alfred Stieglitz and in the European avant-garde through the ideas expressed in Wassily Kandinsky's influential treatise *Concerning the Spiritual in Art*. Before painting *Me and the Moon*, Dove had completed other music-inspired works, including several in 1927 after songs by George Gershwin. In *Me and the Moon*, Dove composed a serene ballad with a line that intentionally sways through the moon while a second, longer, meandering line swerves above. The lines are evocative of what Dove called "force lines," originally a scientific term coined by Michael Faraday to describe magnetic lines of force. Dove adapts them in his modernist vocabulary to convey the unseen forces of energy and motion in everyday experience. ES

Raoul Dufy

b. 1877, Le Havre, France, d. 1953, Forcalquier
(Basses-Alpes), France

The Artist's Studio, 1935
Oil on canvas, 46 ⅞ × 58 ¼ (119.1 × 149.5)
Acquired 1944

Raoul Dufy's subject matter was pleasure. He painted elegant people having a good time in public, especially at racetracks such as Epsom and Ascot, or watching regattas at Deauville, or cavorting on the French Riviera or in Parisian parks. He painted wittily and made it look easy, as Duncan Phillips pointed out, carefully concealing the discipline that underlies his work. He started out as an impressionist but was powerfully affected in 1905 by the revolutionary color and subjectivity of Henri Matisse's painting *Luxe, calme et volupté* (Musée d'Orsay, Paris). Dufy, thereafter, gave up on objective appearances, working for a time in a fauvist vein before finding his signature colorful, exuberant, and calligraphic style. In the 1920s trips to Morocco, Italy, Sicily, and the South of France exposed him to Mediterranean light and led him to brighten his work and start painting in watercolors. Dufy worked widely—and brilliantly—in the decorative arts; he needed the money and made no distinction between fine and decorative arts. He designed textiles for Paul Poiret, the leading couturier of the day, whose tubular fashions provided perfect unarticulated fields for patterns. He also created stage designs, prints, book illustrations, tapestry cartoons, and ceramics.

Dufy made several paintings on the theme of the artist's studio, starting in 1909. The studio in The Phillips Collection's painting was located in the impasse de Guelma in Montmartre. He used it from 1911 until his death. *The Artist's Studio* provides information about the place where Dufy painted and is, at the same time, a sort of self-portrait and summary of his work. Around the studio (it really was cerulean blue) and in the adjoining room on the left are paintings by Dufy, some of them identifiable. On the wall at the left is a floral textile similar to those he designed for Bianchini-Férier, an important manufacturer of luxurious silks used by Paul Poiret. Beyond it are ship models from Dufy's collection (he grew up by the sea and schooners appear in many of his marine subjects), and below them, on the left, his *Great Bather*. The painting on the wall at the right is one of Dufy's homages to Claude Lorrain, and below it is a picture of boaters on the Marne. The reclining nude on the easel recalls many of Dufy's Amphitrites and bathers, as well as his debt to rococo painting. The palette and easel in the foreground are bare: *The Artist's Studio* is the missing painting and the colors are on it—Dufy's favorites, blue and pink with orange, accents of green and red tied together with luminous white, and the indispensable, ever-present black line. The window frame is another easel: through the transparent membrane of the wall, interior and exterior merge as Dufy incorporates the architecture of the street into the studio and the physical world into his canvas. The two zones of the painting, the plain blue space and the patterned pink space, are shorthand, respectively, for Dufy's transparent color and his endlessly inventive and amusing line. JHM

Thomas Eakins
b. 1844, Philadelphia, d. 1916, Philadelphia

Miss Amelia Van Buren, c. 1891
Oil on canvas, 45 × 32 (114.3 × 81.3)
Acquired 1927

Thomas Eakins was an uncompromising realist painter whose work and teaching have inspired many generations of artists. He first studied at the Pennsylvania Academy of the Fine Arts in Philadelphia while simultaneously taking anatomy classes at Jefferson Medical College. He traveled extensively through Europe, including Germany, Switzerland, Belgium, Spain, and France, where he enrolled in a class at the École des Beaux-Arts in Paris under Jean-Léon Gérôme. He returned to Philadelphia in 1870 and soon after began to teach at the Pennsylvania Academy.

Eakins insisted on using models. He saw the bare human form as essential to artistic practice and even used his own body, once famously disrobing in front of a female student to demonstrate the physiology of the hip joint. This incident became the ammunition for Eakins's forced resignation from the Academy in 1886. However, that student, Amelia Van Buren, remained a close friend and is the subject of this work.

This exceptionally strong psychological portrait reveals both Eakins's interest in capturing the personality of his sitter and his own introspection at this late moment in his tumultuous career. Van Buren is lost in thought and gazing out of a nearby window. The light casts a glow on her face and her left hand, on which she leans her face, while the other hand rests in shadow on her lap. She appears marooned in the large chair with the expansive space in rich umber behind her. Her expression betrays a weariness that stands in contrast to the photographs Eakins took of the youthful, light-haired student around this time, yet her pose alludes to strength and determination of character. Van Buren had left Philadelphia to pursue photography and occasionally returned to stay with Eakins and his wife; she sat for the portrait during one of these visits.

Duncan Phillips's interest in Eakins's work emerged in 1926, at a time when the artist was not very popular among collectors. Yet Phillips greatly appreciated Eakins's treatment of color and the psychological complexity of his portraits and wanted to add to the collection a "powerful and patient transcript of truth" by the artist. In 1927 he learned the painting was available from Van Buren herself and wrote to her requesting to see the work. As soon as it arrived, Phillips included it in the 1927 Tri-Unit exhibition, even before solidifying the sale. Phillips wrote: "This portrait...is characterized with the deepest reverence and respect but without so much as a trace of the desire to please the sitter...or the public....Her humanity is offered to us in its outer physical manifestation with sincere patient exactitude...penetrat[ing] to the spiritual depths instead of glittering on the ornamental surface." For Phillips, Eakins's importance and continual influence was undisputed, as he stated that "the American old masters pointed the way and they [modern American artists] have followed." vs

El Greco (Domenikos Theotokopoulos)

b. 1541, Candia (Heraklion), Crete, d. 1614,
Toledo, Spain

The Repentant St. Peter, c. 1600–1605 or later
Oil on canvas, 36 ⅞ × 29 ¾ (93.4 × 75.6)
Acquired 1922

In this image, every gesture expresses the saint's penitence. He is shown as a weeping half-length figure in front of a cave with ivy, symbol of eternal life, growing around it. El Greco depicts the saint with his traditional attributes: white hair and beard, a pair of keys at his waist, and clothing consisting of a blue tunic and a yellow mantle. His tear-filled eyes look up toward heaven. His parted lips turn downward. His hands are clenched over his heart in a gesture of contrition and supplication, a reference to the passage in the Gospel of Matthew that recounts Peter's denial of Christ and his subsequent repentance, the moment El Greco shows here.

Possibly designed as an image for personal devotion, the work associates two events, Peter's penitence and Christ's Resurrection. To Peter's side, in the distance, a radiant angel in chalky white stands by Christ's empty tomb. The tomb is not shown but appears in other versions of this composition. In the middle ground stands Mary Magdalene, one of the Marys who went to Christ's tomb after the Resurrection, with her ointment jar. A former prostitute whom Christ redeemed, according to Christian tradition, she spent the remainder of her life alone atoning for her sins. Her presence underscores the theme of repentance as a path to salvation.

El Greco began painting in the traditional Byzantine manner. He then adopted a Western style, becoming a colorist in the Venetian tradition. The distinctive dynamism and elegance of his style, seen in his characteristic elongation of the human figure and his flickering highlights, suggest the influence of Italian mannerists and Byzantine icons. On stylistic grounds scholars place the Phillips painting late in the artist's career.

El Greco started painting in Candia (modern-day Heraklion), Crete, before moving to Venice by August 1568. There, he came under the influence of Jacopo Bassano, Tintoretto, Titian, and Paolo Veronese. In 1570 El Greco was in Rome and seven years later went to Spain, where Phillip II was decorating the Escorial Palace near Madrid. El Greco, who may have hoped to become a court artist, instead gained commissions for churches in and near Toledo, where he settled. He became a Spanish citizen in 1589.

The artist's reputation faded for two centuries after his death, but he was "rediscovered" in the mid-nineteenth century by critics who responded to the eccentricity of his style. Duncan Phillips discussed El Greco in formalist terms, seeing a connection between his style and that of Paul Cézanne. At the same time, he regarded El Greco as an expressionist, whose work reveals his inner state. Phillips wrote: "At last he could identify his passion for religion with his passion for dynamic emotional expression by plastic means." JHM

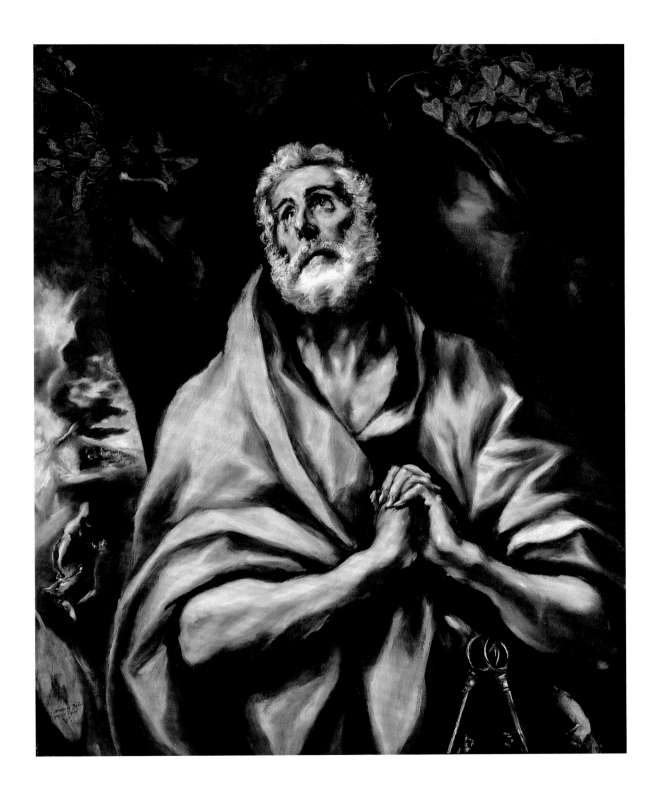

Sam Francis
b. 1923, San Mateo, California, d. 1994,
Santa Monica, California

Blue, 1958
Oil on canvas, 48 ¼ × 34 ¾ (122.6 × 88.2)
Acquired 1958

Sam Francis took up painting as a distraction when he was recovering from a serious spinal injury received in an air crash during World War II. After the war, he dropped his medical studies to apply himself to art. He is associated with the second generation of abstract expressionists. They rejected the angst associated with the first generation as well as its wariness of European art movements, in favor of powerful, lyrical, luminous color. Francis lived in Paris during the 1950s, and among the painters who influenced him most were such great French colorists as Pierre Bonnard, Henri Matisse, and Claude Monet, whose works he studied there. Francis spent 1957 traveling and visited the Far East. His encounter with Japanese aesthetics had a major impact on his art. More and more white space appeared in his paintings, which became increasingly asymmetrical and calligraphic.

Like Monet's late *Water Lilies*, which Francis saw in Paris, *Blue* has no horizon and envelops the viewer. In *Blue*, Monet's plants are replaced by a massing of corpuscular shapes, cobalt blue, Prussian blue, and ultramarine, punctuated by jolts of red, yellow, green, mauve, orange, and yellow. This great cloudlike form drifts slowly rightward and up over seemingly infinite whiteness, trailing drips and spatters that emphasize the vertical orientation of the painting.

Duncan Phillips mounted Francis's first solo museum exhibition in 1958 and bought *Blue* from it. Phillips undoubtedly appreciated the way artists such as Francis combined American gestural painting with the painterly qualities and seductive color that Phillips associated with French painting. JHM

Helen Frankenthaler

b. 1928, New York City

Canyon, 1965
Acrylic on canvas, 44 × 52 (111.7 × 132.1)
Acquired 2001

One of the leading figures of color field painting, Helen Frankenthaler studied with the Mexican painter Rufino Tamayo at the Dalton School in New York and in 1946 attended Bennington College in Vermont. In 1950 she briefly studied with the German-born abstract painter Hans Hofmann at his summer school in Provincetown, Massachusetts. Frankenthaler's early work consisted primarily of cubist-inspired paintings of studio still lifes. During the 1950s she gradually began to soften the rigid painting style of cubism, introducing painterly gestures in response to the works of Jackson Pollock, Arshile Gorky, and Willem de Kooning, whom she met in New York after returning from Bennington College.

But it was her friendship with the influential critic Clement Greenberg and their mutual interest in the work of the French painter Paul Cézanne—who was praised by Greenberg for his "unfading modernity"—that led her to an innovative painting technique that would set off a new style of abstraction. Noticing that Cézanne was able to transfer the softness of watercolor to oil painting, Frankenthaler, who was already a skilled watercolorist, began to stain unprimed, raw canvas with thinned oil paint. The result was her seminal work *Mountains and Sea* of 1952 (National Gallery of Art, Washington). From then on she worked on large sheets of canvas spread on the floor so that she could reach them from all sides. She would pour the thinned paint directly on the canvas, move it around with rags or brushes, and let it soak and stain. Other abstract artists, notably Morris Louis, Kenneth Noland, and Sam Gilliam, soon followed her example, and color field painting was born.

In the 1960s Frankenthaler began to modify her technique by using acrylic paint to create more saturated colors and more solidly defined shapes. She also started to use cropping as a more decisive compositional device. *Canyon*, with its tightly cropped composition, is dominated by a bold field of red surrounded by blue-green, with only a small area of bare canvas left on the upper edge of the painting. This allowed her to render the intensity of experiencing the sublime monumentality of the Grand Canyon with minimal means but to maximal effect. KO

Paul Gauguin

b. 1848, Paris, d. 1903, Atuona, Marquesas Islands

The Ham, 1889
Oil on canvas, 19 ¾ × 22 ¾ (50.2 × 57.8)
Acquired 1951

Paul Gauguin started painting at the age of twenty-three and without any formal training. He was thirty-five when he abandoned his conventional life as a stockbroker to paint full-time. In 1886, five years before he set sail for Tahiti, Gauguin discovered that in Brittany he could satisfy his need for powerful and resonant symbolism. He liked Brittany because he found it savage and primitive. The flat sound of his wooden clogs on Breton cobblestones was the note he said he wished to strike in his paintings. In Brittany, with other artists, he developed synthetism, a version of the symbolist style, combining aestheticism, subjectivity, and realism. It was an approach to painting that was anti-naturalistic, both by virtue of its recognition that a painting is a flat surface and its stress on expressive drawing and colors. These ideas are manifested in the strong, rich colors, intricate and decorative patterns, and spatial complexity of *The Ham*, which Gauguin probably painted in Le Pouldu, a Breton village.

Gauguin painted relatively few still lifes, and *The Ham* is his only painting of a slab of meat. It was probably inspired by Edouard Manet's *Ham* of 1875 (Glasgow Museums, Burrell Collection), which Gauguin is likely to have seen in early 1889 in Edgar Degas's Parisian apartment. Manet's ham sits plump, cooked, and elegant on a counter in front of a chic, decidedly bourgeois wallpaper background, its pattern echoing the veins of fat in the meat. Gauguin's raw-looking ham, possibly smoked, sits on the surface of a round bistro table, the curlicues of fat in the ham and the roundness of the onions with their decoratively twisted shoots echoing the delicate metal supports of the table. Glowing red and orange against a backdrop of intense, exotically orange wallpaper, the ham seems uncannily animated. Gauguin has painted it as though reading faces into the patterns of its fat and making a folk carving of the bone's gnarled end at the left. "Do not paint too much after nature," said Gauguin. "Art is an abstraction. Extract it from nature while dreaming in front of it and think more of the creation which will be the result." Another source of inspiration for this still life was Paul Cézanne, with whom Gauguin painted in 1881 and whose work he collected. Cézanne's influence can be seen in the outlining of the onions and in their highlights, as well as in the tonal variations of the background made by strokes of changing colors. It is also evident in the plasticity of the forms that contradict the flatness of the background and in the way the tabletop tilts upward and is restrained visually only by the vertical patterns of the wallpaper.

Phillips was drawn to Gauguin's vibrant colors, recognizing the originality of his work and its importance for subsequent painting. JHM

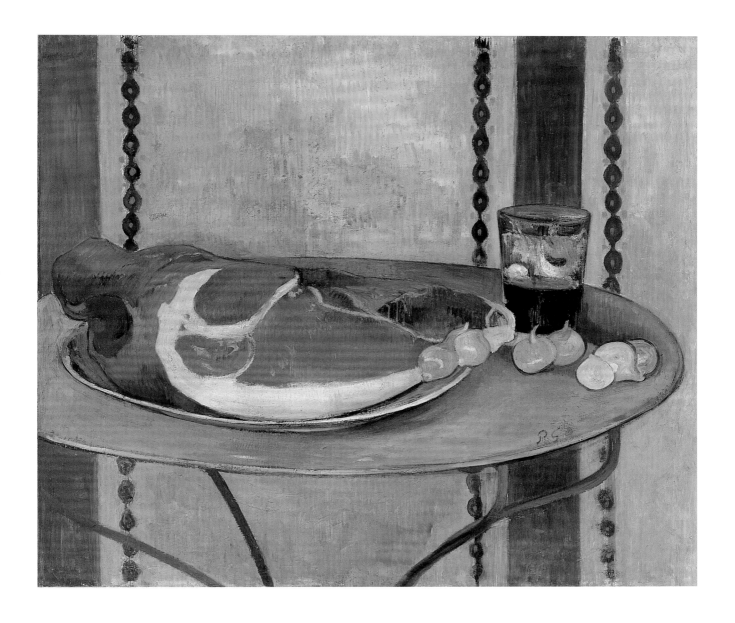

William Glackens

b. 1870, Philadelphia, d. 1938, Westport, Connecticut

Bathers at Bellport, c. 1912
Oil on canvas, 25 × 30 (63.5 × 76.2)
Acquired 1929

After an early career as an artist and reporter in Philadelphia by day and a student at the Pennsylvania Academy of the Fine Arts by night, William Glackens traveled in Belgium and Holland, and eventually to Paris in 1895. Moving to New York on his return, he continued to pursue journalistic illustration, even covering the Spanish American war for *McClure's*. By 1904, however, he had decided to devote himself to painting full-time. Longstanding friendships with John Sloan, George Luks, and Robert Henri, with whom he had shared a studio in Philadelphia, encouraged him to join the new artists group, The Eight (Independent Painters). Not particularly radical in terms of stylistic concerns, these artists sought to liberalize the stultifying American exhibition system.

Although his early work had much in common with that of his colleagues, the real Glackens seems to have emerged in their debut exhibition at the Macbeth Galleries, New York, in February 1908. Glackens contributed colorful images depicting life's ordinary pleasures, forgoing the somber aspects of social realism so important to his fellow artists. He remained a consistently upbeat observer of bourgeois American life, perfecting a style that raised "the anecdote to fine art."

During his second visit to France he had been affected by the impressionistic response to the vitality of such bourgeois pastimes as strolling along the boulevard or frequenting a café or park. The fleeting touch and the airy sunlit colors of artists such as Pierre-Auguste Renoir elicited a profound response in the American artist. His painting *Bathers at Bellport* demonstrates a similar approach in its relatively high-keyed palette and feathery brushstrokes.

The Glackens family summered on Long Island, in the company of many artist friends. Glackens captured the essence of these sun- and sea-splashed days on his canvases. Here bright dabs of red, white, and even yellow ocher lead the eye around the sparkling blue ocean, held in place by a composition of horizontal bands of dock and land in interlocking wedges. Yet Glackens refuses to dissolve the intrinsic structure of his objects in the bleaching light.

Seduced by the cheerfulness of these paintings and the apparent lack of social purpose behind them, it is easy to forget that Glackens was a significant player in the modern art scene. In 1912 he returned to Paris specifically to purchase modern art—works by Renoir, Henri Matisse, and Paul Cézanne—on behalf of his friend and former high school classmate, Dr. Albert C. Barnes. This relationship resulted in the core of the Barnes Foundation. Furthermore, Glackens chaired the committee that selected the American work for the 1913 Armory Show; three of his paintings hung in that groundbreaking exhibition. Later he was named the first president of the Society of Independent Artists. SB

Vincent van Gogh

b. 1853, Groot Zundert, The Netherlands, d. 1890,
Auvers-sur-Oise, France

Entrance to the Public Gardens in Arles, 1888
Oil on canvas, 28 ½ × 35 ¾ (72.3 × 90.8)
Acquired 1930

The Road Menders, 1889
Oil on canvas, 29 × 36 ½ (73.7 × 92.8)
Acquired 1949

All three paintings by Vincent van Gogh in The Phillips Collection date from the last two years of his life, the period of his greatest achievements. After two years in Paris, where he associated with the impressionists and met Paul Gauguin, Van Gogh left in February 1888 for Arles, in search of a quieter life and with dreams of founding a community of artists under the leadership of Gauguin. After some months in Arles, Van Gogh rented a small house on Place Lamartine to be the home of his new community. Across the street from the so-called Yellow House was the public garden. *Entrance to the Public Gardens in Arles* dates between August and October 1888 when Van Gogh was eagerly awaiting the arrival of Gauguin and the start of their artistic collaboration. It was a period of great activity for Van Gogh, as he worked on paintings intended as decorations for the Yellow House. Among them were those he made of the public gardens. Some of these, the Poet's Garden series, were meant for Gauguin's bedroom. They contained symbolic references to the collaborative relationship that Van Gogh hoped for with Gauguin. Other views of the gardens showed their more prosaic aspects. *Entrance to the Public Gardens in Arles* is thought to be one of these, and the entrance shown the one more or less opposite the artist's home. The figure wearing a straw hat recurs in a number of paintings Van Gogh produced during this period and may be a self-portrait. In Van Gogh's

mind, as he dreamed about the artistic life he planned to lead in the South of France, there were associations between Arles and Japan, and Arles and Honoré Daumier, and Daumier and Japanese art. Van Gogh's decorations for the Yellow House included Japanese woodcuts and prints by Daumier. Their influence can be seen in *Entrance to the Public Gardens in Arles*, where the treatment of the foliage recalls that found in Japanese prints, while the figures recall both Japanese figures and those of Daumier. Gauguin arrived in Arles in October 1888, living and working with Van Gogh at the Yellow House until the end of December. He left two days after Van Gogh sliced off his own ear, which led to the Dutch artist's confinement in a mental hospital at Saint-Rémy. On excursions from the hospital in the fall and winter of 1889–1890, Van Gogh witnessed the cours de l'Est (later renamed boulevard Mirabeau) in Saint-Rémy being repaired. This inspired two versions of *The Road Menders*. The Phillips Collection's version is the second of the two. Van Gogh painted it in the studio in December 1889, a year after his breakdown. When he was living in Holland, he had treated the same subject matter of landscapes with workers. Perhaps he associated the theme of road repairs with his own recovery and renewed capacity to travel along the pilgrim's road of life. Working in a paler palette than the one he had used in Arles, Van Gogh expressed a desire to "begin again with

the simpler colors, the ochers for instance." The continued influence of Japanese art on Van Gogh is apparent in the painting's diagonal composition and in the patterned texture of the trees, among other elements.

Duncan Phillips's first response to the art of Van Gogh was unfavorable, but by 1926 his "wish list" declared his desire for examples of the artist's "inventive genius." Phillips considered Van Gogh both "Japanese and Gothic" and made clear his appreciation of the artist's expressionism and palette. Phillips believed Van Gogh, like Cézanne, to be a natural successor to El Greco and hung *Entrance to the Public Gardens in Arles* with El Greco's *The Repentant St. Peter.* JHM

Adolph Gottlieb

b. 1903, New York City, d. 1974, New York City

The Seer, 1950
Oil on canvas, 59 ¾ × 71 ⅝ (151.7 × 181.9)
Acquired 1952

The Seer is one of five hundred pictographs that Adolph Gottlieb produced between 1941 and 1952. In them Gottlieb sought to create paintings with universal meaning as alternatives to the prevailing currents of social realism and regionalism in American art that he found repellent. He collected African art and also attended exhibitions of African, Native American, and prehistoric art because, against the background of World War II, he particularly appreciated the direct way in which primitive art tapped into feelings of terror. Gottlieb emphasized the primitivism of his works in the layers of earth colors he used: black, white, red, and ocher.

Gottlieb's pictographs reject the notion of a painting as a window. They have the look of archaic murals, and with their flat grids and cryptic symbols they resemble ancient picture writing, inviting the viewer to look at them as archaeological finds. To the surface of *The Seer*, scratched and abraded for a timeworn appearance, the artist gave a further archaeological touch by adding sand to the paint. A number of Gottlieb's pictographs refer to the myth of Oedipus with its central themes of seeing and blindness, and the eye, found in the art of many primitive cultures as well as in surrealist art, is the most prominent of the images that Gottlieb uses in *The Seer*. Like the arrow, the eye is also found in the work of Joan Miró and Paul Klee, artists whom he admired.

The Seer is the first of two works by Gottlieb that Duncan Phillips acquired. Perhaps he had Gottlieb in mind when he noted his admiration for the symbols of anarchy, turmoil, and inner tensions in modern art. JHM

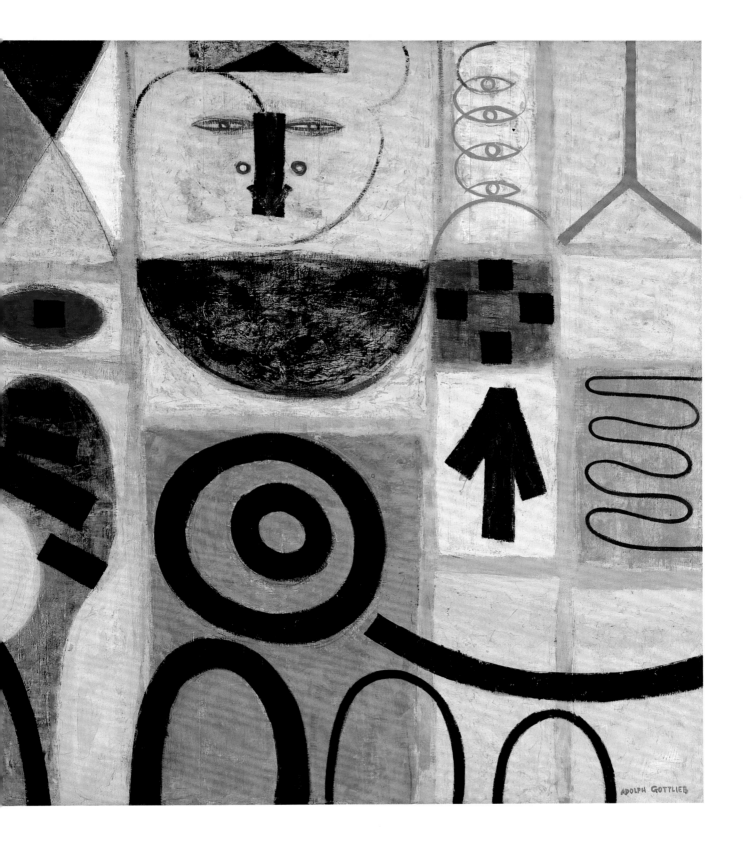

ADOLPH GOTTLIEB

Francisco José de Goya

b. 1746, Fuendetodos, Spain, d. 1828, Bordeaux

The Repentant St. Peter, c. 1820–1824
Oil on canvas, 28 ¾ × 25 ¼ (73 × 64.2)
Acquired 1936

In a powerful image of intense communion with God, Francisco de Goya presents Peter as a half-length figure, his face turned up toward heaven, his lips parted as though speaking, and his eyes full of tears. The artist shows him kneeling beside a rock, a reference to the name Christ gave the apostle. On the rock lies the saint's chief attribute, a pair of keys—Jesus made Peter the guardian of the Gate of Heaven. Goya, like El Greco, gives the saint his traditional garb, a blue tunic and a yellow cloak. In both versions the saint is shown, according to custom, with white hair and beard. Where El Greco provides a physical and theological setting for the image of the penitent Peter, Goya's simple triangular composition consists of a powerful, bulky figure in a dark setting. The figure's foreshortening suggests he designed the painting to be seen from below. It has a pendant, a picture of St. Paul (Private collection, United States); the circumstances of their creation are unknown. On stylistic grounds, The Phillips Collection's painting is dated to the period just before Goya departed for Bordeaux.

The subject of this painting is the penitence of Peter following his denial of Christ. According to the Gospels (Matthew 26:69–75), after the arrest of Christ and after his interrogation at the house of the High Priest Caiaphas, Peter denied being a follower of Christ. Following the third denial, a cock crowed three times and Peter realized that one of Christ's prophecies had been fulfilled. Peter then went outside and wept bitterly.

Goya, whose early work consisted largely of cartoons for the Royal Tapestry Factory of Santa Bárbara, became Painter to the King in 1786 and Court Painter in 1789. His achievement extends far beyond his official work, encompassing satirical prints and private works. His long career spanned tremendous political upheavals, and many of these events are reflected in his works. In 1824, using the pretext of ill health to escape the repressive absolutism of Ferdinand VII, the painter went into voluntary exile in Bordeaux, where he remained and worked for the rest of his life.

Goya's influence on nineteenth-century artists was profound. Duncan Phillips considered him "the stepping stone between the Old Masters and the great Moderns" and saw him as anticipating Paul Cézanne's "modeling by modulations, also his weight and grandeur." The Phillips Collection may be unique among museums of modern art in having two paintings of the repentant St. Peter, one by Goya and the other by El Greco. Given their significance as protomoderns in Phillips's version of modern art history, it is perhaps fitting that both artists are represented by the figure of Peter, Goya's "grubby, earth-bound saint...solid as a rock" and El Greco's "disembodied spirit," as the collector described them. JHM

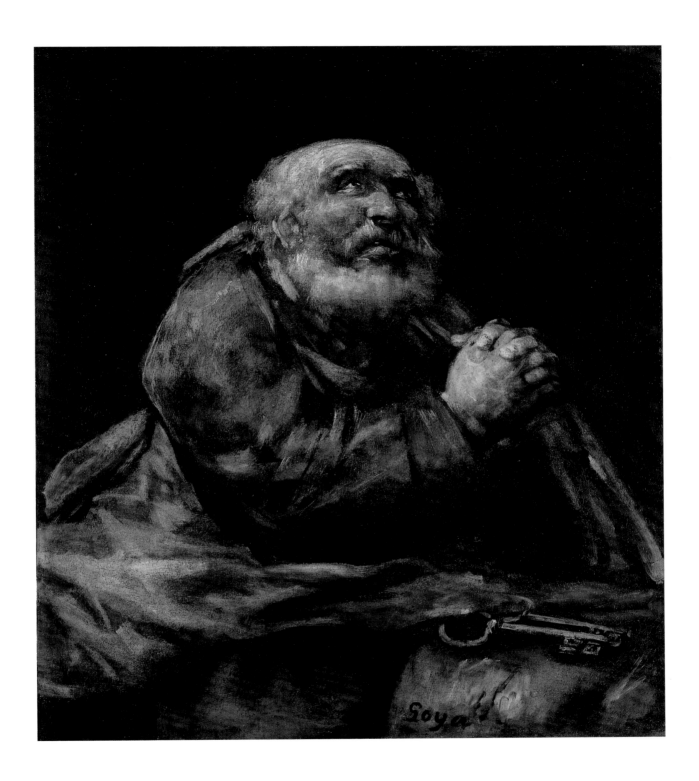

Morris Graves

b. 1910, Fox Valley, Oregon, d. 2001, Loleta, California

Surf and Bird, c. 1940
Gouache on paper, 26 ⅜ × 29 ¾ (66.9 × 75.5)
Acquired 1942

Surf and Bird reflects Morris Graves's deep communion with nature and his lifelong fascination with birds, which was inspired by Zen Buddhism as well as the arts of East Asia. The artist encountered these influences when he traveled to China and Japan as a merchant sailor after dropping out of high school. Largely self-taught, Graves started to paint for the Federal Art Project in 1936. He spent much of his time in the Pacific Northwest, in or around Seattle, and by the early 1940s he had become a leading figure among the so-called Mystic Painters of the Northwest, who included Mark Tobey, Kenneth Callahan, and Guy Anderson.

Duncan Phillips saw Graves's work for the first time in the *Americans 1942* exhibition, organized by Dorothy Miller for the Museum of Modern Art in New York. Alfred Barr, the museum's director at the time, was so taken by Graves's work that he acquired an unprecedented eleven works from the exhibition, while Phillips acquired *Surf and Bird* for himself and collected a total of ten works by the artist over the years.

Graves considered his solitary birds manifestations of an inner reality that he called the "inner eye." *Surf and Bird* depicts a lone bird clinging to a rock in the middle of a vast expanse of water and sky, with waves of white surrounding brushstrokes evoking an exiguous shelter. The rock as well as the bird itself do not threaten its existence but form a protective halo that shields the bird from the nothingness all around it. The bird becomes a symbol for the human condition, for humanity's longing to find answers to the most fundamental and yet unanswerable questions. In Japan Graves had learned to accept and value nature. Graves's existentialism, unlike the urban existentialism of the European philosophers, writers, and artists who tried to liberate themselves from the tyranny of nature, was deeply mystical and immersed in the spiritual and transcendental beauty of nature.

Duncan Phillips, who had traveled extensively throughout China and Japan and had a deep appreciation of Asian art and its influence on European modernism, developed a natural bond with Graves. He regarded Graves as a "seeker of truth, a thinker and a philosopher" and observed early on that Graves was seeking "to symbolize the fate of man through the fate of birds." ᴋᴏ

Juan Gris
b. 1887, Madrid, d. 1927, Paris

Still Life with Newspaper, 1916
Oil on canvas, 29 × 23 ¾ (73.6 × 60.3)
Acquired 1950

After training as an engineer for two years, Juan Gris left Spain in 1906 to settle in Paris. There he moved into the Bateau-Lavoir, the building where Pablo Picasso lived, and began associating with avant-garde circles while supporting himself as an illustrator. Gris had a close friendship with Picasso and Georges Braque, and witnessed their development of cubism. It was in the context of this artistic revolution that Gris became a serious painter. Cubism may have been particularly compatible with Gris's cerebral nature, and his knowledge of technical drawing may have made it a particularly attractive compositional system. There is certainly something cool and analytical about Gris's cubism, which also reveals the artist's abilities as a colorist. Although Gris produced some figure paintings, most of his works are still lifes of objects drawn from the café world of early twentieth-century Paris.

Still Life with Newspaper combines a bottle, bowl of fruit, lemon, glass, and newspaper on a table. Unmistakably Spanish in its rich, somber palette of black, gray, brown, and yellow, with dramatic passages of white, it evokes the restrained still lifes of Francisco de Zurbarán, whom Gris admired. Collage, the kind of cubism that Gris practiced throughout 1914, is clearly reflected in *Still Life with Newspaper*, where the fold in the middle of the clipping from *L'Intransigeant* recalls the artist's use of actual pieces of newspaper pasted onto his vibrant *papiers collés* of that year. The objects in the still life can be read either as shapes that have been cut from a flat surface, moved, layered, and pasted down, or as objects with black shadows that lie next to rather than behind them. Gris had a great attachment to painting of the past and saw his work as continuing its traditions rather than breaking with them. "Mine is the method used by the old masters," he said. This was the same sense of continuity and connection in art that informed Duncan Phillips's view of art history and his collecting. No doubt he recognized it in Gris, whose use of color he must also have appreciated. When Phillips bought *Still Life with Newspaper* from Katherine S. Dreier, he already owned *Abstraction*, a small, beautifully colored and textured painting by Gris that he had bought much earlier, in 1930. JHM

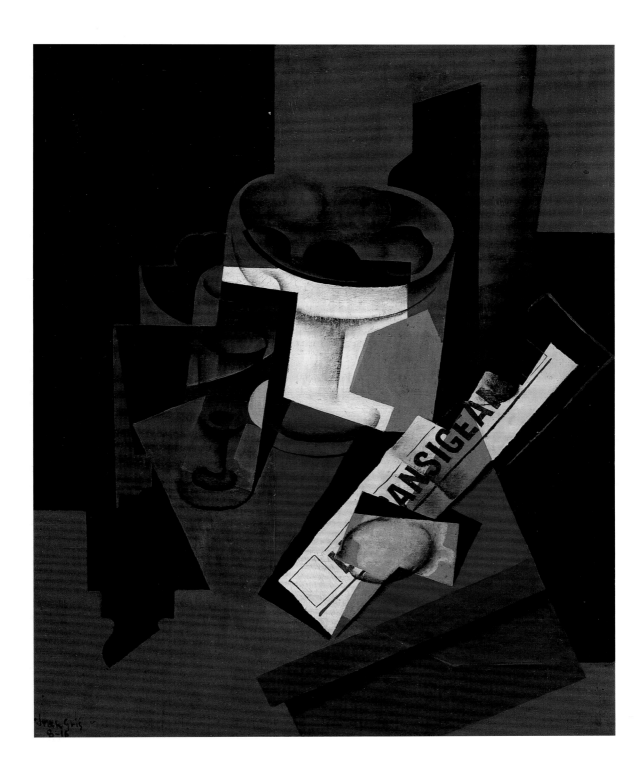

Philip Guston

b. 1913, Montreal, Canada, d. 1980, Woodstock,
New York

Native's Return, 1957
Oil on canvas, 64 ⅞ × 75 ⅞ (164.7 × 192.7)
Acquired 1958

Philip Guston (born Goldstein) grew up in Los Angeles. A high school dropout—he and his friend Jackson Pollock were expelled from Manual Arts High School in 1927 for agitating against school sports and ridiculing their teachers—he was nonetheless a very literate and intellectual man. Largely self-taught as a painter, having attended Otis Art Institute for only three months in 1930, Guston's earliest works were figurative and included murals that he painted for the Works Progress Administration's Federal Art Project during the Depression. Following a year in Rome (1948–1949), he turned to abstract art before reverting in dramatic fashion to unruly figuration in the late 1960s. Guston's major influences were the comic books that he devoured as a boy, and the paintings of such Italian masters as Piero della Francesca, Masaccio, Giotto, and Paolo Uccello that he saw first in art books and later in museums. His inspirations were diverse and included books, films, philosophy, and music.

Native's Return, one of Guston's abstractions, is a hazy and rubbed-looking painting in which clumps of shimmering color, shot through and weighted with black, crowd together, surrounded by a whitish atmosphere. Looking at *Native's Return* one has the uneasy feeling, as is often the case with Guston's abstract paintings, of being in the presence of unrecognizable figures or at least forms that are not completely abstract, a sense the title appears to confirm. The notions of realism or abstraction were not absolute for Guston, and his abstraction is certainly neither the all-over gestural version of Pollock nor Mark Rothko's nondelineated contemplation of the sublime. In fact, Guston arrived at direct expression by standing very close to his canvas and working in very small brushstrokes, very slowly, rather than in the large gestures on large surfaces favored by other abstract expressionists. As a result his abstract compositions, like *Native's Return*, are concentrated below the midsection of the canvas.

Duncan Phillips was entranced by the sensuous color of *Native's Return* but recognized that the painting derived from what he termed "immediate existential needs rather than out of ideal drives." He hung it with paintings by Rothko and Bradley Walker Tomlin. JHM

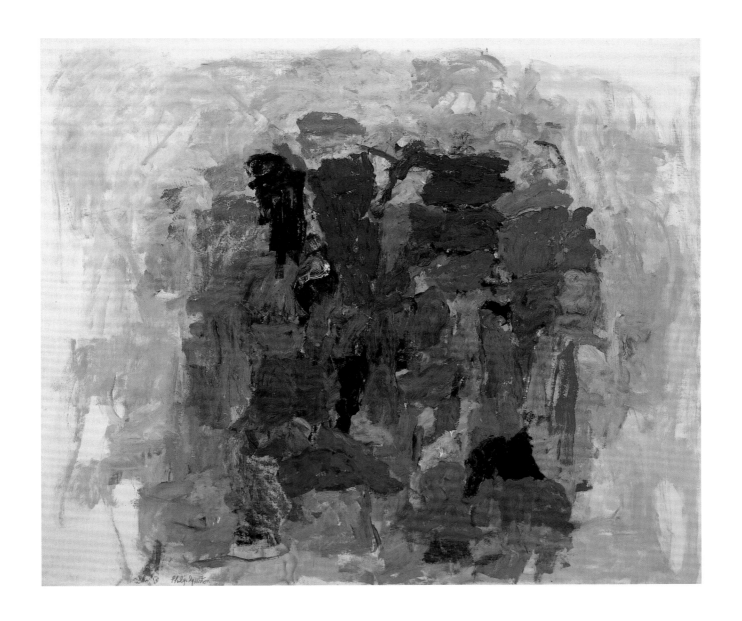

Marsden Hartley

b. 1877, Lewiston, Maine, d. 1943, Ellsworth, Maine

Off the Banks at Night, 1942
Oil on hardboard, 30 × 40 (76.2 × 101.6)
Acquired 1943

Awesome. Brooding. Ominous. Intense. Lonely. Spiritual. These are some of the responses evoked by Marsden Hartley's "sea signatures," many of which were created during the last years of his life when he returned to the coast of his native Maine. Hartley is an artist who can best be understood in terms of his biography. After a childhood in Cleveland, he moved to New York to pursue his artistic career, studying first with William Merritt Chase and then at the National Academy of Design. Although he summered in Maine, the energy of urban life and the changing world beckoned. In 1909 he encountered European modernism and the American avant-garde through the photographer and art dealer Alfred Stieglitz. That year, Hartley had his first solo exhibition at Stieglitz's gallery "291."

With the help of Stieglitz and Arthur B. Davies, Hartley went to live in Paris in 1912 and was exposed to the work of Paul Cézanne, Pablo Picasso, Henri Matisse, and especially Wassily Kandinsky. Extending his studies in prewar Germany, he also was affected by Franz Marc, mysticism, and the group known as Der Blaue Reiter (The Blue Rider). His most successful abstractions come from this period.

World War II forced Hartley back to the United States, but he continued to roam: New England, Bermuda, Nova Scotia, and even Mexico. He also wandered stylistically before eschewing pure abstraction for direct, honest portraits and "scapes" (land and sea) characterized by bold, expressive brushstrokes and dramatic compositions. Although he was prolific and showed frequently, Hartley was never really a financial success. He eventually returned to Maine in the mid-1930s saying, "The quality of nativeness…is colored by birth, and environment, and it is for this reason that I wish to declare myself the painter from Maine." Here Hartley's visceral and structured pictorialism was countered by the immutable strength of the land and sea.

Off the Banks at Night, painted a year before he died, is a profoundly emotional response to a personal loss, the drowning of two dear friends. In the dark middle ground of this largely brown and black canvas two boats seem adrift, their white sails and hulls aimless in a ragged sea with surf that crashes against the rocky shore. Even the sky with its oddly abstract clouds offers little comfort or direction. It comes as no surprise to learn that Hartley was also a published poet.

This painting is a somewhat larger version of an earlier work and is related to the less forbidding, smaller work in the collection, *Off to the Banks* (1936–1938). Duncan Phillips recognized "an ardent…soul" in this "wholly American" painter. The Phillips Collection has eight paintings by Hartley and presented an exhibition of his work in 1943, predating the Museum of Modern Art retrospective. SB

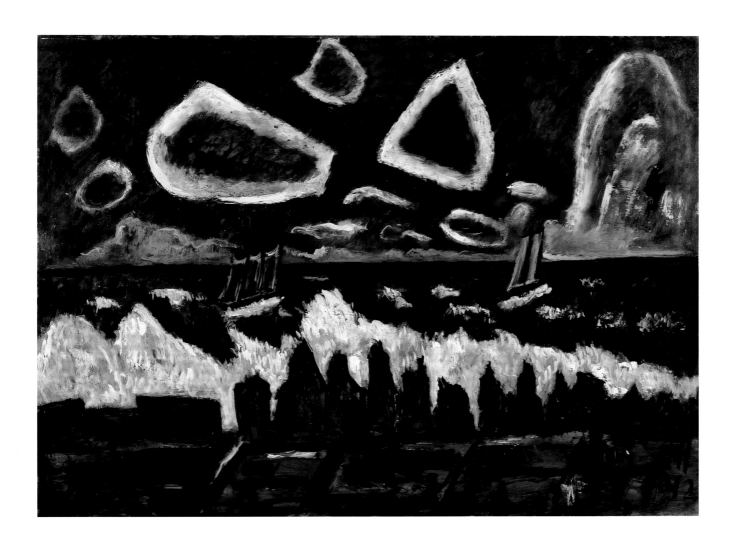

Childe Hassam

b. 1859, Dorchester, Maine, d. 1935, East Hampton,
New York

Washington Arch, Spring, 1890
Oil on canvas, 26 ⅛ × 21 ⅝ (66.4 × 54.9)
Acquired 1921

Painted shortly after an extended visit in Paris, Childe Hassam's *Washington Arch, Spring* is an eloquent example of American impressionism. Although Hassam had studied at the conservative Académie Julian, he was entranced by urban life and the work of the impressionists. Capturing the fleeting effects of light and color came naturally to this accomplished watercolorist. As was generally true of the Americans who adopted this style, Hassam's work was more solidly based in physical structure than that of his French counterparts. More than surface description, his paintings are spatially logical.

Hassam had started his artistic career as an apprentice wood engraver and illustrator. From 1877 to 1879 he studied at the Boston Art Club, the Lowell Institute, and took private painting lessons. When he eventually settled in New York, his apartment overlooked Washington Square, at the south end of Fifth Avenue. Here Hassam had a front row seat during the construction of the arch, modeled on the Arc de Triomphe in Paris and marking the centennial of George Washington's inauguration.

Seen from street level, Fifth Avenue moves as a majestic diagonal toward the arch, which at first glance fills the canvas. Hassam is offering us the experience of the genteel aspects of urban life in the regenerating light of spring. The arch is not painted in detail but instead is partially obscured by a row of trees, and surrounded by well-dressed people going about their business on a sunny day. Horse-drawn carriages, a street cleaner, a nanny, and even the shadow of a street light add intimate touches. The muted, light-washed pastel pinks and blues of the composition are anchored at lower right by the bright green of new plant growth and the brick-red staircase beyond as well as by the glossy darkness of horse and carriage.

Hassam thought of himself as a painter of "light and air." The rapidity of his brushstrokes, his unusual point of view, and the lightened palette are responses to the work he saw on his many European visits. He also reacted to the coastal atmosphere of summers on Long Island and in the emerging artist colonies of Cos Cob and Old Lyme, Connecticut, creating many beautiful canvases.

Hassam was a founding member of The Ten, a group of New York and Boston artists who withdrew from the progressive Society of American Artists in search of better exhibition opportunities. He continued to exhibit throughout his life and was able to support his family. The Phillips Collection also holds *Drydock, Gloucester*, a small watercolor from the same time period, and *Mt. Beacon at Newburgh* (1916), seen from across the sparkling waters of the Hudson River. SB

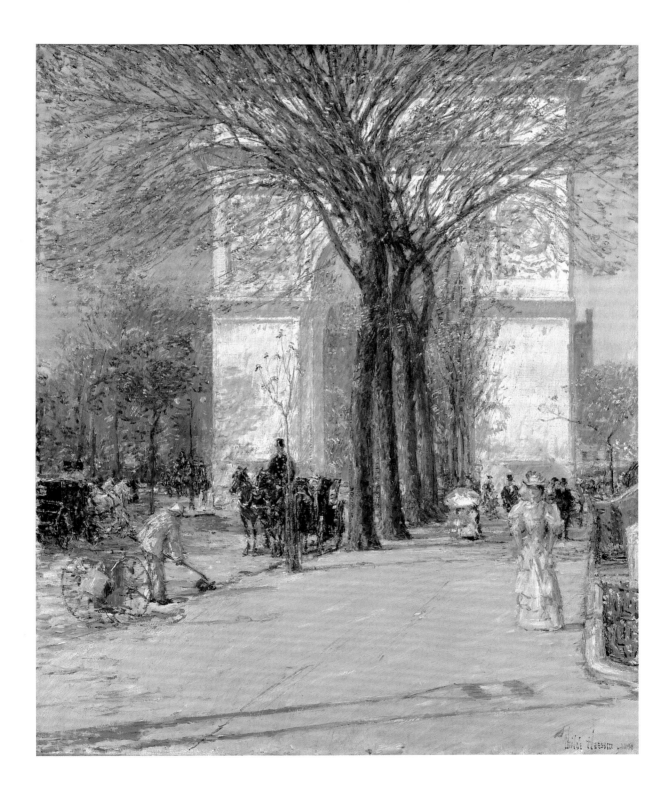

Howard Hodgkin

b. 1932, London

Torso, 2000
Oil on wood, 49 ½ × 52 ¾ (125.7 × 133.9)
Acquired 2001

Howard Hodgkin dates the beginning of his life as an artist to a time spent in New York from 1940 to 1943, when as a boy he became interested in pictures. Born in London, Hodgkin studied there at the Camberwell School of Art and at the Bath Academy of Art in Corsham. He was given his first museum retrospective at the Museum of Modern Art, Oxford, in 1976, represented Britain at the Venice Biennale in 1984, and was knighted in 1992. Yet, to this day he believes his strongest audience is in this country. The Phillips Collection introduced Hodgkin's work to American viewers in 1984 with an exhibition organized by the British Council, and in 2001 acquired its first work by the artist. Hodgkin says his work deals with emotion, psychology, and memory. From the start he depicted certain situations and the feeling between specific people in a specific place. While the work ceased literally to describe these situations, it has continued to evoke them.

Like most of Hodgkin's works of recent decades, *Torso* is painted on a wooden panel that melds seamlessly into its frame. Since 1972 he has made a practice of painting on wood. The physicality of the wood offers an emphatically fixed support for the gesture and richness of the artist's layers of paint. It also reinforces the presence of the work as an object. Turning convention on its head, the actual frame becomes part of the painting's support, while a painted frame is implicated in the work's composition and subject. The resulting dialogue between surface and depth, pattern and illusion evokes landscapes or interiors and often figures with sensuality and intensity of mood.

Torso reveals many stylistic characteristics of the artist's work, from concentrated dabs of color superimposed on others that speak to Hodgkin's admiration for Edouard Vuillard and Georges Seurat, to the broad, sweeping strokes with which he applies dazzling complementaries of red and green with a bravura reminiscent of his fellow countrymen John Constable and Thomas Lawrence. The nearly sculptural presence of the orange form that occupies the center of the composition reminds us of Hodgkin's abiding interest in the three-dimensional physicality of sculpture to which many of his paintings make reference. Because gesture is paramount in his painting, Hodgkin's works appear to be quickly executed. Employing an approach that has been described as a mixture of passion and deliberation, however, Hodgkin often takes years to complete a painting. He tends to have many works in progress at any given time. Each results from carefully conceived and orchestrated brushwork, color, and pattern. The state of psychological and emotional tension that imbued his earliest works continues to be expressed in recent and seemingly nonrepresentational ones. As he himself put it, "I am a representational painter but not a painter of appearances. I paint representational pictures of emotional situations." ER

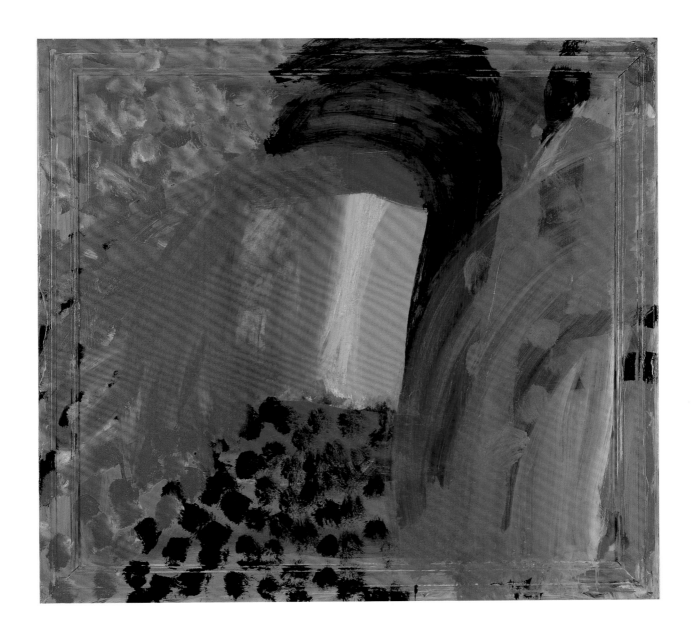

Winslow Homer

b. 1836, Boston, d. 1910, Prouts Neck, Maine

To the Rescue, 1886
Oil on canvas, 24 × 30 (60.9 × 76.2)
Acquired 1926

One of America's great realist painters of the nineteenth century, Winslow Homer began his career as an illustrator on the battlefields of the Civil War, before studying painting in Paris. After a brief sojourn to the bleak Northumberland coast of England, Homer settled in 1883 on the Maine coast at Prouts Neck, where he concentrated on capturing humanity's struggle against the sea. For the rest of his life, nature and the sea became his primary subjects. *To the Rescue* typifies Homer's obsession with the shipwreck theme as a progression from life to death. The sparse narrative avoids all direct description of the rescue mission that is the painting's unseen subject. It is presented as a four-part drama of sea and land, and the complementary roles of men and women—here, the former active and focused on the task at hand, the latter passive and anxious. The strength of the painting lies in its limited chromatic scheme, the severity of the confrontation between human beings and the elements that threaten to engulf them, and the simplified, sketchy quality of the paint handling.

For Duncan Phillips, as for American artists who came of age in the early years of the twentieth century, Homer was one of the true heroes of realism. His work captures the ruggedness of the Maine coast and life along those New England shores that, by the end of the nineteenth century, had assumed a mythic place in the American landscape. His canvases, as scholars have noted, enshrine a heroic mythology derived from the saga of hardy, virile sailors and fishermen and their kinfolk, pitted against the brutal power of wind and sea. Although Homer's subject matter is ostensibly grounded in the everyday, he goes beyond mere storytelling with paintings that convey a sense of mystery and universality of experience—a prelude to Edward Hopper's realism in the twentieth century. SBF and LF

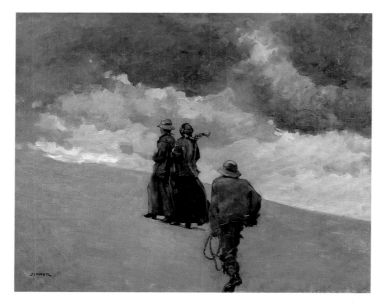

Edward Hopper

b. 1882, Nyack, New York, d. 1967, New York City

Sunday, 1926
Oil on canvas, 29 × 34 (73.6 × 86.3)
Acquired 1926

Approaching a City, 1946
Oil on canvas, 27 ⅛ × 36 (68.9 × 91.4)
Acquired 1947

Edward Hopper's experiences as a student of Robert Henri and Kenneth Hayes Miller at the New York School of Art in the early 1900s were critical to his development as a realist painter. Both Henri and Miller emphasized truthful, contemporary subjects as revelatory of the modern urban experience, while Henri further encouraged his students to use composition, color, and line as emotive elements in their representational works. Hopper's work is sharper and tougher than Henri's. Although he sold his first oil painting at the Armory Show in 1913, Hopper did not find favor with collectors until 1924, when he was finally able to give up his work as a commercial illustrator and dedicate himself solely to painting.

Executed on the eve of the Depression, *Sunday* provides visual form to prevailing states of mind—often of unfulfilled longing or nostalgia—in the United States in the 1920s. Hopper's work reveals the essential isolation of people in the twentieth century. *Sunday* depicts an empty street in Hoboken, New Jersey, where a solitary, middle-aged man sits on a sunlit curb, oblivious to the viewer's gaze. The row of old wooden buildings with their darkened and shaded windows suggests the stores are closed for the day. Even though there is a strong sense of sunlight, it is not warming, but cool. Devoid of energy and drama, *Sunday* is ambiguous in its story but potent in its impression of inertia and desolation. Hopper acknowledged that "great art is the outward expression of an inner life in the artist," but much of the tension conveyed by a Hopper picture is the result of the conflicts between the artist's ideas and his observations.

Duncan Phillips acquired *Sunday* practically right off the artist's easel. Writing about this newly acquired painting in his book *A Collection in the Making* (December 1926), Phillips became the first critic to identify contrasting content in Hopper's work, pointing out the manner in which the artist defies our preconceptions of the picturesque by emphasizing the "boredom of the solitary" figure and the psychological isolation of modern life.

Travel is a recurring theme in Hopper's art. Actively seeking commonplace subjects, Hopper often gave more significance to the journey than to the destination. His most effective travel pieces are joyless, as if experienced by a commuter. Places travelers use regularly, such as train stations, bridges, and hotels, are purged of anything too specific or inviting. *Approaching a City*, a haunting painting, depicts an arrested moment on a train trip: a wide-angle view of railroad tracks and an underpass that evokes the sensation of the train's deceleration as it moves into the heart of the city. Hopper compels the viewer to focus on the bleak setting and prepare for what lies beyond the tunnel. Using a somber palette, he emphasizes the uncertainty of the journey, rather than the excitement and energy associated with the modern city.

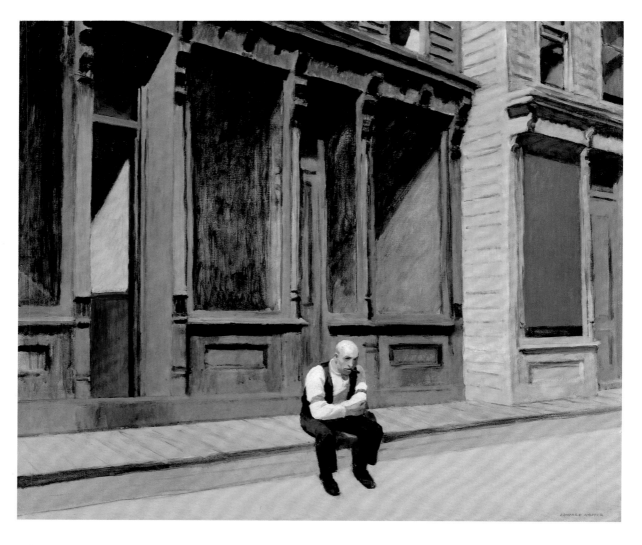

Referring to this work, Hopper said he wanted to evoke the "interest, curiosity, fear" one experiences when entering or leaving a city.

Ultimately, *Approaching a City* conveys a paradox of contemporary life. The unseen traveler is in limbo between city and country. Although the railroad made faraway places accessible to ordinary people, it also made them less distinctive. By asserting the anonymity of the place and not revealing the train's destination, Hopper suggests a future that is both predictable and unknown. SBF and RR

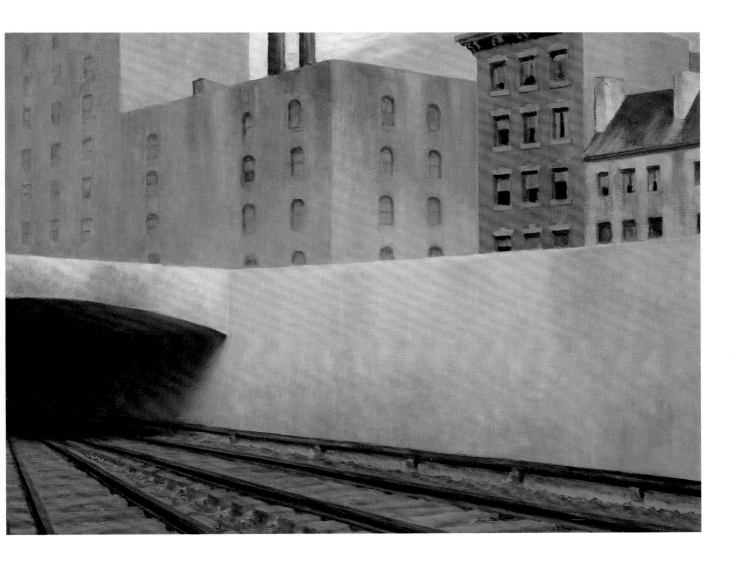

Jean-Auguste-Dominique Ingres

b. 1780, Montauban, France, d. 1867, Paris

The Small Bather, 1826
Oil on canvas, 12 ⅞ × 9 ⅞ (32.7 × 25)
Acquired 1948

Jean-Auguste-Dominique Ingres's painting shows a female nude seen from behind and seated on a grass-covered ledge by a stream in a woodland setting. Just behind her and on the right, a tumble of red cloth and the gathered, frilled wrist of a sleeve are draped over the earthy bank. In the dim background, on the other bank of the stream, a reclining nude turns toward a companion. In the stream, a partially draped woman bathes a young girl, and to the right of the bather, the upper torso of a sleeping woman is visible, her face resting on the palm of her hand supported by her bent elbow. The cool, motionless, meticulously painted central figure in *The Small Bather* comes from the *Bather of Valpinçon*, executed eighteen years earlier. (Valpinçon was the name of the collector who bought the painting, now in the Musée du Louvre, Paris.) Her pose in the earlier painting is identical. Her turban is similarly wrapped, although it has red and white stripes, and she has the same drapery around her elbow. The red mule lies on the same spot on the floor by her feet. The setting is different: a bed with white sheets, within an indeterminate surrounding of black marble, and gray, brown, and white drapery. In The Phillips Collection's much smaller version, Ingres has grassed over the sheets, substituting earth for the valence and placing the

sleeping girl's head in the space occupied by a pillow in the earlier painting. Ingres was clearly fascinated by the bather's physical type, and he used the central figure in two other works painted after the one in The Phillips Collection.

Carefully lit to show off her smooth and perfect flesh and the sinuously rounded, supple curves of her neck and shoulder, the curiously boneless bather suggests the icily erotic marbles by Antonio Canova, Ingres's great Italian contemporary. Ingres studied in Paris under Jacques-Louis David and was a prodigious draftsman. A great admirer of High Renaissance Italian painting, especially the work of Raphael, Ingres spent many years in Rome. In the debate over the relative merits of line versus color, his support of line is always contrasted with that of Eugène Delacroix for color, but Ingres was, in fact, a great admirer of Titian. This is reflected in *The Small Bather* in the warmth that underlies the flesh tints and in the landscape setting, which has its origin in the Venetian pastorals of Titian and Giorgione.

Duncan Phillips, a collector for whom color and painterly handling represented the highest values in painting, had no natural affinity for Ingres. He included him in his collection as a foil to Delacroix, considering him representative of what more painterly romantics were struggling against. JHM

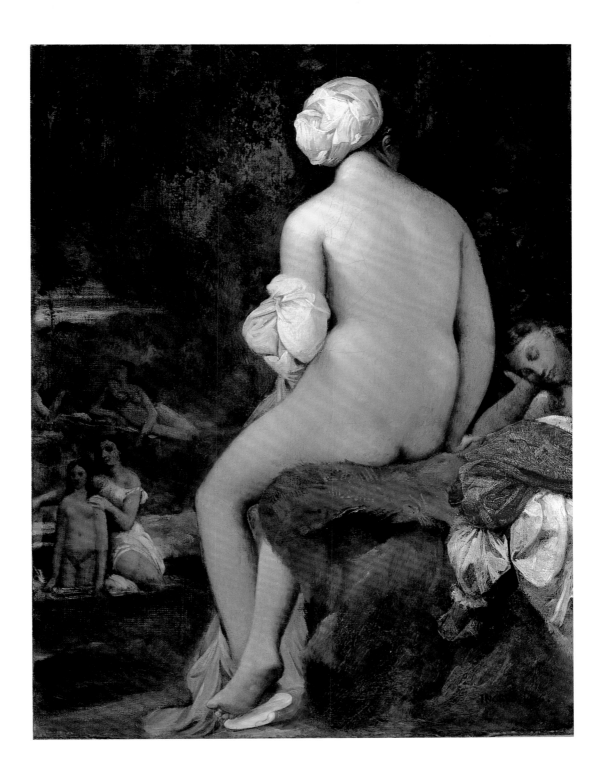

George Inness

b. 1825, Newburgh, New York, d. 1894, Bridge of
Allan, Scotland

Lake Albano, 1869
Oil on canvas, 30 ⅜ × 45 ⅜ (77.2 × 115.3)
Acquired 1920

What Duncan Phillips called "the great American school of landscape painting" found strength in a realism that relied less on tortuous detail than on the artist's inner vision to interpret the natural world. Key to this shift was George Inness, considered the greatest American landscape painter during his lifetime. Trained in Paris, Inness preferred what he later called "civilized landscape" to the wilderness that attracted his Hudson River School colleagues. His aim, as he described it, was to "reproduce...the impression which a scene has made." Unlike his American contemporaries, Inness did not believe that art must be uplifting or moral. Instead, as evidenced in this midcareer painting, he was a landscape painter in the Claudian tradition who was influenced by the broad suggestiveness of the French Barbizon style. A romantic with mystic instincts, Inness found inspiration in the arcadian landscapes of Italy, where Lake Albano was a favorite subject. Painted in the studio, Inness's landscape interpretations are often carefully considered orchestrations of luminosity, classical tranquility, and deep space. This luminous landscape was intended to capture the full sensation of Italy in all its facets—from the Roman ruins, the cypress trees, the contemporary tile-roofed villas, and the distant lake to the carefully deployed cast of characters engaged in various pleasurable activities on a bucolic afternoon. SBF and ET

Wassily Kandinsky

b. 1866, Moscow, d. 1944, Neuilly-sur-Seine, France

Sketch I for Painting with White Border (Moscow), 1913
Oil on canvas, 39 ⅜ × 30 ⅞ (100 × 78.5)
Acquired 1953

Succession, 1935
Oil on canvas, 31 ⅞ × 39 ⅜ (81 × 100.1)
Acquired 1944

A pioneer of abstract art, Wassily Kandinsky dated to the fall of 1910 his recognition that the formal elements of art were expressive even without subject matter. Yet, the artist continued to refer to the material world in his paintings for many years afterward. Kandinsky was highly educated and an intellectual. He studied ethnography and practiced law before deciding to become an artist at the age of thirty. His religious convictions led him to believe that art was inherently spiritual. Hence, he had no use for art as description, which only got in the way of its redemptive, expressive nature. He put many of his ideas on art in writings that describe his efforts to create a language of color by assigning symbolic values to particular hues. Similarly, Kandinsky thought that line spoke a language and believed that "line freed from delineating...functions as a thing in itself, its inner sound...receives its full inner power."

Kandinsky's *Sketch I for Painting with White Border (Moscow)* is a study for *Painting with White Border (Moscow)* in the Solomon R. Guggenheim Museum, New York. The Phillips Collection's study appears as part of the final painting, the center-left area. Although he would not be pinned down on the exact significance of some of the elements in the painting and warned against overinterpretation, Kandinsky wrote at some length about its themes. These include highly abstracted memories of his "gold-crowned" native city that recur in many of his works. They can be recognized by comparing different paintings and constitute a private language. Among the references are elements of traditional Russian folk iconography, including the troika, the three yellow-rimmed arcs at the upper left, and an abstraction of the backs of three horses. Most important is the blue rider, who appears in many of Kandinsky's works and who is seen here galloping diagonally up the painting from lower right, his white lance extending across the picture plane as he attacks a crouching dragon, while an angel flies overhead. Kandinsky, who was active in avant-garde circles in Munich and nearby Murnau where he also lived, helped found several artists' groups, including Der Blaue Reiter (The Blue Rider), whose members wanted to renew the spiritual dimension of art. Kandinsky associated the blue rider with Moscow's patron saint, St. George, the subject of many Russian icons. After the Nazis came to power in 1933, Kandinsky moved from Germany to Paris. The bright, pastel-colored, calligraphic *Succession*, one of the works he produced there, is typical of the paintings he created in the last phase of his career. Delicate biomorphic forms fly, float, and tumble across the lined canvas like notes on a sheet of music, punctuated with geometric grids and bars like Bauhaus color exercises. The biomorphic shapes are reminders that Kandinsky was interested in natural history and that he was friends with Jean Arp and Joan Miró, both of whose work included similar inventions. JHM

Rockwell Kent

b. 1882, Tarrytown, New York, d. 1971, Plattsburg,
New York

The Road Roller, 1909
Oil on canvas, 38 ⅛ × 44 ¼ (86.7 × 112.4)
Acquired 1918

As a student of Robert Henri and Kenneth Hayes Miller in the early 1900s, Rockwell Kent was thoroughly grounded in the American realist tradition. However, unlike his colleagues Edward Hopper and George Bellows, who were also in Henri's drawing class at the New York School of Art, Kent showed little interest in depicting the city, its inhabitants, or the industrial countryside. Instead, powered by ideas of Christian socialism that valued poverty and hard work, Kent found artistic inspiration in harsh and remote locations around the globe, including Newfoundland, Greenland, South America, and Russia. Acknowledged by critics as a direct inheritor of Winslow Homer's heroic realism, he drew inspiration from nature's grandeur and man's relationship to nature's elemental forces. In the winter of 1908–1909, Kent was living in Dublin, New Hampshire. There he created *The Road Roller*, which depicts the Dublin Township roller that packed the snow on the local roads for horse-drawn sleighs.

Kent made a conscious effort in this painting to monumentalize the human figure. The standing men, silhouetted against a vast, threatening sky, are seen from a low vantage point. The viewer's eye is caught by the direct gaze of the dog, which anchors the convex curve of the road in the lower half of the canvas and, in turn, leads to the main subject—the roller, the horses, and the men, who are trying to control the opposing forces of gravity and animal strength. Both the placement of the black-and-white collie in the foreground and the slanting shadows on the hillside establish a sense of depth, while the thick impasto and fluid brushwork reflect Kent's early training under Henri.

In 1918 and 1919 Duncan Phillips acquired many works by artists associated with The Eight, especially paintings that emphasized the drama of the moment and the heroism of the Everyman. Phillips became one of Kent's first patrons, providing material support for the artist as early as 1918. In 1925 Kent wrote appreciatively to Phillips that his financial support "has done more to give me freedom to work than I have ever had before in my life." SBF and VSB

Paul Klee

b. 1879, Münchenbuchsee, Switzerland, d. 1940,
Muralto, Locarno, Switzerland

Tree Nursery, 1929
Oil with incised gesso ground on canvas,
17 ¼ × 20 ⅝ (43.8 × 52.4)
Acquired 1930

Arab Song, 1932
Oil on burlap, 35 ⅞ × 25 ⅜ (91.1 × 64.5)
Acquired 1940

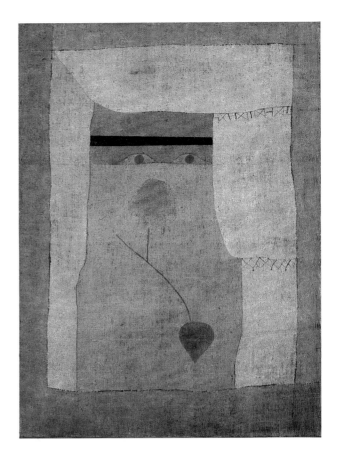

Paul Klee began his career as a draftsman and printmaker, working on a very small scale, as he did in most of his paintings. His graphic training stayed with him his entire life, as is demonstrated by the lines that characterize so much of his art. Klee was essentially a visual poet, combining formal invention with linguistic signs to create mysterious, whimsical, and frequently runic works.

Tree Nursery (right) culminates a series of more than twenty "script pictures" that Klee made between 1924 and 1929. From the beginning, he understood the power of line—what he called a "point set into motion"—as a vehicle for personal expression. Pictorial writing is present in much of his work; however, by the mid-1920s, it assumed an even greater role as the all-encompassing element of his "script pictures." *Tree Nursery* builds on Klee's inventive system of notational signs—both familiar and imaginary—which became the building blocks of his formal vocabulary.

Klee found a way to meld his love of writing and music with his artistic sensibility, resulting in works that blend the pictorial with the poetic. Like an ancient tablet chiseled in stone or an illuminated manuscript, Klee's *Tree Nursery* is replete with a variety of hieroglyphic signs incised into the thinly painted white ground of the canvas. After etching the signs

into the wet ground in a gridlike pattern, he painted over them with horizontal bands of alternating color. The measured composition is suggestive of a musical score, with characters moving through time and space at various intervals. Klee's complex signs are intentionally indecipherable; they signify a life beyond the frame, inhabited by earth's creatures and plant forms.

An avid naturalist from a young age, Klee ardently believed that the process of creating art was analogous to the generative process of creation in nature. As he said, "Of course the painter must study nature....Follow the natural paths of creation, the genesis and functions of forms. That is the best school. Through nature you will perhaps achieve your own configurations, and one day, be nature yourself, creating like nature." At the time of *Tree Nursery*, Klee was in his last years teaching at the Bauhaus in Dessau, Germany. He urged his

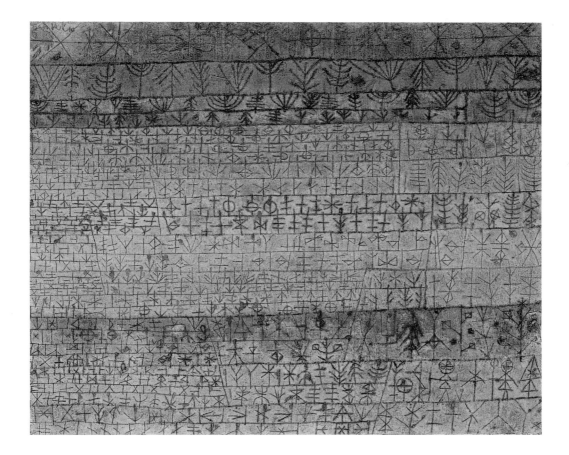

students to study the structure of nature's forms to discern their internal rhythms. In one lesson, he demonstrated how the patterns of a leaf radiated off a central axis point in a perfectly symmetrical arrangement. Klee recognized the same basic structure in tree forms, traces of which may be found in *Tree Nursery*. To Duncan Phillips, Klee's notations suggested "baby plants arranged in rows," and he renamed the painting *Tree Nursery*, over the original title *Young Plantation*.

More than a decade after this acquisition, Phillips added an eighth work to his rapidly growing Klee unit, a painting on burlap known as *Arab Song* (left). Made following Klee's visit to Egypt in 1928, it marked his second trip to North Africa after a 1914 sojourn in Tunisia. A turning point in his art and life, the experience in Tunisia had awakened Klee to the power of color to convey innermost feeling. He wrote in 1927, "This is what I

search for all the time: to awaken sounds, which slumber inside me, a small or large adventure in color." *Arab Song* is evocative of a melody, a song spun from the warm tonalities and mesmerizing sounds of Egypt. The means Klee used to interpret his trip were as simple and reductive as hieroglyphs. Phillips noted: "With only a raw canvas stained to a few pale tones, he evoked a hot sun, desert dust, faded clothes, veiled women, an exotic plant, a romantic interpretation of North Africa." The composition of *Arab Song* is mysterious and ambiguous, framing both a face and a view through a window of a desert landscape with trees, hills, and an oasis. In the 1960s, the stained canvas became an important example for the painters of the Washington Color School. ES and JHM

Oskar Kokoschka

b. 1886, Pöchlarn, Austria, d. 1980, Montreux,
Switzerland

Portrait of Lotte Franzos, 1909
Oil on canvas, 45 ¼ × 31 ¼ (114.9 × 79.5)
Acquired 1941

In the early years of his career, as a portraitist, Oskar Kokoschka was more interested in revelatory gestures than in other external facts. In his dramatic and intense portrait of Lotte Franzos (1881–1957), this did not sit well with the subject. Kokoschka wrote to her: "Your portrait shocked you; I saw that. Do you think that the human being stops at the neck in the effect it has on me? Hair, hands, dress, movements are all at least equally important... I do not paint anatomical preparations." The wife of a prominent lawyer, Franzos was in her twenties when Kokoschka painted her. The tension that infuses the portrait and undercuts the elegance of her presentation comes from the conflicting impulses Kokoschka saw expressed in her nervous hands, one clutching her dress while the other seeming to want to gesture. Young Franzos was perhaps more inhibited than her modern, wavy bob and patronage of the avant-garde suggested.

Kokoschka shows her seated against an indeterminate background, surrounded by transparent blues, reds, and yellows, with much of the ground exposed. Decorative marks scratched in the thin paint radiate from the figure, blurring it like ghostly ectoplasm, as in a "spirit photograph." Kokoschka, who may have been in love with his patron, said, "I painted her like a candle flame: yellow and transparent light blue inside, and all about, outside, an aura of vivid dark blue....She was all gentleness, loving kindness, understanding."

Duncan Phillips said Kokoschka was "one of our favorite artists of the twentieth century." Phillips's view, promoted in the 1930s, that expressionism had descended from El Greco may have predisposed him to like Kokoschka's work. Kokoschka and Phillips met when the painter visited Washington, and they maintained a friendly correspondence. JHM

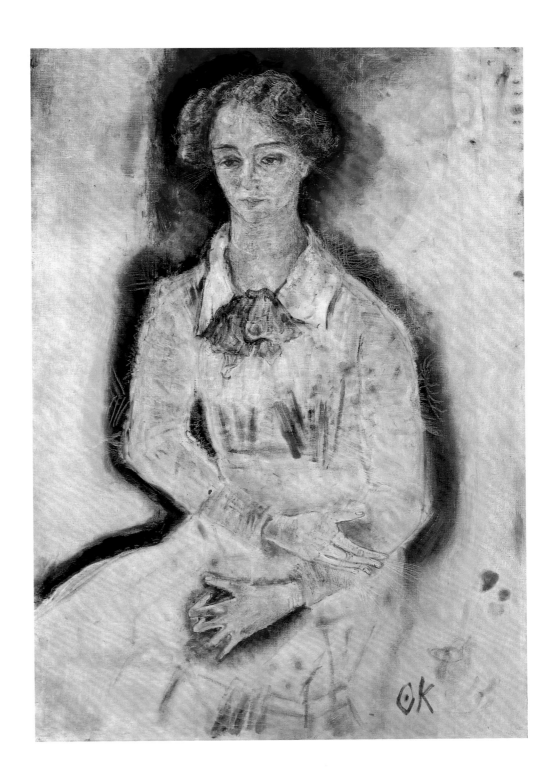

Walt Kuhn

b. 1877, Brooklyn, d. 1949, White Plains, New York

Plumes, 1931
Oil on canvas, 40 × 30 (101.6 × 76.2)
Acquired 1932

Trained in Paris and Munich, Walt Kuhn became an early promoter of modern art in America after returning to New York in 1903. He was a founding member of the Association of American Painters and Sculptors, the organization responsible for mounting the Armory Show in New York in 1913. In this role he traveled through Europe in 1912 looking at art and helping to select works for that exhibition. Kuhn was not only a renowned painter, but also a cartoonist, printmaker, writer, teacher, and, until 1925, a producer of vaudeville shows. Although highly independent, in the years leading up to World War I he was connected to the circle around the progressive painter Robert Henri, who emphasized contemporary subjects as revelatory of the modern urban experience and encouraged the use of rapid brushwork to express the mood of the subject and the artist's inner emotions. Kuhn often depicted disillusionment in his mature "portraits" of theatrical performers and showgirls.

Plumes, the fourth work by the artist to enter The Phillips Collection, is quintessential Kuhn: a performer, shown in frontal view with a slightly disillusioned expression, is placed against a simple background and depicted in bright, dissonant colors. Painted directly from the model, *Plumes* was one of several canvases the artist created after a European trip that included a visit to the Prado in Madrid where Kuhn particularly admired the work of Francisco José de Goya and Diego Velázquez. The theme of the routinely underpaid show girl wearily crowned by a fantasy of theatrical finery frequently recurred in Kuhn's mature oeuvre, reflecting his experience as a producer of vaudeville shows, and met with a great deal of success. Quiet and poised, Kuhn's disillusioned performer in this painting stares out from the canvas, seemingly ready to move at any moment. SBF and LEM

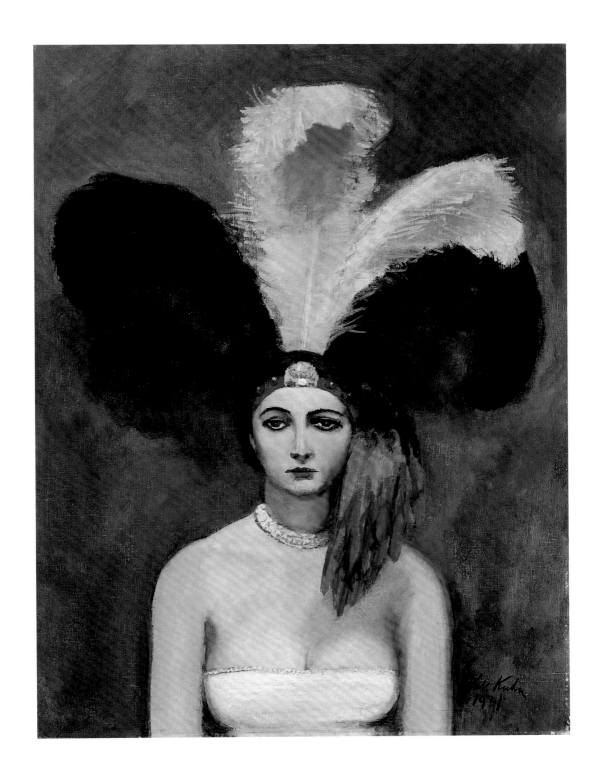

Jacob Lawrence

b. 1917, Atlantic City, d. 2000, Seattle

The Migration Series, 1940–1941
Casein tempera on hardboard, each panel 18 × 12
(45.7 × 30.5)
Acquired 1942

The Migration Series, a sixty-panel narrative masterpiece by the American artist Jacob Lawrence, portrays the migration of more than a million African Americans from the rural South to the industrial North, following the outbreak of World War I. This exodus, fueled by wartime labor shortages in the North, resulted in the largest population shift of African Americans since the time of slavery. By Lawrence's own admission, this was a broad and complex subject to address in paint — one never before attempted in the visual arts. Yet Lawrence had spent three years addressing similar themes of struggle, hope, triumph, and adversity in narrative portraits on the lives of Harriet Tubman, leader of the Underground Railroad (1940), Frederick Douglass, abolitionist (1939), and Toussaint L'Ouverture, liberator of Haiti (1938).

For Lawrence, telling the story of the migration meant telling a story deeply interlaced with his own life experiences. Born in Atlantic City to parents who had migrated north from Virginia and South Carolina, Lawrence spent his childhood in Philadelphia and Harlem among a continually expanding community of southern migrants. "I was part of the migration. I grew up hearing tales about people coming up, another family arriving," he later explained. Many in Lawrence's community had a migration story to tell, from street orators and preachers to librarians, teachers, and the actors of the Apollo Theater in Harlem. Lawrence heard their stories, observed their struggles, and witnessed firsthand the realities of life in the "Promised Land."

Using bold forms, colors, and gestures, Lawrence distilled the migration experience into a powerful expression of the human condition. From lynching in the South to the bombing of African-American homes in the North, Lawrence's panels take us deep into the struggles of people in search of greater economic, social, and political freedom. Lawrence conceived each small, same-size panel as part of a larger whole, like the storyboards of a film. He approached the series methodically, first writing captions and making preparatory drawings before priming the hardboards with gesso and painting each panel with a hand-mixed casein tempera. To ensure a uniform appearance, Lawrence applied a given color to all the panels in succession, starting with the darkest hue, black, and proceeding to the lighter values. Integrating text and image, his epic statement is made in poetic cadences of simple shapes and colors as well as recurring symbols of movement: the train, the station, and people traveling.

Soon after its completion, critic Alain Locke brought Lawrence's work to the attention of New York art dealer Edith Halpert. Halpert arranged for *The Migration Series* to be published in *Fortune* magazine in 1941, exhibited at her Downtown Gallery in 1941–1942, and jointly purchased by The Phillips Collection (odd-numbered panels) and the Museum of Modern Art (even-numbered panels) in 1942. At the young age of twenty-four, Lawrence received national acclaim for a series he later deemed "the creative highlight of my career." ES

Morris Louis
b. 1912, Baltimore, d. 1962, Washington, DC

Number 1-82, 1961
Acrylic on unprimed canvas, 82 ¼ × 33 ¼
(208.9 × 84.4 cm)
Acquired 1963

In 1952, Morris Louis moved permanently to upper northwest Washington, DC, and set up a studio in the small dining room of his home. A frequent visitor to The Phillips Collection, Louis was inspired by the great French colorists in the collection, specifically Pierre Bonnard, Arthur Dove, Pierre-Auguste Renoir, as well as American abstract painters Mark Rothko and Augustus Vincent Tack. Louis began teaching at the Washington Workshop Center of the Arts in Dupont Circle, where he befriended fellow instructor Kenneth Noland. A year later, in 1953, on a trip to New York City, Louis, Noland, and critic Clement Greenberg saw an early stained painting by Helen Frankenthaler, *Mountains and Sea* (1952), and works by Franz Kline and Jackson Pollock. Shortly thereafter, Louis and Noland launched into a period of experimentation, applying paint to canvas in new ways and eliminating texture and pictorial depth from their compositions. The work of Frankenthaler had become an inspiration, "a bridge between Pollock and what was possible."

By 1954, in his 12 by 14 foot studio, Louis began his Veil series, pouring acrylic paint in layers onto large quantities of unstretched, unprimed canvas. He used quick-drying Magna, which, when diluted, remained vibrant and held a consistency of watercolor. In 1961, Louis developed his Stripe paintings, of which *Number 1-82* is an important example. From the top of his large work stretcher where canvas was most probably loosely attached, Louis began his Veil series, pouring acrylic paint in layers and draining any excess off the bottom edge. The result was an array of transparent and opaque color stripes that absorbed and integrated with the weave of the canvas, creating a stainlike effect. The position of the stripe stack, slightly off-center and weighted at the bottom, was determined when the painting was stretched. The flare marks at top are drips from the paint container. When asked if his paintings had a distinct top or bottom, Louis replied: "It doesn't matter."

Because of his love for color Duncan Phillips responded to the work of Louis. He purchased *Number 1-82* from the André Emmerich Gallery after seeing it at the Corcoran's 28th Biennial exhibition in 1963. It was one of the first works by Louis to enter a museum collection. *Number 1-82* was installed for the first time with *Paintings from the Collection and Some Loans* in the museum's print rooms, about a month after its acquisition and ten years after the artist's first solo show. A prominent example of the Washington Color School, *Number 1-82* was later installed for many years on the third floor of the Annex, a space reserved for contemporary art. The Phillips Collection owns seven works by Louis: four early drawings and three paintings. RM

Edouard Manet

b. 1832, Paris, d. 1883, Paris

Spanish Ballet, 1862
Oil on canvas, 24 × 35 ⅜ (60.9 × 90.5)
Acquired 1928

Edouard Manet was one of the most interesting and complex French artists of the nineteenth century. While he clearly hoped for professional acclaim, the honors did not come his way. Instead, he gained notoriety in the 1860s for the spirit of his adaptations of compositions by older masters.

Spanish Ballet does not show an actual performance by the troupe of Spanish dancers who appeared at the Paris Hippodrome from August to November 1862. Instead, some of the principal dancers, including the famed Lola de Valence (Lola Melea), shown here seated on a bench, posed for Manet in a studio as though performing a scene from the ballet *La Flor de Sevilla*. Nevertheless, their poses in the final painting owe something to photographs.

Manet often incorporated borrowings from prints, photographs, and other paintings, including his own, into his works. In *Spanish Ballet*, the figure of the seated musician in the foreground is taken from Manet's painting *The Spanish Singer*, made a year earlier, and the figures in the background at the left are taken from Francisco de Goya. The overall composition of *Spanish Ballet* is based on a work in the Musée du Louvre, erroneously attributed in Manet's time to Diego Velázquez, a painter whom he admired very much. Some of the elements that annoyed Manet's critics, who regarded him as incompetent rather than as daringly modern, are evident in the painting: the peculiar scale, the use of black and white as colors, the absence of middle tones, and the spatial inconsistencies. JHM

Franz Marc
b. 1880, Munich, d. 1916, Verdun, France

Deer in the Forest I, 1913
Oil on canvas, 39 ¾ × 41 ¼ (100.9 × 104.7)
Acquired 1953

Franz Marc abandoned the study of philosophy and theology to take up painting as a career. A sort of pantheist with intellectual roots in German romanticism, Marc invested animals, his preferred subjects, with human and moral qualities. For example, the cow, he believed, represented steadfastness, the bird stood for spirituality, and the horse signified power. Marc himself owned a herd of domesticated deer, the subject of The Phillips Collection's painting. For Marc, the animal served as a metaphor for vulnerability, innocence, and gentleness. Of his paintings of deer, Marc said that he wished to convey their feelings. In *Deer in the Forest I* five deer rest on the ground. The treatment of their surroundings as fragmented, interlocking colored planes echoes the way he handles their bodies, reflecting Marc's belief in the interconnectedness of all life, matter and spirit, at the same time as providing a design equivalent for camouflage at a naturalistic level. The painting may allude to the legend of St. Julian Hospitator as told by Gustave Flaubert. Marc read the story and made a gouache of a scene from it in 1913. The painting is dense with nineteenth-century romantic allusions. The spindly trees around the deer are painted white, perhaps suggesting their immaterial nature.

Marc, cofounder with Wassily Kandinsky of the Blaue Reiter group, shared a belief in colors as vehicles of spiritual meaning. The central tree may be Goethe's archetypal plant, and the bird perhaps a divine messenger. In the tree branches, an energetic white looping line signals a spiritual presence. Marc's animal paintings in 1913 contain many images of apocalyptic destruction and regeneration, and in The Phillips Collection's painting are suggestions of flames and smoke. Frighteningly, Marc's romantic world view included the belief that immolation of a corrupt world in the fire of war would bring about its regeneration as well as purification. His longed-for holocausts were realized in the slaughter of World War I that claimed his life at Verdun.

Duncan Phillips was not initially enthusiastic about German art, describing it in 1927 as "given to nightmare 'expressionism' and to sexual fantasies." The Great War probably did not help. However, a few years later he made a list of artists to consider adding to the collection and included Marc on it. Phillips included *Deer in the Forest I* in installations of works that shared its formal qualities. JHM

John Marin

b. 1870, Rutherford, New Jersey, d. 1953, Addison,
Maine

Maine Islands, 1922
Watercolor and charcoal on off-white watercolor
paper, 16 ⅞ × 20 ⅛ (42.9 × 51.1)
Acquired 1926

Bryant Square, 1932
Oil on canvas, 21 ⅝ × 26 ⅝ (54.9 × 67.6)
Acquired 1942

John Marin grew up in eastern New Jersey across from midtown Manhattan. From 1899 to 1901, he studied at the Pennsylvania Academy of the Fine Arts in Philadelphia with the realist painter Thomas Anshutz, who was Thomas Eakins's pupil and successor. Marin spent the years 1905 to 1911 in Paris before returning to live in New York. In 1914 he discovered the coastal areas of Maine. For the rest of his life he split his time between New Jersey in the winter and Maine in the summer.

An early American modernist, Marin was closely associated with Alfred Stieglitz. Influenced by cubism and futurism, as well as Asian aesthetic styles, Marin developed a unique style of painting that interpreted both the rhythms of the city and those of the countryside. From the outset, his art was rooted in the visible world. Marin was sensitive to the weather and atmospheric conditions, the seasons, and geography, whether painting in the suburbs of his home state or in the remote reaches of Maine or western Massachusetts. Steeped in the realist tradition of Eakins, Marin followed Delacroix's dictum that nature must be viewed through a temperament in his belief that "it is this 'moving of me' that I try to express....How am I to express what I feel so that its expression will bring me back under the spell?" Using color dynamically and abstractly, and rhythmical line as an independent element, Marin was

able to capture the energy of the city, as well as the beauty and vitality of the landscape of suburban New Jersey and the rugged outdoors of Maine and the Adirondack Mountains.

Maine Islands was painted from a hilltop in Stonington Harbor, Maine, a locale Marin began to frequent in 1920. Highly abstract, the work reflects his effort to arrive at simplicity and clarity of design. Although derived from nature it does not closely illustrate the actual site, but instead emphasizes the expressive potential of color and form. Marin depicts a tranquil landscape of distant islands within a border of strong, fragmented diagonal lines. One of his more famous works, *Maine Islands* was among the first to use the internal frame, a structural device derived from cubism. Although the impression of looking through a window is implied, the diagonal lines also lead the viewer's eye into the distance.

Marin first depicted New York around 1911, and it became one of his favorite themes. His views share similarities of style and purpose with futurism and Robert Delaunay's early, pre-Orphist work. Marin's images of the city personify the hurly-burly pace of urban life in twentieth-century America. In *Bryant Square*, angular planes thrust inward from the sides of the composition, evoking a sense that the towering structures are jostling against each other, vying for prominence. Through

his handling of line, Marin creates sequences of movement that lead the eye across the image and into the canyon of skyscrapers, expressing the excitement and momentum of the streets of New York. The idea that music was related to the rapid tempo of modern life was familiar to Marin, who wrote that "while these powers are at work, pushing, pulling, sideways, downwards, upwards, I can hear the sound of their strife and there is great music being played." The syncopated beat of jazz best symbolized for Marin New York's pulsating energy and became a metaphor for modern American culture in general.

Duncan Phillips, one of the earliest collectors of Marin's work, saw him as both an impressionist and an expressionist because of his aesthetic vocabulary and ability to capture the immediacy of a moment and a place along with his subjective response to it. Calling him "an epigrammatic poet-painter" and an "inspired...wizard of watercolor," Phillips became Marin's most ardent supporter. The two men became close personal

friends after Marin visited the museum in 1929. Acquiring his first work by Marin in 1926 and his last shortly after the artist's death, Phillips amassed nearly thirty works in all media from all periods of Marin's career and gave the artist nine individual shows at the museum, including his first solo museum exhibition in 1929. SBF and LBW

Henri Matisse

b. 1869, Le Cateau-Cambrésis, France, d. 1954,
Vence, France

Studio, Quai Saint-Michel, 1916
Oil on canvas, 58 ¼ × 46 (147.9 × 116.8)
Acquired 1940

Interior with Egyptian Curtain, 1948
Oil on canvas, 45 ¾ × 35 ⅛ (116.3 × 89.2)
Acquired 1950

Henri Matisse first gained attention for the very subjective paintings in bright anti-naturalistic colors that he exhibited with André Derain and Maurice Vlaminck at the Salon d'Automne in 1905 and that earned them the name *fauves* (wild beasts). Matisse's subsequent efforts to refine his work by, as he said, subjecting his intuitively sensuous and personal responses to life to intellectual rigor, led to an exquisite balance of color and line in his art. The two paintings by Matisse in The Phillips Collection each represent a turning point in the artist's career and eloquently reflect these polarities.

In 1916 Matisse painted *Studio, Quai Saint-Michel*, just before leaving Paris for the South of France where he would create works more lush and extravagant in hue, full of the vitality of Mediterranean foliage and light and far from the austerity of his Paris studio with its view of the stony edifices across the river, the Palais de Justice (Palace of Justice) and the Sainte-Chapelle. One of four paintings he did of this particular studio with its view over the Seine to the opposite bank, this work comes at the end of a period of radical reduction and compositional experimentation. Characteristically, the artist's presence is implied, in this case by a sheet of paper on a board propped on a chair and his Italian model Lorette extended on the couch. Matisse eliminated the arabesques of the grill work in the lower portion of the window that he included in other

paintings of the studio, further emphasizing the rectilinear structure of the space and the painting's composition itself. Subdued in palette and severe in its conception, this painting did not lastingly endear itself to Kenneth Clark, to whom it was sold in 1939 by Douglas Cooper. It was soon acquired, however, by Duncan Phillips and remains one of the monumental treasures of The Phillips Collection.

Matisse worked to the very end of his long life. His last paintings were a series of interiors. Painted when he was seventy-nine, in the year of his first designs for the Dominican chapel in Vence, *Interior with Egyptian Curtain* demonstrates the artist's vigorous approach and endless capacity for innovation. From 1943 he lived in a villa on the south coast of France; in a magazine article published in May 1948, he wrote about the stirrings he felt at the coming of spring to the Mediterranean. In *Interior with Egyptian Curtain* Matisse combines, with the wild energy granted to some great artists in old age, several elements related to the theme of growth, which is common in his paintings throughout his career. The wintry blackness of the curtain teems with life, its pulsating red and green motifs possibly metaphors for regeneration. The pomegranate, shown in section with its faceted seeds visible, refers to fertility, the vine to creative energy, and the spear motif in the curtain's border to maleness. The palm tree, seen through the window,

is a reference to longevity. Life-giving light from the swirling palm fronds, painted in slashes of green, yellow, and black against a bright blue sky, explodes into the darkness of the room, warming fruits — pomegranates perhaps — in a bowl on the coral tabletop. Matisse owned this Egyptian curtain. Its bold and brightly colored appliquéd design was a source for the paper cutouts on which Matisse was working when he made this painting and which occupied him until his death six years later.

Duncan Phillips's first reaction to Matisse's work was hostile. Among the epithets he used to describe it in 1914 were "crude" and "insanely depraved." By 1927 Phillips's understanding of post-impressionism had grown and his attitude had changed. He was ready now to acknowledge Matisse as "a daring and lucid agitator for direct decorative expression and luminous chromatic experiment...the brilliant descendant of a great Oriental tradition...." Phillips bought several works by Matisse, some of which he deaccessioned, settling finally on *Studio, Quai Saint-Michel, Interior with Egyptian Curtain*, and a late drawing, *Head of a Girl* (1946). JHM and ER

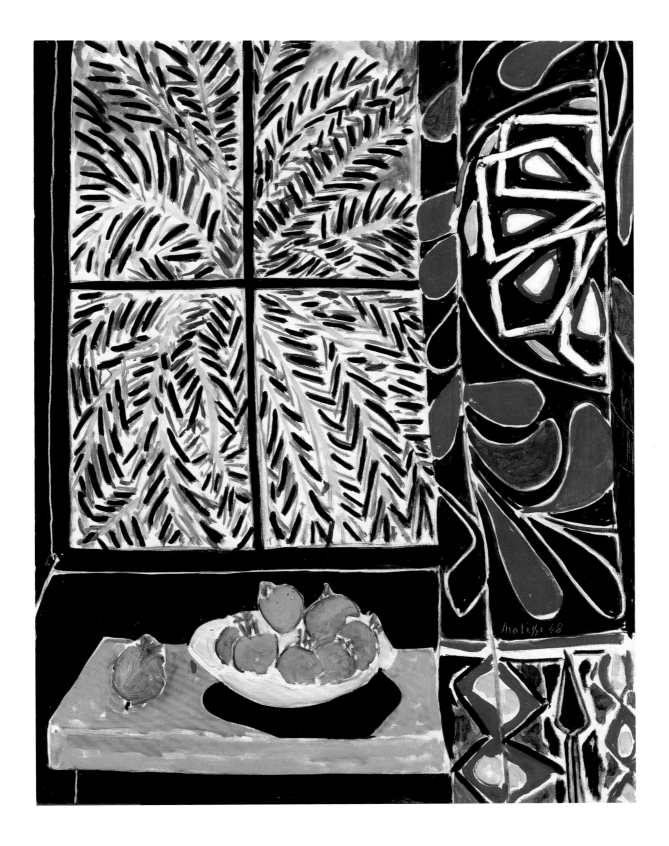

Joan Miró

b. 1893, Barcelona, d. 1983, Palma de Mallorca

The Red Sun, 1948
Oil and gouache on canvas, 36 ⅛ × 28 ⅛
(91.8 × 71.4)
Acquired 1951

One of the truisms of the history of art is that many of the most influential painters of the twentieth century remain consistently, and often consciously, apart from all the categories or movements characteristic of the field. The Catalan painter, printmaker, and sculptor Joan Miró created his own cosmos.

Miró initially pursued studies of commerce but then turned to art, studying at the Escuela de Artes y Oficios de la Lonja in Barcelona, in an atmosphere of realism tempered by cubism and the new French art. After a few relatively unsuccessful years in Paris, Miró retreated to the family farm at Montroig near Barcelona in 1920 to reconsider his work. This was the beginning of a pattern of alternating environments—urban/rural—that was to serve him well over the years to come. Here Miró began to find his way, charting the beginnings of a unique visual language. Still rooted in realism, his shapes became increasingly abstract and poetic as he released the essence of an object as a sign or ideogram on the canvas.

Miró was back in Paris in 1924 when André Breton issued his first Surrealist Manifesto, promulgating the significance of psychoanalysis, Freud, and particularly dreams as the source of creativity. For the surrealists, automatism or responsive drawing from the subconscious was the only way to evade the limitations of reason. Although Miró shared their interest in fantasy, participated in their first exhibition, and was called by Breton "the most Surrealist of us all," he remained stubbornly individualistic and would not commit to the group.

The fall of France in 1940 forced Miró and his family back to Montroig and Mallorca, where they grappled with the Franco regime as well. By now the vestiges of pure surrealism had vanished from his work, and in a series of small gouaches known as Constellations the mature and even more mystical Miró was revealed. Rooted in the calligraphic signs and pictographs of the 1920s, Miró's paintings spoke a fresh language of movement, one created out of color, shape, and line, and characterized by music. "The night, music and stars began to play a larger role in suggesting my paintings. Music…began to take the role poetry had played earlier."

Painted in postwar Barcelona, *The Red Sun* is emblematic of the definitive Miró. The composition is simplified, the calligraphy minimalized. Biomorphic forms float untethered in and across an intangible bluish-gray ground. Space is intense, yet the picture plane has ceased to exist. The mustachioed dancing figure soars, taunting the bird-headed, uniformed Napoleon look-alike. The red sun dominates this ethereal conversation. But what is it all about? It is testament to Miró's immense pictorial skill and sense of humor that none of this is discomfiting. Cryptic and ambiguous, his figures cavort lyrically, content in their assuredness. The poetic ideogram is not indecipherable. It has become elemental. SB

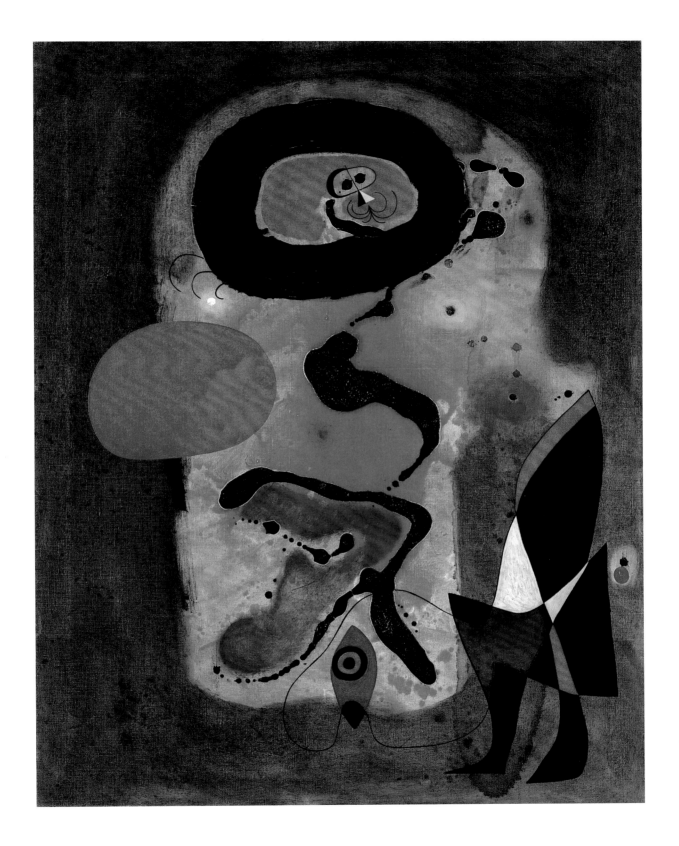

Joan Mitchell

b. 1925, Chicago, d. Vétheuil, France, 1992

August, **Rue Daguerre**, 1957
Oil on canvas, 82 × 69 (208.3 × 175.3)
Acquired 1958

A singularly poetic painter of abstractions, Joan Mitchell attended a progressive school in Chicago before studying art at Smith College. In 1947, after three years at the Art Institute of Chicago, she moved to New York, the center of abstract expressionist activity and, for her, the work of Jackson Pollock and Arshile Gorky. In 1948 Mitchell moved to Paris for a few years, and later, back in New York, she was so respected by her fellow artists that she was invited to join the exclusive Artists' Club— one of only a few women to do so. She split her time between these two artistic capitals before decamping to France in 1959 and settling in Paris and Vétheuil for the balance of her life.

August, Rue Daguerre shows us Mitchell confident at the height of her career. The lessons of abstract expressionism have been digested and picked over and she has emerged, in the words of the critic Clement Greenberg, a personal and quixotic artist of "post-painterly abstraction." Her imagery consists of open, gentle arcs of color tightly distributed across and up and down the picture plane of the large white canvas.

The light-infused colors are laid carefully and energetically, overlapping sometimes and overpainted with white at others. Thick impasto, spatter. Open, closed. Balance is all.

At first glance these rich brown, blue, and red strokes appear random, even spontaneous, and then one senses the structural organization that binds them. For Mitchell, this bravura handling of paint is the means for evoking her response to a particular place, at a particular time. It is not about the street itself. Mitchell's approach to painting has more in common with the surrealists than the abstract expressionists, as she is tapping into her unconscious response to an experience. We do not see the bustle and activity of that Parisian street on a summer day, but we sense how Mitchell remembers being there. Not fractious, nor jumbled, Mitchell's memory of this urban environment is alive, yet delicate and even orderly. At the same time, the fact that this is about a distinct time and place suggests the quality of pure poetry. In its very specificity Mitchell's painting speaks to Everyman. SB

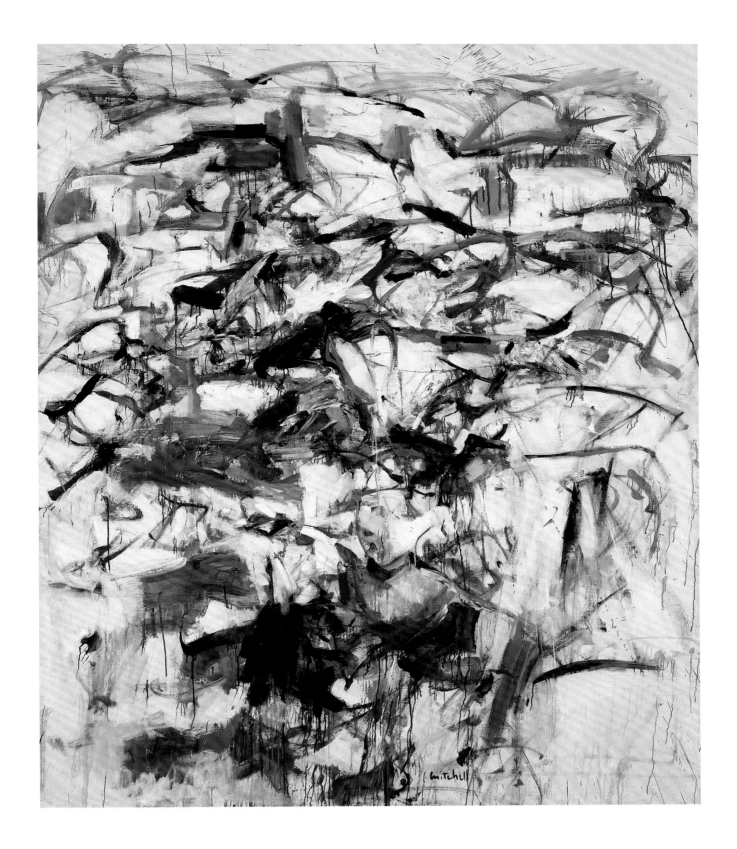

Amedeo Modigliani

b. 1884, Livorno, Italy, d. 1920, Paris

Elena Povolozky, 1917
Oil on canvas, 25 ½ × 19 ¼ (64.7 × 48.8)
Acquired 1949

Amedeo Modigliani's captivating portrait of the French artist Elena Povolozky honors a woman who was known for her generous spirit. Elena and her husband, the Russian émigré Jacques Povolozky, were ardent champions of the artistic avant-garde. During the 1910s, Modigliani was struggling financially, unable to find buyers for his abstract portrait and figure paintings. Elena supported him and other artists with food and money. Her husband, an art dealer and publisher, did his part to foster the latest tendencies in modern art through his Galerie Povolozky in Saint-Germain in Paris and through publications of artists' theoretical writings.

Dependent on a human subject for inspiration, Modigliani often painted his lovers and friends in the circle of Montparnasse. He was known for probing his sitters' character so deeply that they felt he had somehow laid bare their soul. By this time, Modigliani had earned a reputation for his quick execution, facile brushwork, and adept handling of the oil medium. Though he had dreamed of becoming a sculptor, he gave it up in 1914 because the stone dust affected his lungs. Nevertheless, Modigliani's true passion for three-dimensional form never left him, even as he moved on to painting and drawing. His exquisite modeling of Elena's face is reminiscent of a face chiseled from stone. Modigliani models her face and neck through color and volumetric contours that suggest his transposition of the methods of sculpture to a two-dimensional pictorial surface.

In exchange for Elena's support, Modigliani painted her portrait twice in 1917. The Phillips's painting, the larger of the two, shows his benefactor in an interior space positioned in front of what appears to be the round frame of a chair at far right. The portrait reveals several of Elena's distinctive facial and physical traits, including her high forehead, broad cheekbone, angular jaw line, tightly drawn black hair, mannish bow tie, and fur-collared brown jacket. At the same time, Modigliani abstracted her appearance. The increasing abstraction is particularly evident in his second portrait, which pictures Elena in a more closely cropped view staring outward from a nondescript, shallow interior space.

Both paintings call out the identity of the sitter through the inscription "ELENA." Like the cubists, Modigliani experimented with the blending of word and image through the incorporation of the first names of his sitters on the painted surface. In the same year Modigliani completed the portrait of Elena he also unveiled a new series of sexually charged nude pictures—the very antithesis of the prim and heavily garbed *garçonne* he had captured in the form of Elena. ES

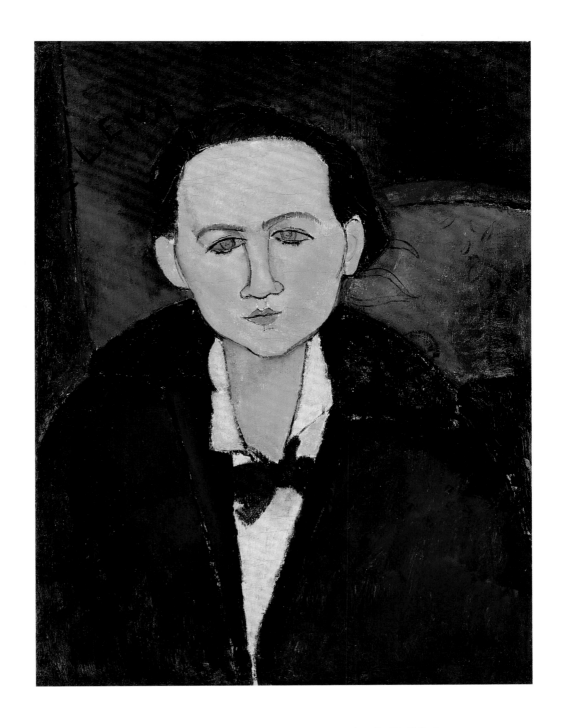

Piet Mondrian

b. 1872, Amersfoort, The Netherlands, d. 1944,
New York City

Tableau III with Red, Black, Yellow, Blue, and Grey,
1922/1925
Oil on canvas, 19 ⅜ × 19 ⅜ (49.2 × 49.2)
Acquired 1946; © 2011 Mondrian/Holtzman Trust
c/o HCR International Washington DC USA

Composition No. 9 with Yellow and Red, 1939–1942
Oil on canvas, 31 ⅜ × 29 ¼ (79.7 × 74.3)
Acquired 1953; © 2011 Mondrian/Holtzman Trust
c/o HCR International Washington DC USA

Tableau III is an example of Piet Mondrian's classic neoplasticism, a movement in early modern art that aimed to establish harmony, both formal and spiritual. Advocating geometric abstraction, that is, the pure relationships of line and color, and guided by "intuitive contemplation," neoplasticism established the ideal of an art devoid of the representation of reality, individual expression, and narration, and instead expressive of fundamental principles and universal equilibrium.

When Duncan Phillips purchased the work, he remarked that the painting "had cast a sort of spell over me." Indeed, the painting had warmed the collector to an artist whom he previously had seen as "too cold and austere for my taste." For Phillips, the canvas offered an ideal representation of pictorial harmony. He wrote: "I do not think I would find a better Mondrian, one more tonic and satisfying to one's inner need for balance and perfect relations." Tableau III was painted while the artist was living in Paris, at a time when Mondrian was developing his mature style. While he was initially drawn to the cubists when he first arrived in Paris in 1912, Mondrian later determined that their methods fell short of "the expression of pure reality." He pared his art down to the essential elements, elevating the plasticity of primary colors and geometric forms.

In Tableau III, Mondrian uses a palette of primary colors: red, yellow, blue, gray, and white, bisected by a network of black vertical and horizontal lines. However, the composition is far from static, as the meandering pattern keeps the eye searching for the relationships between the planes of color and their delineations, and fields rise and recede in the interplay of abstract forms. The composition blurs boundaries between line and color: a red field opens up to the edge of the painting and is balanced by a closed, vertical rectangle of gray, whereas a black plane creates a void that is leveled by a structure of yellow. In this arrangement, Mondrian searches for "pure reality," an absolute balance of oppositional forces: horizontal and vertical, open and closed, warm and cool, constant and dynamic.

Years later, in 1941, Mondrian summarized his position: "To create pure reality plastically, it is necessary to reduce natural forms to the *constant elements* of form and natural color to *primary color*." His harmonies of colors relate to musical patterns, in his groupings of black-gray-white and red-blue-yellow. The colors also represent an emotional and spiritual quality. For Mondrian, yellow was an "inward" or spiritual color, while red was the opposite, "outward" or worldly. In Composition No. 9, the artist lifts the canvas with a bold plane of yellow and charges the composition with small bars of red that emerge

and inhabit the clusters of thin black lines. Mondrian began the work while living in London, where he relocated in the advent of World War II, and most likely completed the canvas after his arrival in New York in 1940.

The artist's move to New York was significant for a generation of American artists, especially the members of the Association of Abstract Artists. Mondrian responded to the speed and sound of New York, as evidenced in the rhythmic movement of *Composition No. 9*, which anticipated his later *Boogie-Woogie* (1941–1944) paintings. The enclosed areas between the constructed grids evoke a man-made cityscape. However, Mondrian is not painting a portrait of New York, but rather offering a utopian vision of a world, purified by dynamic relationships of colors and lines. While Mondrian's paintings from the 1920s and 1930s have an almost scientific austerity, the works from the 1940s are bright, dynamic paintings, reflecting the upbeat music and energy of the city in which they were made. vs

Claude Monet

b. 1840, Paris, d. 1926, Giverny, France

Val-Saint-Nicholas, near Dieppe (Morning), 1897
Oil on canvas, 25 ½ × 39 ⅜ (64.8 × 100)
Acquired 1959

Above all a landscape painter, Claude Monet was born in Paris but grew up in Le Havre. His early mentors, Eugène Boudin and Johan Barthold Jongkind, practiced painting out of doors, and especially along the northern coast of France. As a leading member of the impressionists, a group of independent artists who rebelled against the prevailing subjects and style of academic painters, Monet did not look to the old masters for inspiration so much as to nature herself. Late in life, Paul Cézanne praised Monet for his unparalleled eye.

Although Monet painted a broad range of outdoor subjects, his entire life he favored and excelled at painting effects of light on water. Often he populated his scenes with figures, capturing the quotidian pleasures of modern life both in urban and rural settings. The paintings of his later years, however, tend to exclude figures, allowing the elements of nature alone to be the focus of the work. *Val-Saint-Nicholas, near Dieppe (Morning)* comes from Monet's most prolific period of extended visits to the Normandy coast. There he ventured out into the fields and along the beachheads of Dieppe, Pourville, and Va-rengeville, seeking the perfect subject and setting up his easel in all sorts of weather conditions. In this painting he captures the shimmering effect of light on water that almost dissolves the solid mass of the cliffs in the foreground, where his broken brushstrokes of multiple individual hues combine to evoke the rosy tonalities of early morning light. At this time Monet had already exhibited a group of fifteen paintings of grain stacks done in Giverny at the Durand-Ruel gallery in Paris in 1891, deliberately showing his interest in varying effects of light at different times of day. He achieved great success with this exhibition, selling many of the paintings before it even opened to the public. Fueled by the favorable reception of the paintings of grain stacks, in 1898 Monet exhibited a series of twenty-four paintings of the Normandy coast under the heading *Falaises* (Cliffs). While Duncan Phillips had purchased a painting by Monet in 1920 featuring an inland view — of the road to the village of Vétheuil — he felt he had acquired a painting of unsurpassed beauty by Monet when he purchased this work in 1959. ER

Giorgio Morandi
b. 1890, Bologna, d. 1964, Bologna

Still Life, 1953
Oil on canvas, 8 × 15 ⅞ (20.4 × 40.2)
Acquired 1954

Giorgio Morandi's uneventful life was spent within the con-fines of his native city. He lived and painted in an apartment that he shared with his mother and three unmarried sisters. He taught drawing in local elementary schools and etching at the Accademia delle Belle Arti in Bologna, where he had been an art student. Morandi spent summers in the country and occasionally traveled to other Italian towns. He made three brief excursions to Switzerland in 1956, but otherwise he never left Italy.

Morandi's work shows how unconfining restrictions can be. His small studio, which could be reached only by go-ing through the bedroom of one of his sisters, was crammed with dust-covered receptacles: bottles, bowls, vases, pitchers, tins, boxes, and other containers. These vessels constitute Morandi's still-life iconography, appearing over and over again in subtly different arrangements in hundreds of paint-ings. Morandi made sure that reflections or other possible sources of distraction, such as labels, would not get in the way of his research by painting over many of his studio ob-jects in matte gray or white paint, neutralizing them, reveal-ing them as shapes and volumes, often distinctively beautiful and sensuous ones. He took as reductive an approach to his palette as he did to his subjects, producing miracles of lumi-nosity in his poetic monochromes.

Morandi's subject was the abstract, formal relation-ships in the still-life setups he made in his studio and also in the landscapes he painted looking out of his studio window. He studied the objects he painted and their relationships with the discipline and concentration of a Zen master. He worked very slowly and commented that a half dozen pictures would be enough for a lifetime. It is no surprise that among the paint-ers he most admired were Paul Cézanne and Georges Seurat. The Phillips Collection's still life in browns, white, blue, and yellow is typical of Morandi's work. Quiet, enigmatic, and somehow insistent, the vessels herd together, interlocking forms in an indeterminate space, their solidity undermined by the artist's deliberately tremulous outlines. The spatial ambi-guity of the composition is offset by the amorphous shadow falling on the right, the pale curve at its apex a graceful inver-sion of the mouth of the tallest vessel.

Duncan Phillips acquired two paintings by Morandi in the 1950s and saw in his work qualities he found in Jean-Siméon Chardin. In 1957, Phillips became the first American museum director to give Morandi a solo show. JHM

Berthe Morisot

b. 1841, Bourges, France, d. 1895, Paris

Two Girls, c. 1894
Oil on canvas, 25 ⅝ × 21 ¼ (65 × 54)
Acquired 1925

Berthe Morisot and her sister Edma, daughters of upper-middle-class parents, took drawing classes and studied painting out-of-doors with Jean-Baptiste-Camille Corot. Edma gave up art when she married, but Berthe rejected the amateur status conventionally accepted by women artists at the time. That many of those who bought her works were the most important artists of the period indicates the respect with which she was regarded professionally. Morisot exhibited at the Salon from 1864 to 1868 and was the only female founding member of the impressionist circle of painters, participating in seven of their eight exhibitions. She was a close colleague of Edouard Manet and married his brother, Eugène, in 1874.

Two Girls was painted after she was widowed and had moved with her daughter Julie to an apartment on rue Weber in Paris. She painted in her drawing room and would put away her small canvases when receiving visitors. *Two Girls* is one of Morisot's many images of women shown in the privacy of their homes. Although Julie was Morisot's favorite model, the figures in *Two Girls* were professionals. The disheveled blonde with sensuously tousled hair, her camisole slipping off her shoulders, is about to wash her feet, while the *peignoir*-clad brunette with pearly skin looks on. The tasks of *la toilette* are only an excuse for the real subject of the painting: the informal, dreamy atmosphere in which they are performed.

Morisot's luminous harmonies in blue, pink, gold, and silver attest her love of François Boucher's radiant works, from which she learned how to infuse her paintings with light through the use of white, much in evidence in this painting. In the last decade of her life she was a close friend of Pierre-Auguste Renoir, who shared her taste for the rococo. His influence can be seen in the outlining strokes that make the volumes of the figures stand out from their setting. Morisot's bold, rapid brushstrokes define forms at the same time as they dissolve them into abstraction. She typically painted from the center out and did not work the corners of her canvases, and in *Two Girls* some areas on the edges are unpainted. Her style was sketchy, but *Two Girls* may in fact be an unfinished work because it bears a studio stamp rather than the artist's signature.

Duncan Phillips appreciated Morisot particularly as a colorist and understood her importance in the development of modern painting. He wrote, "Her line led to Lautrec and her color to Redon and Bonnard—stylists all of them and all painters of the intimate and the idiomatic expression." JHM

Robert Motherwell
b. 1915, Aberdeen, Washington, d. 1991,
Provincetown, Massachusetts

In White and Yellow Ochre, 1961
Oil, charcoal, ink, tempera, and paper collage,
40 ⅞ × 27 (103.8 × 68.6)
Acquired 1965

The youngest and arguably the most articulate of the abstract expressionists working in New York during the 1940s and 1950s, Robert Motherwell became one of the preeminent spokesmen and theorists of the American avant-garde. He had studied philosophy and art history and was personally familiar with the European artistic tradition. When the rumblings of World War II resulted in the displacement of many European modernists, the focus of the art world shifted from Paris to New York. American artists were searching for a new artistic voice, one that was neither provincial, nor nationalist, nor social realist.

For Motherwell the key to this new language of art lay in the automatism of the surrealists, to which he had been introduced by the Chilean artist Matta. However, he viewed the intuitive tapping of the subconscious as a "plastic weapon with which to invent forms." Motherwell sought to create a synthesis out of the struggle between the conscious and subconscious by balancing the contradictory opposites. Then, the very act of painting would express the content and, therefore, the meaning of the work of art. When not constricting his large black-and-white paintings with political significance, he created works with elegantly nuanced fields of color more evocative of the Mediterranean than the battlegrounds of Spain and Ireland. Although sympathetic to the gestural abstraction or "action painting" of Jackson Pollock, Willem de Kooning, or Franz Kline, Motherwell had the closest affinity with the chromatic abstractionists, Mark Rothko, Clifford Still, Barnett Newman, and Adolph Gottlieb.

Throughout his career Motherwell also made collages, often using the less formal medium to resolve issues for his large painted canvases, finding resonance for the medium in the work of Pablo Picasso, Henri Matisse, and Kurt Schwitters. Over the years Motherwell produced a substantial oeuvre of these mixed-media paintings, some playful and others lyrical. A large selection was the focus of an exhibition at The Phillips Collection in 1965.

At first glance, *In White and Yellow Ochre* is both hauntingly beautiful and ambiguous, difficult to interpret. Its shapes are not readily identifiable and yet it is highly structured. If the artist is exploring only the relationships of color and form, what then is that large black eye about, superimposed onto the scrap of newspaper? How does one explain the tension between the rigid field of ocher paint that holds the picture plane firmly in place, and the ragged edges of the torn paper and the splashes and drips below? Characteristically, Motherwell has placed the collage element more or less in the center of the larger, painted field. However, by adding the flaglike fillip of sky blue on the right, he has altered the dynamic completely. The spontaneous process of collage, creating a new context for disparate elements, attests to the centrality of personal experience for Motherwell. The detritus of his everyday life—the wine labels, postcards, musical scores, wrapping paper found about the studio—forms fragments of an autobiography. SB

Ben Nicholson

b. 1894, Denham (Buckinghamshire), England, d. 1982, London

17 March 1950 (Still Life), 1950
Oil on canvas, 22 × 24 (55.8 × 60.9)
Acquired c. 1956

Ben Nicholson's parents were both painters. He studied briefly at the Slade School of Fine Art, London, and during the 1920s he visited Paris frequently and became keenly aware of artistic developments there. On one of his visits he saw a 1915 work by Pablo Picasso that profoundly affected his style. Nicholson was a proponent of non-figurative art through the 1930s and was the first British painter to champion the international modernist style. His art combines romantic mood with modernist formalism.

Still life was one of Nicholson's main themes throughout his career. His father had a beautiful collection of striped and spotted jugs, mugs, and goblets, as well as octagonal and hexagonal glass objects, with which Ben grew up. Nicholson said that they were the source of his interest in the subject. Nicholson's work, as he himself noted, integrated abstraction with the tangible world, and his abstract still lifes sometimes included realistically painted views of Cornwall, where he lived from 1939 to 1958, seen in the distance through a window. *17 March 1950 (Still Life)*, a tabletop still life, is typical of the artist's still lifes of the early 1950s, with its translucent, overlapping layers, its surface rubbed smooth, and its paint applied in thin washes of subtle colors, their quiet richness undercutting the strictness of the composition. The same mugs, cups, goblets, jugs, and plates reappear in different combinations again and again as simple forms. Here a yellow mug is layered over a lilac goblet.

Nicholson's particular reconciliation of formalism with a romantic mood proved irresistible to Duncan Phillips. He fell in love with Nicholson's work and held the artist's first solo exhibition in a United States museum in 1951. The Phillips Collection owns six works by Nicholson, the last of them given in Phillips's honor in 1967 by his widow and son. JHM

Kenneth Noland

b. 1924, Asheville, North Carolina, d. 2010,
Port Clyde, Maine

April, 1960
Acrylic on canvas, 16 × 16 (40.6 × 40.6)
Acquired 1960

Shortly after his first solo exhibition in Paris, Kenneth Noland moved to Washington, DC, in 1949 and became an instructor for the Institute of Contemporary Art. Beginning in 1952, he taught at the Washington Workshop Center of the Arts where he met Morris Louis. During the mid-1950s, Washington-based artists Noland, Louis, Gene Davis, Howard Mehring, Thomas Downing, Paul Reed, and others were exploring the effects of pouring and painting with thinned acrylic paints on unprimed canvas. Their all-over, vibrant and optical paintings marked the style of the city's first modern art movement, the Washington Color School.

After some experiments with staining, Noland reached a turning point when he began painting pictures that featured brilliant circular bands of color. *April* belongs to this important series (1958–1963). Despite its small size, the painting imparts both an intimate and a commanding presence. Starting at the center and working outward, Noland first drew graphite circles in various sizes on the canvas. He then freely painted in the circles, soaking the unprimed canvas with acrylic. He based the color of each on what the preceding circle demanded. The brushy, gestural edges of the outer bands are in contrast to the defined edges of the inner rings. Color pulsates throughout the work and energy radiates from its center. The circles appear to float and rotate on the canvas.

Noland was very open about his high regard for The Phillips Collection. He credited the museum with helping him find his mature style, and he often spoke about how important the paintings in the Paul Klee unit were to him. He spent hours examining works such as *Printed Sheet with Picture* (1937) and was impressed by the artist's retrospective at the museum in 1950. Nearly a decade after Duncan Phillips purchased *Inside* (1950), the first work by Noland to enter his museum, he became interested in acquiring a concentric circle painting, having seen several at the Jefferson Place Gallery in 1959. *April* was purchased from the gallery a year later and exhibited for the first time at The Phillips in a *Loan Exhibition of Contemporary Paintings* in 1969. The Phillips Collection owns four paintings and one print by Noland. RM

Georgia O'Keeffe

b. 1887, Sun Prairie, Wisconsin, d. 1986, Santa Fe, New Mexico

Pattern of Leaves, 1923
Oil on canvas, 22 ⅛ × 18 ⅛ (56.2 x. 46)
Acquired 1926

Ranchos Church, 1929
Oil on canvas, 24 ⅛ × 36 ⅛ (61.3 × 91.8)
Acquired 1930

Though painted just six years apart, *Pattern of Leaves* and *Ranchos Church* are from two distinct moments in Georgia O'Keeffe's art and life. In the former, she evokes the warm autumnal colors of Lake George, New York, in the latter, the arid Southwestern desert of Taos, New Mexico. From 1918 to 1928, O'Keeffe and Alfred Stieglitz spent each fall at the photographer's family home at Lake George, in the Adirondacks. The season's warm hues and refreshing climate—O'Keeffe's favorite time of year—unleashed her imagination and offered a sense of artistic renewal. In *Pattern of Leaves*, one of several leaf still lifes she painted during the 1920s, O'Keeffe filled the field with a close-up view of three overlapping maple leaves placed diagonally across the pictorial field. The contrasting patterns of dark and light create a rhythmic dance, from the jagged steps of the reddish-brown leaf to the undulating dip of the silvery white and olive green leaves that jut out from below. Floating freely within a shallow space, the leaves appear against an amorphous background that is divorced from the natural world. The abstract arrangement of line, form, and color communicates a depth of feeling that recalls the lessons of her teacher, Arthur Wesley Dow. In *Composition*, a textbook for students and teachers, Dow emphasized art as personal expression rather than description, which, Dow argued, was for the botanist. Art was about "filling space in a beautiful

way." In 1912, when O'Keeffe was all but ready to give up on painting, Dow's empowering message motivated her again. His ideas continued to inform O'Keeffe's work until the end of her life.

O'Keeffe painted *Ranchos Church* in the summer of 1929 during her first extended stay in Taos, New Mexico. Following in the footsteps of artists who had made the pilgrimage before her, she sought out the famous eighteenth-century adobe church of St. Francis Ranchos de Taos. She called the massive adobe "one of the most beautiful buildings left in the United States by the early Spaniards," seeking to make it her own in at least seven paintings made between 1929 and 1931. The painting seen here, also known as *Ranchos Church II*, the second in a series of three oils, was inspired by the artist's 1929 visit. The series format was well suited to O'Keeffe's artistic sensibilities. Reminiscent of the 1926 series Jack-in-the-Pulpit, in *Ranchos Church I–III* O'Keeffe subscribed to the same process of selection, elimination, and emphasis. In *Ranchos Church I* (Norton Simon Museum, Pasadena) and *II*, O'Keeffe accentuated the architectonic planes of the rear view and the distinctive triangular buttress of the church's apse. As she progressed from the first to the second painting, she slightly altered the perspective to bring the church up closer and parallel to the picture plane. She also expanded the view of the building's left side to fill a

much larger horizontal field. In *Ranchos Church III* (Private collection), O'Keeffe zoomed in on the L-shaped walls at far right and omitted all other architectural details from the composition, distilling the subject into an inviting window onto the cloud-filled sky. In all three versions, O'Keeffe did not seek to faithfully record the true appearance of the church but rather the "intangible" feelings it elicited in her. An entirely different feeling is evoked by a contemporaneous photograph of the same site by Ansel Adams, the photographer O'Keeffe befriended in Taos in 1929. O'Keeffe's reductive, planar vocabulary of forms in *Ranchos Church* anticipates the bold geometry seen in her mature work of the 1950s and 1960s. ES

Alfonso Ossorio

b. 1916, Manila, Philippines, d. 1990, New York City

Reforming Figure, 1952
Ink, wax, and watercolor on paper, 60 × 38
(152.4 × 96.5)
Acquired 2008

Alfonso Ossorio was one of the most colorful figures in postwar American art. An artist, collector, and patron of European and American artists, particularly Jackson Pollock and Jean Dubuffet, he spent most of his creative life in East Hampton, New York. Born in the Philippines to a Spanish father and a Chinese-Filipino mother, and educated in England and in the United States, he began to exhibit regularly in New York in 1941. Ossorio worked as a medical illustrator for the U.S. Army during World War II and became a surrealist painter thereafter. He was a multicultural artist who synthesized ideas derived from surrealism, abstract expressionism, and Dubuffet's *art brut* collection (works produced outside the mainstream of fine arts and typically as a result of mental or social constraints) with his Hispanic and Asian roots.

Reforming Figure is typical of the freedom in imagery and technique that was a direct result of Ossorio's close familiarity with the works of Pollock and Dubuffet. He learned from Pollock how the medium itself could become the image, recording not detailed subjects but gestural force, and from Dubuffet how a consciously intended image could be abstracted to its most primitive essentials and presented in the bluntest possible manner. Yet in his own works Ossorio stopped short of complete abstraction.

Reforming Figure is related to a large series of highly personal and emotionally charged paintings on paper that Ossorio began while working on a mural for the Chapel of St. Joseph the Worker in Victoria, on the Philippine island of Negros, between 1949 and 1950. It was Ossorio's first visit to the Philippines since he was eight years old. *Reforming Figure* is composed of dense layers of calligraphic brushstrokes and thin washes of color, with rudimentary, childlike figures, and lines drawn in white paint over the surface like graffiti. The aggressively simple and childlike execution bears witness to Ossorio's deep engagement with Dubuffet's "anticultural position," which, accompanied by Ossorio, he advocated in a lecture at the Arts Club of Chicago in 1951.

Like most of Ossorio's work during that time, *Reforming Figure* is done in the so-called wax-resist technique. This technique, which takes advantage of the fact that wax repels water, was discovered by Ossorio while studying the work of Victor Brauner, a Romanian surrealist painter working in Paris. It enabled him to develop a language informed by Pollock and Dubuffet, yet fiercely independent, by combining the free-associative psychic automatism of surrealism with direct, painterly expressionist gestures. *Reforming Figure* is evidence of Ossorio's new positive understanding of his future artistic development. ко

Guy Pène du Bois

b. 1884, Brooklyn, d. 1958, Boston

Blue Armchair, 1923
Oil on plywood panel, 25 × 20 (63.6 × 51)
Acquired 1927

Guy Pène du Bois was one of the most stylish painters living in New York in the 1920s. American-born, of French-Louisianan ancestry (he was named after Guy de Maupassant who was a close friend of his father's), his cynical portrayals of New York's high society have become a paradigm for the jazz age. He studied at the conservative New York School of Art, where his work was transformed by the young painter Robert Henri who arrived at the school as an instructor. Henri not only recruited his students to form a baseball team and compete against the team of the rival Art Students League, but he also taught them "to see life in the raw," as Pène du Bois would later recall, "the coffee houses of Second Avenue; the burlesque on Houston Street." Henri's blunt realism, mockingly referred to by his critics as the "Ashcan School," brought a breath of real life into the academicism represented by the older generation of painters.

Encouraged by Henri's example, and aided by his own experience as a police and court reporter and later art critic and magazine editor, Pène du Bois plunged into the life and morality of post-World War I. He chose to record, in a witty and gently satirical style, urban scenes in cafés and restaurants, at horse races and train stations, rendered on canvas with almost invisible brushstrokes. But unlike Edward Hopper, whose paintings were filled with emotional barrenness, Pène du Bois turned his attention to social discourse and the unfathomable relationships between men and women.

Blue Armchair was painted in 1923 in Westport, Connecticut, where the artist had moved with his family during Prohibition to escape an unruly New York. It is a portrait of Pène du Bois's eleven-year-old daughter Yvonne, who would grow up to become an accomplished painter herself, which seems to be uncannily foretold by the framed landscape hanging on the wall behind her. She is sporting a bob cut, a short hair style with a fringe at the front that was popularized by the silent-film actresses Colleen Moore and Louise Brooks in the early 1920s and worn by young girls as a sign of independence. Her pose is awkward and her stylized, rounded body somewhat dwarfed by the enormous blue armchair. She seems uncomfortable, an unwilling model, which is not uncommon for children posing for their artist parents.

Duncan Phillips purchased the painting from John Kraushaar's gallery in New York in 1927, where Pène du Bois had his first one-man exhibition in 1922. KO

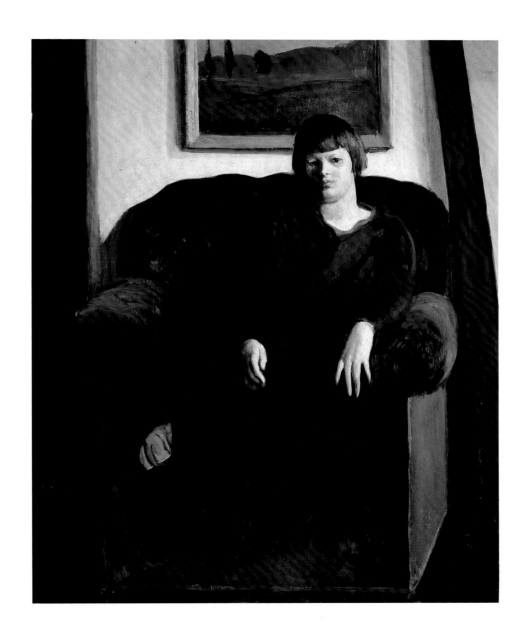

Pablo Picasso

b. 1881, Málaga, Spain, d. 1973, Mougins, France

The Blue Room, 1901
Oil on canvas, 19 ⅞ × 24 ¼ (50.4 × 61.5)
Acquired 1927

Bullfight, 1934
Oil on canvas, 19 ⅝ × 25 ¾ (49.8 × 65.4)
Acquired 1937

Pablo Picasso's art, and probably his persona, too, represented challenges to Duncan Phillips. He found it difficult to assimilate cubism and its sense of rupture, with which Picasso's name is synonymous, into his vision of modern art as a continuation of the art of the past. Although Phillips accepted cubism as an integral feature of twentieth-century painting, as his commitment to Georges Braque's synthetic version makes clear, he attributed Picasso's endless stylistic innovations to insincerity. Nevertheless, Phillips liked the artist's early work.

Like other introspective and melancholy paintings of Picasso's Blue Period (1901–1904), *The Blue Room* can be read in the symbolist language of the nineteenth century as documenting Picasso's own sense of isolation as a young foreigner in Paris. Although the privacy of the subject, an interior with a solitary nude bathing, recalls Edgar Degas, Picasso's focus here, unlike Degas's, is expressive rather than formal. Picasso exploits the pose in *The Blue Room* for its pathos as he does in other canvases around this time, for example *Woman Ironing* of 1904 (Solomon R. Guggenheim Museum, New York). In *The Blue Room*, the thin woman with hunched shoulders droops over the bath. Her gesture of dejection and world-weariness is echoed by the color of her surroundings: in the color language of romanticism, blue signified spiritual yearning. Blue also pervades the paintings of Pierre Puvis de Chavannes, an important influence on Picasso's early work. In *The Blue Room* the simplified contours of the flat figure, its stillness and color echo the style of Puvis de Chavannes. Picasso also drew inspiration from his adopted countryman, El Greco, for the attenuation and chalky whiteness of the nude's limbs. Above the bed, the fizz of Henri de Toulouse-Lautrec's dancing figure of *May Milton* contrasts sharply with the mood of the figure in the room, but its presence also recalls Picasso's debt to Lautrec's sinuous outlines, as is evident in the figure of the bather. Phillips, whose response to Picasso was complex, called *The Blue Room* "a succulent, sumptuous little picture." He noted its rhythmical design and said, "in spite of the realism of the bed and the early morning light the distortion and unreality of the figure are appropriate to a scene which is already more of a Hispano-Moresque pattern than a picture."

Picasso first treated the subject of bullfighting in 1900. After a trip to Spain in 1933, the artist took up the theme again in a series of paintings and drawings. In a highly colored image of ferocious energy, The Phillips Collection's abstracted *Bullfight* shows the savage clash of a bull with a white horse. Lanced by a picador, the bull gores the rearing, screaming horse, whose blood pours from his gaping wound. The flying cape of the matador and the figure of the picador protectively frame the ritual murder that takes place inside the bullring. The focus of the composition is entirely on the drama, with the spectators reduced to flecks of paint and their surroundings rendered

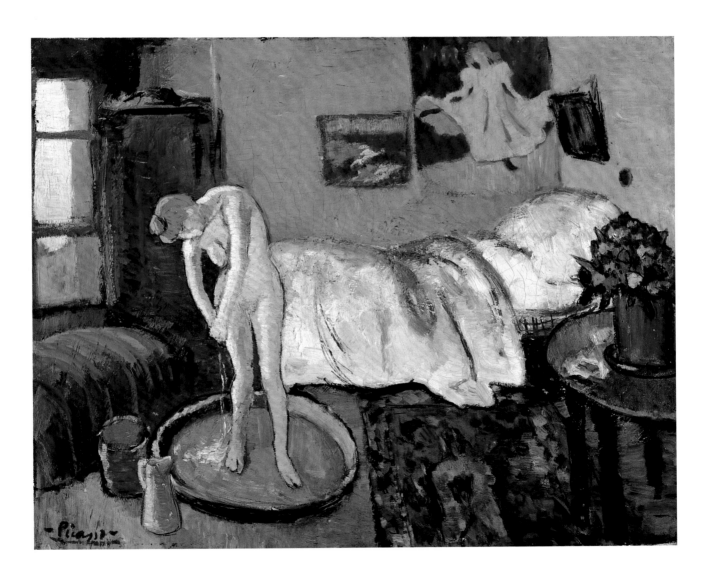

in the most generalized way. *Bullfight* translates life's polarities into the language of bullfighting, itself an ancient and highly symbolic activity: good and evil, light and dark, male and female, life and death. These oppositions may directly apply to Picasso who, as the creative artist destroying conventions and seeding new ground, can be identified with the energetic and highly sexed bull that symbolically penetrates the virginal horse. Although Phillips often found Picasso's work impersonal, he clearly recognized the expressive quality of *Bullfight*. He wrote: "This abstraction is vividly expressive of the light and excitement of a bull fight in the Spanish sun. It is a composite of Picasso's life extending from his racial background to his latest emotions in the bull pen of Europe today." JHM

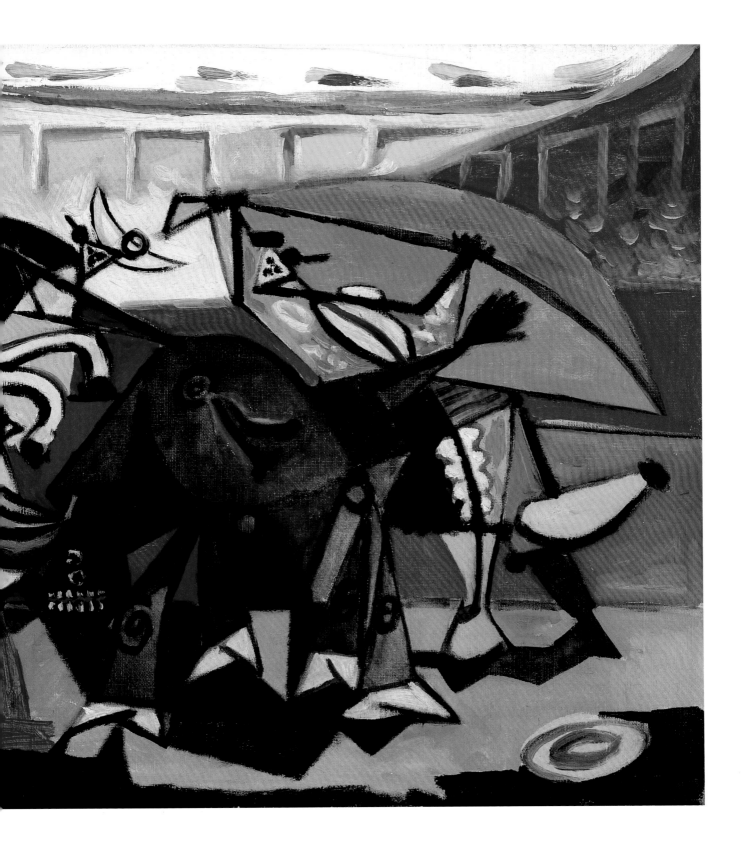

Horace Pippin

b. 1888, West Chester, Pennsylvania, d. 1946, West
Chester, Pennsylvania

Domino Players, 1943
Oil on composition board, 12 ¾ × 22 (32.3 × 55.8)
Acquired 1943

In his late work of the 1940s, the self-taught artist Horace Pippin turned his brush on the interior spaces of the home and the quiet domestic activities of everyday life. In *Domino Players*, Pippin vividly recalls a common pastime that characterized African-American life at the turn of the century. Drawing on his childhood memories, Pippin pictured himself as the young boy at the table and suggested that two of the three other figures were female relatives: the woman in the black polka-dot blouse may recall his mother, and the woman sitting opposite her his grandmother. Pippin suffuses the nighttime scene in a moody gray, white, and black atmosphere relieved by touches of red throughout. Oblivious to the crumbling plaster walls, the figures fill a room rich in the intensity of black and white and the textural layers of the pictorial surface. These expressive elements impart a sense of beauty to an otherwise routine aspect of life, demonstrating Pippin's ability to find beauty in the everyday. This idea is reinforced by the harmonious design integrated into the overall fabric of the composition, from the single tea cup on the edge of the table, to the lantern and clock placed on top of an elegant embroidered cloth, to the open scissors atop the red, white, and black quilting scraps on the floor. Moreover, he creates a dynamic structural tension between the hard-edged geometry of the windows, doors, table,

and floor boards and the softer, circular forms of the chair backs, faces, head scarves, lantern, and pail. A noticeable sense of stillness pervades the image; none of the figures makes eye contact and their gestures appear stilted, as if Pippin had captured a moment frozen in time.

Pippin's masterful eye for two-dimensional design, experimentation with decorative surface patterning, and application of strong contrasts of black and white, flat color, and expressive outlines recall some of the key pictorial attributes of the French Nabis style of the late nineteenth century. One of its principal adherents, Edouard Vuillard, shared Pippin's love of small, intimate scenes of domestic life.

Domino Players carries on a longtime tradition of painting scenes with figures around a table playing games; it specifically recalls an impressionist painting by Paul Cézanne, *Card Players* of c. 1890–1892 (Barnes Foundation, Philadelphia), in its similar arrangement of three figures around a square table set against a spare background. The theme of games continued to inform modern painting after Pippin's time. Jacob Lawrence adapted the theme in several boldly patterned works from the 1950s, including his close-up *Dominoes* of 1958 (Private collection). ES

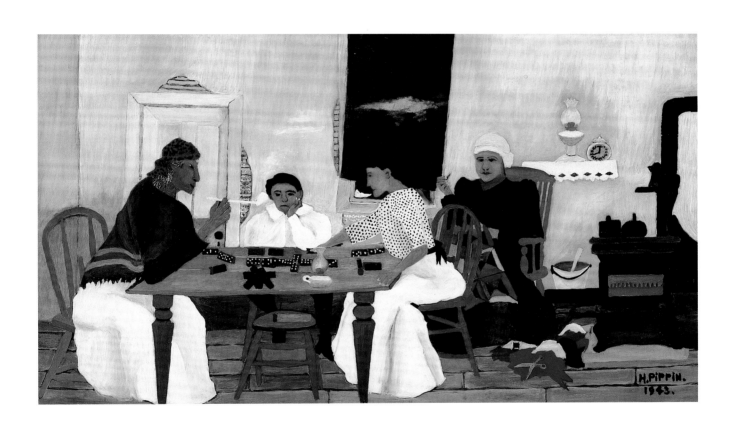

Jackson Pollock

b. 1912, Cody, Wyoming, d. 1956, Springs, New York

Untitled, c. 1951
Collage of papers, oil, ink, and glue on canvas, 50 × 35
(127 × 88.9)
Acquired 1958

Jackson Pollock is best known for his abstract action paintings, which he created by pouring paint from cans or flinging and dripping it from brushes or sticks onto canvases laid out on the floor of his studio. He used the movement of his entire body, reminiscent of the automatic drawings of the surrealists. Yet throughout his career Pollock also produced a number of collages on newsprint with oil paint, beginning as early as 1943, when Peggy Guggenheim invited him to participate in an exhibition of collages at her gallery, Art of This Century. While those initial collages, which he created in collaboration with another invited artist, Robert Motherwell, have since disappeared, Pollock made variants on the collage technique thereafter, including the untitled collage and oil acquired by Duncan Phillips from Pollock's exhibition at the Sidney Janis Gallery in 1958, and a related work, *Number 2, 1951* (Hirshhorn Museum and Sculpture Garden). Both contain pieces from the same black and orange drawing on Japanese paper. Pollock's wife, Lee Krasner, recalls that he would soak drawings in Rivit glue, a refined polyvinyl emulsion similar to Elmer's glue, which had been his primer of choice for his earlier drip paintings, and then overlay them so that they are only partially visible.

The Hirshhorn collage contains pebbles, twine, and wire mesh, and was paired in the exhibition *Sculpture by Paint-ers* at the Peridot Gallery in New York in 1951 with a large sculpture (since destroyed), made by wrapping some of the same drawings as those in the collage, soaked in glue, around chicken wire. The Phillips collage lacks the three-dimensional texture of its Hirshhorn sibling, and its pasted shapes relate more closely to a series of collages Pollock made between 1948 and 1950 that feature cut-out and layered humanoid figures. Both collages are considered important transitional works made just prior to Pollock's return to figuration with his so-called Black Paintings, executed between 1951 and 1953, when totemistic figures reappeared in his oeuvre. The collages are a key to understanding Pollock's creative dialogue with his close friend, patron, and fellow artist Alfonso Ossorio, and the influence on Pollock of a series of paintings on paper made by Ossorio between 1949 and 1950 in the Philippines. During that time Pollock and Krasner lived and worked in Ossorio's studio on MacDougal Alley in New York. There, Pollock would have looked through shipments of Ossorio's paintings from the Philippines as they arrived in his studio. In 1951 Pollock wrote to Ossorio: "I've had a period of drawing on canvas with some of my old images coming through." KO

Maurice Prendergast

b. 1858, St. John's, Newfoundland, d. 1924,
New York City

Ponte della Paglia, 1898–1899, completed 1922
Oil on canvas, 27 ⅞ × 23 ⅛ (70.8 × 58.7)
Acquired 1922

Noted for his colorful, decorative scenes of outdoor leisure in Europe and North America, Maurice Prendergast, a Bostonian, studied in Paris in the early 1890s, absorbing influences from French impressionist and post-impressionist art before returning to Boston in 1895. To familiarize himself with the most current trends in the art world, Prendergast returned to Europe frequently until World War I.

Ponte della Paglia is one of Prendergast's earliest oil paintings and also one of his latest. Begun during a visit to Venice in 1898–1899, it was not finished until right before it entered The Phillips Collection in 1922. The view is looking left down the Grand Canal from a balcony of the Doges' Palace and corresponds exactly to one of his watercolors from the same date. It is Prendergast's only known painting executed identically in two mediums. Prendergast was known for keeping canvases in his studio and reworking them from time to time. Wanting to add some brilliant accents in his current style before the painting was sent to Washington, the figures were extensively repainted by the artist in 1922 with colorful, thick, broad brushstrokes and heavy outlines. The style was Prendergast's personal adaptation of a tapestry-like technique that reflected his assimilation of the styles of Paul Cézanne and Henri Matisse, which he had seen on his trips to Paris around 1907. The bright, gay crowd is animated with colorful dresses and umbrellas. These promenades of upper-class men and women are typical of Prendergast's work throughout his career. The composition of *Ponte della Paglia* also reveals the artist's interest in Japanese prints. The vertical format, with its high horizon, was unusual for a city scene and very modern in spirit.

Prendergast moved to New York in 1914, where he enjoyed commercial success among collectors such as Duncan Phillips, who recognized in him a playful, romantic original and someone, as Phillips asserted, "modern in mind." Phillips wrote passionately about the artist and became a lifelong friend of the Prendergast family, acquiring a significant group of watercolors and oils by the artist. He championed Prendergast's work for its synthesis of the decorative and the representative through simplified and colorful pictorial patterns, often installing works by Prendergast alongside paintings by Pierre Bonnard, Cézanne, and Claude Monet. SBF and GHL

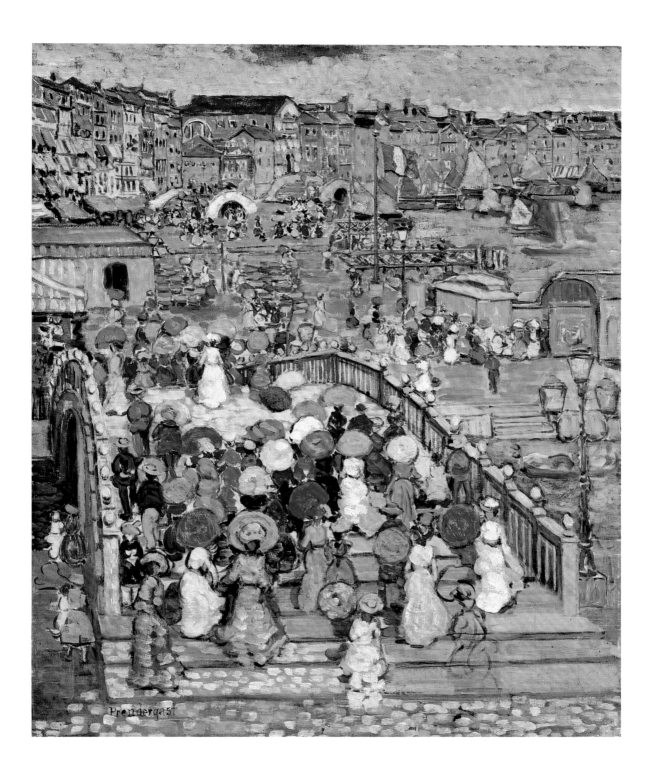

Pierre-Auguste Renoir

b. 1841, Limoges, d. 1919, Cagnes-sur-Mer, France

Luncheon of the Boating Party, 1880–1881
Oil on canvas, 51 ⅛ × 69 ⅛ (130 × 175.6)
Acquired 1923

Pierre-Auguste Renoir's *Luncheon of the Boating Party*, the most famous painting in The Phillips Collection, is a paean to life's pleasures: glorious weather, a leisurely day on the river, food and wine, and the company of friends. The painting commemorates no particular event but celebrates modern life in the late nineteenth century. It is an updated *fête champêtre*. Renoir's attractive young sitters, members of the newly ascendant middle class seen dallying over lunch at the Restaurant Fournaise on an island at Chatou, outside Paris, are modern counterparts to the gorgeously costumed eighteenth-century aristocrats who frolic in arcadian images by Antoine Watteau and Jean-Honoré Fragonard.

The convivial sitters were Renoir's friends. His fiancée, coquettish Aline Charigot, playing with her dog in the foreground, sits across the table from Renoir's great friend, the wealthy Gustave Caillebotte, impressionist painter, oarsman, and boat designer. Alphonse Fournaise, the restaurateur's son, dressed in boating clothes, leans against the railing, and further along it, an unidentified young woman chats with former cavalryman Baron Raoul Barbier. Actress Ellen Andrée sits drinking, opposite the baron. At the back, on the right, Paul Lhote, in a straw hat, has his arm around the waist of Jeanne Samary, a famous actress at the Comédie-Française, in conversation with bowler-hatted Eugène Pierre Lestringuez of the Ministry of the Interior. Wearing a top hat, Charles Ephrussi, a financier and the editor of the *Gazette des beaux-arts*, talks to a younger man, possibly poet Jules Laforgue. The girl in the foreground on the right is Angèle, an actress and model, and the

man leaning over her is a journalist, Maggiolo. But as Duncan Phillips's wife, Marjorie, said, their identities were not important because they were "everyman."

Luncheon of the Boating Party is larger than most impressionist paintings. Its composition is intricate and complex, including as it does in the tight space of the balcony so many group portraits as well as an opulent still life and elements of a landscape, yet Renoir did not make studies and sketches for this ambitious painting. It is believed that although the picture was probably completed in his studio, much of it was painted outside at Chatou. Just managing the comings and goings of so many sitters must have taken patience and organization, although it was not necessary to have them all present at once.

By the time he painted *Luncheon of the Boating Party*, Renoir had already had some commercial success, and the painting was well received. The dealer Paul Durand-Ruel bought it immediately and sold it soon afterward, but very quickly reacquired it. Duncan Phillips saw the painting first in 1911 and wrote warmly about it in his travel journal. He saw it again in 1923 while lunching at Durand-Ruel's gallery in Paris, fell in love with it, and started negotiating to buy it. He knowingly paid a record price for it, realizing that by doing so he was adding to the aura and reputation of the painting and to its drawing power. The day after closing the deal, Phillips, in a letter to his treasurer about the purchase of "one of the greatest paintings in the world," presciently wrote: "Its fame is tremendous and people will travel thousands of miles to our house to see it." JHM

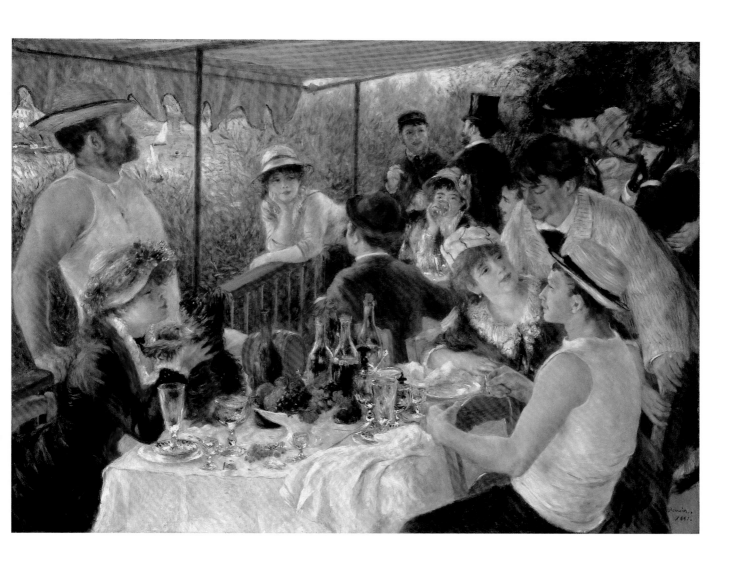

Mark Rothko

b. 1903, Dvinsk, Russian Empire, d. 1970,
New York City

Green and Maroon, 1953
Oil on canvas, 91 ⅛ × 54 ⅞ (231.5 × 139.4)
Acquired 1957

Mark Rothko (born Marcus Rothkowitz) is generally considered, along with Jackson Pollock, the preeminent artist of his generation. He is closely identified with the New York School, a group of painters who emerged during the 1940s and reinvented American art. While he was one of the most prominent pioneers of color field painting, which uses thin, diaphanous paint to achieve quiet, almost meditative effects, Rothko was in reality an outsider, largely self-taught, and an abstract painter almost against his will, having worked for more than half his life in a figurative style. He painted figures, still lifes, and street scenes in the 1920s and 1930s, and having achieved a greater sense of freedom from representational constraints in his semi-abstract paintings inspired by Greek mythology, he moved into pure abstraction in 1946, arriving at his signature style in 1949. This style, which consisted of two or three floating rectangles of color painted against a monochrome background, characterized his work until his death.

Rothko was highly literate, immersing himself deeply in philosophical and religious writings. He was obsessed with the idea that abstract painting, more than any other art form, could express the full gravity of religious yearnings and the anguish of the human condition. His extraordinary talent enabled him to transfer these impulses to the canvas with a power and magnetism that stuns viewers of his work, often bringing them to tears. As a young man he had hopes of pursuing a career as an actor, and the theater, especially the Greek tragedies, remained close to his heart. He once

famously remarked that he thought of his pictures as "dramas" and the shapes in the pictures as "performers."

Duncan Phillips may have been first introduced to Rothko's work in 1950 by the artist Theodoros Stamos, who had compared Rothko to Bonnard. By 1956 Phillips was sufficiently enamored by Rothko's paintings that he decided to borrow six to be exhibited at The Phillips Collection. *Green and Maroon* was acquired by Phillips from that exhibition. In 1960 Phillips mounted another exhibition of Rothko's paintings. Of the seven works on display he acquired two more, *Green and Tangerine* (1956), and *Orange and Red on Red* (1957). After purchasing one last Rothko painting in 1964, *Ochre and Red on Red*, the current four-painting scheme was introduced. The Rothko Room, the first space dedicated to Rothko's paintings, has remained virtually unchanged since 1966.

Like all of Rothko's paintings after 1949, *Green and Maroon* was begun by saturating the stretched, unprimed canvas with a wash of powdered pigments mixed with glue. The green and blue shapes were created by lightly brushing diluted glazes of powdered pigment and egg from the center of the canvas outward. In *Green and Maroon* the colors are dimmer and rendered denser by the underlying darker shades of blue, red, and gray, emanating a quiet glow. Hanging on the northeast wall of the Rothko Room, together with the other three canvases, it perfectly embodies what Phillips once called "the life-enhancing power of art." KO

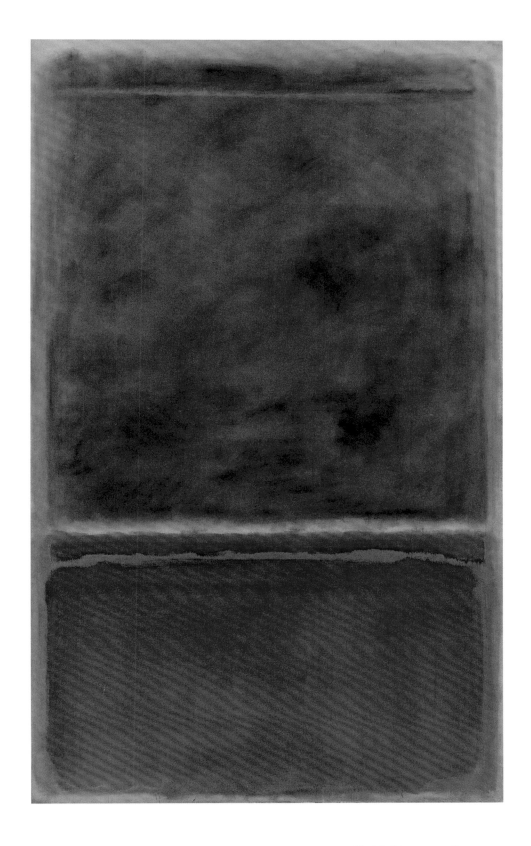

Georges Rouault

b. 1871, Paris, d. 1958, Paris

Circus Trio, 1924
Oil on paper, 29 ½ × 41 ½ (74.9 × 105.4)
Acquired 1933

Georges Rouault was a deeply spiritual artist with close ties to the important French religious writers Jacques Maritain and Léon Bloy. Fittingly for an artist who claimed he belonged to the age of cathedrals, Rouault initially trained as a stained-glass artist, which marks his paintings with their rich colors, thickly applied paint, and distinctive black outlines akin to glass leading. Even after training as a painter in the studio of Gustave Moreau, he worked like a stained-glass artist, with his canvas flat on a table rather than propped on an easel.

Circus Trio shows a male clown flanked by two female circus girls, or *écuyères*. It exemplifies Rouault's lifelong interest in circus iconography, which he began painting around 1903. Rouault, like Pablo Picasso, greatly admired Honoré Daumier and, like Picasso and Daumier, he subscribed to the romantic idea of the sad clown. *Circus Trio* is a somber painting because for Rouault the clown stood for human vulnerability, false hopes, and unfulfilled dreams. In much the same way as The Phillips Collection's sculpture *The Jester* (1905) by Picasso associates a circus character with Christ as the Man of Sorrows, Rouault's *Circus Trio* is a modern Pietà, alluding to Italian Renaissance images of half-length figures of the dead Christ supported by angels or by the Virgin and St. John.

Duncan Phillips thought of Rouault in association with Rembrandt and Daumier, and called him "gothic." *Circus Trio* is one of a large group of works (eight paintings and eighteen prints) by Rouault in The Phillips Collection, evidence of the collector's great admiration for him. JHM

Henri Rousseau

b. 1844, Laval, France, d. 1910, Paris

Notre Dame, 1909
Oil on canvas, 12 ⅞ × 16 ⅛ (32.7 × 40.9)
Acquired 1930

Nicknamed "Le Douanier," Henri Rousseau was not a customs inspector, as is popularly believed, but a *gabelou*, a lowly collector in the municipal toll service. Rousseau became a Sunday painter, and his first works date from 1877. He was completely self-taught, although along the way some well-known academic painters gave him pointers. The official Salon did not accept his works for exhibition, so from 1886 he showed with the Société des Artistes Indépendants. Rousseau retired from his job in 1893 to paint full-time, living in desperate poverty on a tiny pension and earning extra money by giving music and art lessons. Even when dealers started buying his works at the very end of his life, his financial situation remained dire. Yet, these hard circumstances did not cow him. Rousseau took himself seriously as a painter, refusing to return an official decoration sent to him in error by the French government and using it for self-promotion. There was something magically irrepressible about his naiveté, dignified self-confidence, and generosity. Young members of the avant-garde took him up:

Pablo Picasso gave a big party in his honor, Robert and Sonia Delaunay bought examples of his work (including The Phillips Collection's *Notre Dame*), and the poet and critic Guillaume Apollinaire defended him against critical ridicule. Rousseau's paintings won the admiration of artists belonging to the Blaue Reiter group, who also liked folk art. Characteristically, Rousseau accepted the avant-garde's promotion of him at face value.

Notre Dame was painted the year before Rousseau's death. Its simple composition, slightly askew perspective, and clear and beautiful colors are typical of his late work. The high finish of the painting recalls the artist's aspirations to Salon-style academicism. Characteristic, too, is the painting's introspective, dreamlike quality. Here, he captures the melancholy of Paris at twilight, as a solitary figure, perhaps the painter himself, looks over the Seine from one of the quays toward Notre Dame. Recognizing in the painting Rousseau's instinctive sense of design and color harmony, Duncan Phillips bought it at a time when he had an interest in folk art. JHM

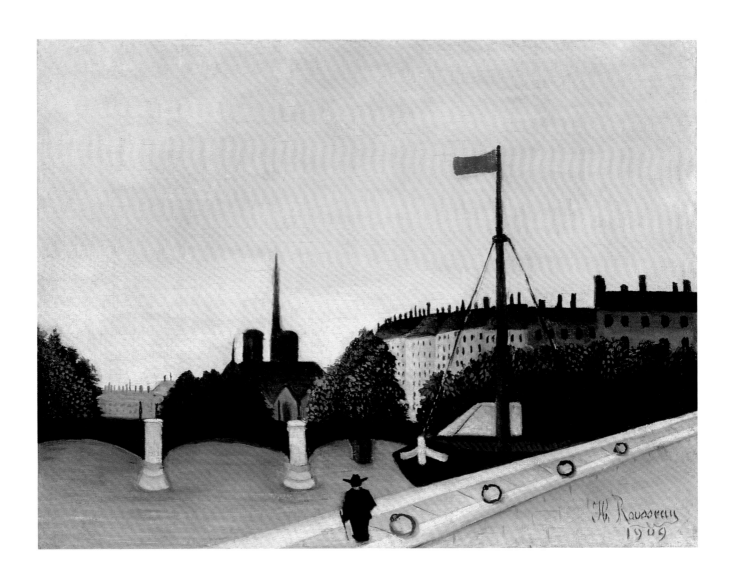

Albert Pinkham Ryder

b. 1847, New Bedford, Massachusetts, d. 1917, New York City

Moonlit Cove, early to mid-1880s
Oil on canvas, 14 ⅛ × 17 ⅛ (35.9 × 43.5)
Acquired 1924

Dead Bird, 1890s
Oil on wood panel, 4 ⅜ × 10 (11.1 × 25.4)
Acquired 1928

Albert Pinkham Ryder's special landscape sensibility is evident in *Moonlit Cove*, in which he juxtaposes masses of shapes in dark colors with luminous elementary forms that reveal his fascination with nocturnal light. The contours of the moored boat, and the dark mass of the cliff and sky, are arranged in a rhythm whose carefully measured intervals create a tight, interlocking structure, yet its simplicity suggests a random depiction of a scene found in nature. A master of simplified form and abstract design, Ryder was revered in his later years by both conservative and avant-garde American artists for his moonlit imagery and powerfully expressive and romantic vision of nature. *Moonlit Cove*'s presence in the 1913 Armory Show highlighted its status as an icon for the generation of American modernists coming of age before World War I.

One of the most poetic, romantic, and elusive of American artists, Ryder was born in New Bedford, Massachusetts, an important whaling port, where his brief education ended with grammar school. He began his artistic training in New York, studying at the National Academy of Design from 1870 to 1875. Four trips to Europe, the first in 1877, gave Ryder the opportunity to absorb firsthand much from the old masters and contemporary art, including works by Jean-Baptiste-Camille Corot, the Barbizon painters, and the Dutch artist Matthew Maris, whose studio he likely visited in 1882. Ryder was a reclusive and independent-minded visionary whose works exhibit a mood and sensibility that emphasize the mysterious along with the romantic. Scholars like Barbara Novak have pointed out that Ryder had both an intuitive grasp of the painting itself as a self-contained structure and autonomous object, and a heightened awareness of the expressive potential of paint to convey thought and feeling. In 1905 Ryder wrote that "the artist should fear to become the slave of detail; he should strive to express his thought and not the surface of it; what avails a storm cloud accurate in form and color if the storm is not therein?" He translated his close study of nature, music (especially Richard Wagner's operas), and literature into a new pictorial language of abstracted form and vital rhythms intended to convey the essence, not the details, of his subjects, which were linked to the primacy of nature as a spiritual force in the transcendentalist tradition of Walt Whitman, Henry David Thoreau, and Ralph Waldo Emerson.

Though intimate and small in scale, *Dead Bird* is one of Ryder's most powerful images and testimony to his masterful draftsmanship as he captures the coexistence of the corporeal and the ethereal. With starkly realistic details that create a moving evocation of suffering and death, such as the rigidly curled claws painted in heavy impasto and the subtle textural contrasts of plumage and beak, Ryder's picture evokes tradi-

tional nineteenth-century memento mori images. Duncan Phillips cited *Dead Bird* in his 1916 article on Ryder as an example of the artist's ability to paint directly from nature without a literary context. Although the bird was often used as a symbol of the soul, the dead bird appeared in the literature and imagery of Ryder's contemporaries as a "lamentation over lost innocence" and lost love.

Though beset by technical problems and using materials that have deteriorated over time, Ryder's art left a lasting impact on subsequent generations of American artists, including Arthur Dove, Marsden Hartley, and Jackson Pollock. Hartley, in particular, championed Ryder for his "incomparable sense of pattern and austerity of mood." For Phillips and other critics, Ryder's modernity derived from two sources: one was a subjective aesthetic that created a "tragic landscape and seascape of the indwelling mind"; the other was his ability to use the formal elements of shape, line, and tone to lend abstract organization to his canvases. SBF and LF

Kurt Schwitters

b. 1887, Hannover, Germany, d. 1948, Ambleside, England

Radiating World (Merzbild 31B), 1920
Oil and paper collage on cardboard, 37 ½ × 26 ¾
(95.2 × 67.9)
Acquired 1953

The German Kurt Schwitters was one of the most influential figures of the European avant-garde. Educated at art schools in Hannover and Dresden, Schwitters was originally influenced by cubism and expressionism. In 1918 he came in contact with Hans Arp, a German-French artist and poet and a founding member of Dada, the anarchist cultural movement that was determinedly anti-art, as well as other Berlin and Zurich dadaists, when he was invited to exhibit in the experimental gallery Der Sturm in Berlin. Encouraged by Arp, he began creating a series of collages composed of torn scraps of newsprint, candy wrappers, and bus tickets, often adding pieces of wood or metal wire, which he called *Merzbilder* (Merz Pictures). The term *Merz* derives from the German verb *ausmerzen* (to eradicate) and the second syllable of the German *Kommerz* (commerce), to signify the break with artistic tradition and the revaluation of the vernacular, "the spoils and relics" of everyday life. The Merz Pictures form a bridge between his earlier representational work and the formal abstraction of his later works. *Radiating World* belongs to the larger collages, designated by the letter "B" added to the title. Both the title and the work's highly dynamic composition evidence Schwitters's interest in scientific discoveries related to matter and energy. The collage is informed by several earlier collages, especially *Bild mit heller Mitte (Picture with Light Center)* of 1919 (Museum of Modern Art, New York), which contain light washes of color that create a sense of internal light. *Radiating World* features radiating diagonals that play off a circular form. The number 825, a fragmentary postal code, is prominently featured, as are other text fragments, such as a bold "Die" (the German feminine article) and "Wertpacket" (package of value), and the programmatic "MOUVEMENT DADA." Strategically applied patches of white, blue, and green paint show off the artist's renowned mastery of color and light. Schwitters is said to have made more than two thousand collages.

Schwitters's ambition to "make connections between all things" found its culmination in his *Merzbau* (Merz Construction), a continuously changing, room-size sculpture constructed of found objects that evoked both cubist paintings and Gothic architecture. It became his life's work: he began it in 1923 in Hannover (it was destroyed by an allied air raid in 1943). After seeking refuge in Norway in 1937, he undertook a second *Merzbau*, which he had to abandon two years later. He attempted a third *Merzbau* in England in 1947, one year before his death. Among his friends and collaborators were the dadaists Raoul Hausmann, Hanna Höch, and Tristan Tzara. *Radiating World* was given to Duncan Phillips by the estate of Katherine Dreier, who had founded the Société Anonyme, a Dada outpost in New York, with Marcel Duchamp and Francis Picabia and who had introduced Schwitters to the American public. KO

Georges Seurat

b. 1859, Paris, d. 1891, Paris

The Stone Breaker, 1882

Oil on wood panel, 6 ⅛ × 9 ¾ (15.6 × 24.8)
Acquired 1940

The career of Georges Seurat, who died at age thirty-one, was one of the shortest and yet most influential of any artist in modern history. In only eleven years he revolutionized both the practice and the reception of the art of his time and that of future generations. Seurat studied painting at the prestigious École des Beaux-Arts in Paris from 1878 to 1879 under the conservative academic painter Henri Lehmann, a follower of the neoclassicist Jean-Auguste-Dominique Ingres, at a time when many artists, notably those associated with the impressionist movement, were revolting against the classical tradition.

After a year in military service, Seurat worked on drawings in black and white to experiment with light and shadow under the influence of the nineteenth-century French chemist Michel Eugène Chevreul, who had observed that any color is heightened when placed next to its complement. In 1882 Seurat followed the impressionists' habit of traveling to the countryside and painting outdoors, *en plein air*, which had become possible largely after the introduction of collapsible screw-cap paint tubes by Winsor & Newton and the portable box easel in the mid-nineteenth century.

The Stone Breaker is one of many preparatory small sketches made by Seurat at the time. He called them *croquetons*, after the French term *croquis* (sketch). Painted on the fly, on wooden panels frequently cut from his father's discarded cigar boxes, they fit easily into Seurat's box easel. Often part of the wood is left in its natural state, without being treated with white ground to create a warm tonality. His subjects were primarily the landscape and rural life outside Paris. The subject matter of *The Stone Breaker* shows an affinity with the realism of Gustave Courbet's earlier painting of the same subject, *Stone Breakers* of 1849 (now destroyed), Jean-François Millet's *The Gleaners* of 1857 (Musée d'Orsay, Paris), and Gustave Caillebotte's *The Floor Scrapers* of 1875 (Musée d'Orsay); however, Seurat's paintings of stone breakers, farm workers, and road sweepers captured in Le Raincy, a small commune near Paris, lack the social criticism embedded in the works of Courbet and Caillebotte. Seurat focused on the contrast of color and light. The large crisscross brushstrokes of bright color are informed by the primacy of color over line, advocated by Eugène Delacroix, and by Seurat's reading of Chevreul and the American physicist Ogden Nicholas Rood, whose book on color theory, *Modern Chromatics, with Applications to Art and Industry*, appeared in French translation in 1881.

Duncan Phillips preferred these rough early oil sketches to Seurat's highly refined later works. He regarded these *croquetons* as precursors of Henri Matisse and Pablo Picasso. KO

b. 1883, Philadelphia, d. 1965, Dobbs Ferry, New York

Skyscrapers, 1922
Oil on canvas, 20 × 13 (50.8 × 33)
Acquired 1926

The Philadelphia-born artist Charles Sheeler trained as a painter at the Pennsylvania Academy of the Fine Arts under William Merritt Chase. In 1912 he began exploring artistic photography and associating with the movement's leaders, including Alfred Stieglitz, Edward Steichen, and others in the Stieglitz circle. By the time of his move to New York in 1919, he had adopted the hard-edge, smooth surfaces of the precisionist style, as seen in the present painting. Sheeler had been drawn to the skyscraper as a subject beginning in 1920, the year he and photographer Paul Strand produced the film *Manhatta*, a seventeen-minute capsule of New York at its "intensest terms of expressiveness." One of his favorite photographs in that film inspired this later painting, *Skyscrapers*, as well as a related pencil drawing, *New York* (1920), one of the rare instances where the artist explored the same motif across three media. The original photograph was taken from the top of the forty-one-story Equitable Building at 120 Broadway, looking down on the undulating rear walls of the thirty-two-story Park Row Building. At the time it was completed in 1899, it was the tallest structure in the world, to be surpassed only by the Empire State Building in 1931.

A comparison of the photograph with the painting provides telling insight into the way Sheeler freely transformed the photograph to suit his own interests in pictorial rhythm and pattern. To accentuate the elegant geometry of the tall, vertical shafts, in the painting Sheeler sharpened the contours, added harder-edged lines and cleaner surfaces, and eliminated many details. No longer transparent, the raking shadows and vaporous recesses between the buildings become solid planes of color. Following *Skyscrapers*, Sheeler continued to explore the aesthetic possibilities of industrial and architectural subjects drawn from the man-made world; however, people are noticeably absent in all these pictures. As he once said, "It's my illustration of what a beautiful world it would be if there were no people in it."

Springing up in great numbers during the first decades of the twentieth century, skyscrapers altered the face of the modern city and opened up new, exciting perspectives on the world. A decade before Sheeler, Alvin Langdon Coburn had turned his gaze upon New York's changing skyline in dynamic views compiled in his portfolio, *New York* (1910), and his later series *New York from Its Pinnacles* (1912). Sheeler likely would have been familiar with Coburn's dynamic views of the Park Row Building, as well as those by his contemporaries, Alfred Stieglitz, John Marin, and Joseph Pennell. ES

Walter Richard Sickert

b. 1860, Munich, d. 1942, Bath, England

Ludovico Magno, 1930–1931
Oil on canvas, 21 ½ × 30 (54.6 × 76.2)
Acquired 1941

Walter Sickert cuts one of the most interesting figures in all of British art. German-born, educated in England, a devotee of the theater and himself an actor, an international traveler and Francophile, he studied with James Abbott McNeill Whistler and befriended his chosen mentor, Edgar Degas, in the 1880s, arriving on his doorstep in 1883 with a letter of introduction from Whistler, an artist of similarly international expatriate outlook. Straddling, as Sickert does, both the nineteenth and twentieth centuries, he carries forward central concerns and subjects of late nineteenth-century painting while ultimately arriving by 1940 at aesthetic approaches that seem ahead of his time in the twentieth century. Most of his six works in The Phillips Collection date from the middle years of his long career.

Ludovico Magno depicts a Paris street scene by the Porte Saint-Denis, an arch built in the seventeenth century and inscribed on its north side with the name Louis XIV. Continuing the impressionist desire to capture modern life, Sickert places the viewer on the street behind a man in a hat and looking past the shop signs and wares through the arch itself, giving us the sensation of moving along the crowded sidewalk and being a part of the scene. Clearly inspired by Degas's dynamic and radi-cal works that put the viewer in the orchestra pit or the café audience, Sickert uses a similar framing device for his composition. He often chose grittier subjects, whether music halls or street life, while making clear his homage to his mentor. Sickert and his wife owned several works by Degas, which they treasured. The ultimate cosmopolitan, Sickert lived in Dieppe for two extended periods, from 1898 to 1905, when he saw Degas frequently, and from 1919 to 1922. He continued to cross the Channel in ensuing years for visits to France.

Probably based on a photograph, *Ludovico Magno* reveals signs of squaring up an existing image for transfer to this coarsely woven canvas and signals a preoccupation with the power of the photographic image that Sickert would take to stronger statement later in his life. Here he employs a subtle palette, offset by an arresting and dramatic point of view, dashes of scarlet, and the darker tonalities of the objects close to the viewer, as opposed to the fainter, apparently light-struck neutral tonalities of the distant view of the street. While the title refers to the arch itself and its historical context, Sickert's take on it shows the monument diminished and practically swallowed up in the to and fro of contemporary life. ER

Alfred Sisley

b. 1839, Paris, d. 1899, Moret-sur-Loing, France

Snow at Louveciennes, 1874
Oil on canvas, 22 × 18 (55.9 × 45.7)
Acquired 1923

Alfred Sisley's fuzzy impressionist brushstrokes perfectly correspond to the dense atmospheric conditions of *Snow at Louveciennes*. In it, the snow sifts down, blurring edges, muffling forms, and muting colors along the chemin de l'Etarché, the lane behind Sisley's house, seen here from the artist's first-floor balcony. Confirming reports of heavy snowfalls in December 1874, the snow looks to be several inches deep on top of the wall along the lane and on surrounding rooftops. In the bare trees, the snow appears as a smoky haze. The painting's emphatic composition, rare in Sisley's oeuvre, highlights the contrast between the built and the natural world. One feels sympathy for the solitary, small, dark figure out in her apron, making her way through the snow, her black umbrella held at an angle against the weather. In the diffused light, there are no shadows. Instead, light bounces between the white surfaces of falling snowflakes and fallen snow, reflecting all nearby colors. Sisley faithfully records in his broken whites the muted echoes of the painting's keynote colors, the cool blue-green and the warm rust of the gates at the center of the composition.

Snow at Louveciennes was the third composition by Sisley that Duncan Phillips bought and the only one he kept. He regarded the painter as a genius, a "landscape painter of the first rank," and saw in his work a connection to English poetry. Of *Snow at Louveciennes* Phillips wrote that it was "a lyric of winter, enchanting both in its mood and in its tonality of tenderly transcribed 'values.'" JHM

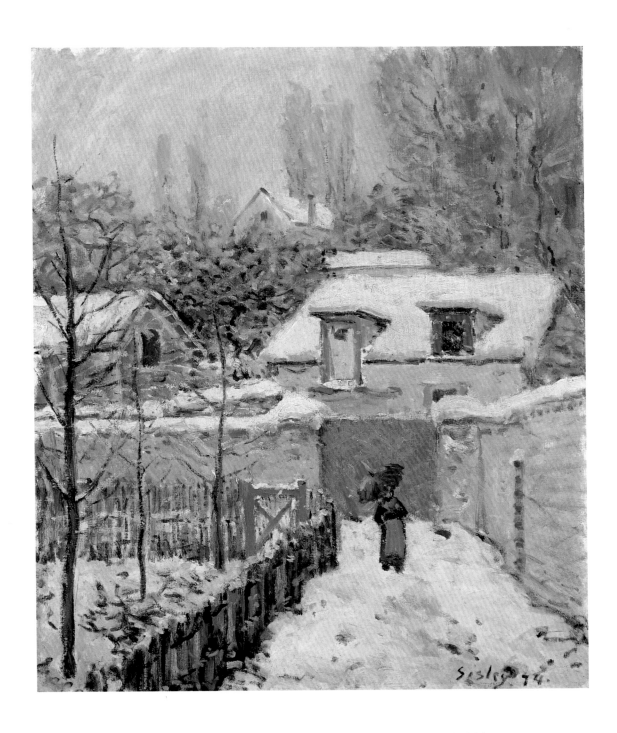

John Sloan

b. 1871, Lock Haven, Pennsylvania, d. 1951, Hanover,
New Hampshire

The Wake of the Ferry II, 1907
Oil on canvas, 26 × 32 (66 × 81.3)
Acquired 1922

Six O'Clock, Winter, 1912
Oil on canvas, 26 ⅛ × 32 (66.4 × 81.3)
Acquired 1922

While a student at the Pennsylvania Academy of the Fine Arts in Philadelphia in 1892, John Sloan met Robert Henri, who became his closest friend. Originally a Philadelphia newspaper artist-reporter, in 1900 Sloan began to exhibit his paintings, which the critics recognized for their narrative power. In 1904 Sloan moved to New York, where he was fascinated by the vigor of the city in all its shabby drabness. Sloan looked at the city with the eyes of a reporter, choosing his subject matter from the mainstream of everyday experience, often from the rough working-class neighborhoods of New York's Lower East Side.

Few collectors and even fewer museums were attracted to the work of Sloan and his colleagues, who were considered revolutionary New York artists because of their subject matter, dark palette, and aggressive style. Labeled "apostles of the ugly," they were eventually nicknamed the "Ashcan School." Duncan Phillips was one of the few collectors who celebrated their work. Recognizing Sloan's passionate interest in "the curiously different ways people live in different sections of the same great city," Phillips noted that Sloan "points out not only the crowd but the lonely individual caught in the maelstrom."

A gifted painter and draftsman, Sloan was a major force in American culture for fifty years, training successive generations of artists at the Art Students League in New York. Resisting the lure of French painting at the turn of the century, he

was an early organizer of exhibitions for dissident American artists who wanted to exhibit their work without the intervention of a jury, beginning with the exhibition of The Eight at Macbeth Gallery in New York in February 1908. Energized by this sense of freedom, some of Sloan's finest paintings were done in the months preceding that exhibition, including *The Wake of the Ferry II*. Here, Sloan captured the boat and river theme that was so popular among the members of his circle. The subject may well have been suggested by the occasions when Sloan accompanied his wife, Dolly, to the Jersey City ferry on her way to Philadelphia for medical treatments. The first version of the painting was damaged in a quarrel Sloan had with his wife, when he threw a rocking chair at the canvas. He made some changes to the composition in the second version, but the melancholy mood remains in the listless pose of the figure set off to the right and Sloan's reduction of the palette to tonal grays and near blacks. Duncan Phillips admired Sloan's ability to evoke a specific mood, writing that Sloan could take the ugly facts of a scene like the deck of a ferry and make his use of gray not only dramatic but also infinitely subtle in its range. The ferry's tilted framing of the river view and the diagonal of the wake receding into the mist reinforce the sense of loneliness and distance. The sense of rocking movement may reflect Sloan's awareness of the new medium of moving pic-

tures, which recorded the motions of the sea by mounting a camera to the side of a passenger boat.

Sloan's ability to capture drama in an everyday scene is very much in evidence in *Six O'Clock, Winter,* which depicts the Third Avenue "El" (short for "elevated train") at the peak of the evening rush hour. Painted in February 1912, this canvas is late in the group of New York city-life scenes that Sloan executed from memory. He was beginning to place increased emphasis on formal order, and here he achieves unprecedented monumentality. The shop girls, clerks, and working men that form a narrow band at the bottom of the canvas seem generally unaware of the omnipresent elevated railway looming high above them. The massive and powerful train is poised for only a moment, its dark diagonal stretching across the canvas, threatening to burst out of the picture frame, held back only by the vertical steel posts that are seemingly anchored in the crowd. Silhouetted against an ice-blue, early evening winter sky, the waiting train appears threatening. Sloan was disappointed that the Carnegie Institute rejected *Six O'Clock, Winter* for its 1912 annual exhibition. Phillips, however, admired Sloan's creative integrity and freedom from the whims of public taste. He was the first to buy a painting by Sloan for a museum collection, purchasing the first of three major oils in 1919. SBF and VSB

Chaim Soutine

b. 1893, Smilovichi, Russian Empire (Lithuania),
d. 1943, Paris

Return from School After the Storm, c. 1939
Oil on canvas, 18 ⅛ × 19 ¾ (46 × 50.1)
Acquired 1940

In 1937, ten years after his first one-person show in Paris, Chaim Soutine met Gerda Groth, a German refugee with whom he traveled to Civry-sur-Serein, France, and who would become his companion. Soutine painted *Return from School After the Storm* in Civry-sur-Serein, probably during the summer of 1939. In it, a boy and girl, perhaps brother and sister, scamper hand in hand down a dirt road, while a dark sky, low, threatening clouds, and windswept trees reveal a distant storm. This work is part of a late series that features children in pairs walking or running down a road toward the viewer. Created when Soutine was returning to a more classical approach in his work, it shows a move toward clarity and timelessness in subject matter. Although still handled with a nervous energy somewhat similar to that seen in his earlier pictures, Soutine here paints a more stable composition, fully integrating figures into the landscape. Looking to the history of art, Gustave Courbet's *The Beach at Saint-Aubin-sur-Mer* (1867), admired by Soutine, may have been an early influence. "What Soutine found in painting of the past complemented his own natural expression. He used the great masters to further refine a personal statement; he looked selectively and took from past art those images and the stability and gravity of expression that could reinforce his vision." While Soutine and Groth were in Civry-sur-Serein, war broke out. The turbulent forces of the time may have also shaped this work. The children have been interpreted as symbols of "a kind of innocence in the face of impending and overpowering forces, analogous to Soutine's own vulnerability as a Jew in hiding in occupied France."

Duncan Phillips described Soutine's painting as a "cataclysmic upheaval as if he had a premonition of our world's agony of total war." *Return from School After the Storm* is the first of three works by Soutine purchased by Phillips. It is also among the earliest works by Soutine ever acquired by a museum in the United States. The year after its acquisition, the work was shown at The Phillips Collection in the exhibition *The Functions of Color in Painting*. In 1943, it was featured at the museum in the first solo exhibition in the United States devoted to the art of Soutine. RM

Nicolas de Staël

b. 1914, St. Petersburg, Russia, d. 1955, Antibes, France

Fugue, 1951–1952
Oil on canvas, 31 ¾ × 39 ½ (80.6 × 100.3)
Acquired 1952

Born in St. Petersburg to aristocratic Russian parents of Swedish descent, Nicolas de Staël was orphaned at an early age, grew up with foster parents in Belgium, and spent most of his adult life in France. A handsome, towering figure, he saw himself taking his place in the history of French painting and admired such titans as Gustave Courbet and Georges Braque who, like de Staël, often used a palette knife to apply paint to canvas, building their surfaces in broad, bold strokes. Also among those he most emulated and drew inspiration from were Paul Cézanne and Henri Matisse. After struggling to establish himself in the 1940s, he experienced a meteoric rise to fame and success in the early 1950s, when his reputation spread to Britain and the United States, making him suddenly a rich and famous man. With success, however, came unsustainable demand and the pressure to produce larger works at a more rapid rate. At the peak of his renown, de Staël threw himself to his death from his studio in Antibes.

Although in the course of his career de Staël moved toward an ever greater degree of reference to the visible world, developing his work from what appears to be pure abstraction in the 1940s to landscape, still life, and figure painting in the early 1950s, he himself did not divide the two. *Fugue*'s physical reality alone removes it from the world of pure abstraction. This painting comes from a period when the artist, responding to the muted tonalities of Paris, was developing a nuanced palette of grays that inspired a series of paintings of the city's rooftops and walls. Built up in layers of thick paint that allow edges of underlying colors to show through, *Fugue* invites the viewer to appreciate the subtle choices made throughout the painting process. Among the qualities de Staël derived from his admiration for Braque were shallow pictorial space, tonal refinement, and a subtle and keen sense of color, as well as the ability of a single hue to sing out as, for example, the small touches of yellow do in this particular work. Most of all, Braque's love of the physical medium of paint itself may be unsurpassed by any other artist of de Staël's generation.

When the art dealer Theodore Schempp drove up to The Phillips Collection in 1950 with works by de Staël in his station wagon, Phillips immediately bought the first of eight works he would acquire by the artist, making this the first acquisition of the artist's work by an American museum. Finding beauty in *Fugue*'s qualities of rhythm and repetition, Phillips gave the work its title, signaling its relationship to an art that also builds through rhythm and repetition to its full expression over time. ER

Clyfford Still

b. 1904, Grandin, North Dakota, d. 1980,
Baltimore

1950-B, 1950
Oil on canvas, 84 × 67 ⅛ (213.4 × 170.5)
Acquired 1969

Clyfford Still remains an important abstract painter, but his work is relatively unknown. A passionate man, with strongly held opinions, Still disliked and distrusted the art world—he considered it parasitical—and strictly limited his participation in it. He wanted complete control over his work, which he regarded as a totality. Believing that his paintings could only be understood properly in relation to one another, he did not wish them to be separated from one another. As a result, few of his works appeared on the market or made their way into public collections.

Still drew and painted from an early age. He grew up in Spokane, Washington, and in Alberta, British Columbia. He attended the Art Students League in New York City briefly in 1925, and he studied at Spokane University in 1926–1927 and again from 1931, graduating in 1933. He attended graduate school at Washington State College, where he obtained his master's degree in fine arts in 1935. He lived and taught in different parts of the United States, including San Francisco, where his forceful personality and the nonobjective works in his 1947 one-person exhibition at the California Palace of the Legion of Honor greatly affected his colleagues at the California School of Fine Arts. From 1961 he lived and painted in seclusion in Maryland.

Still's early works were figurative, but he gradually turned to abstraction. His work is associated with both abstract expressionism and color field painting. In his dark, jagged canvases the paint seems to be torn open to reveal fields of bright color. *1950-B* is painted in thick black, fused with areas of burnt sienna and earth brown, with bright spots of orange and indigo revealed in the black. Still considered his paintings essentially self-portraits. His themes developed from his study of anthropology, psychology, and myth as a graduate student, and *1950-B* is interpreted as being generally about regeneration and the confrontation of death and life. More specific interpretations involve the "buried sun" or cycle of death and rebirth—in the myth of Persephone and Demeter, which is known to have interested the artist, and an American Indian iconography of regeneration. In this interpretation, the image is read as the head of a shaman, the Earth Shaker, who experiences his own death and rebirth. JHM

Augustus Vincent Tack

b. 1870, Pittsburgh, d. 1949, New York City

Night, Amaragosa Desert, 1935
Oil on canvas mounted on plywood panel,
84 × 48 (213.4 × 121.9)
Acquired 1937

Augustus Vincent Tack, who came of age at the end of the aesthetic movement in the nineteenth century, was fascinated by Asian art, design theory, and French symbolism. Deeply spiritual, with a pantheist's view of the natural world, he shared with the American modernists Arthur Dove, John Marin, and Georgia O'Keeffe a desire to extract from nature an abstract visual vocabulary. A first view of the Rocky Mountains in summer 1920 permanently reoriented his approach to painting. In 1922, at the height of his career as a successful society portraitist and muralist, Tack began to experiment with works expressing what he called "motion" or "mood" studies, developing abstract, decorative compositions of form and color that he claimed were based on "essential rhythms." Nature and New Testament subjects were the primary inspiration for his early experiments in abstract painting.

Probably inspired by a trip to California in the summer of 1933, _Night, Amaragosa Desert_ is one of the most important abstractions Tack created in the 1930s. It is the foremost example of expressionist brushwork in his late abstractions and, as with many of these decorative canvases, is adapted from a design segment embedded in another picture. By manipulating negative and positive form and creating somber color harmonies, Tack was able to render in this work a sense of mystery and loneliness that suggests nature's cataclysmic grandeur.

Duncan Phillips was the first to appreciate Tack's venture into abstraction, buying his breakthrough works in 1923 and 1924. He became Tack's most outspoken patron, championing his decorative and mystical abstractions for the next forty years—works that Phillips believed were the first true blending of Eastern and Western art in America. Shortly after acquiring _Night, Amaragosa Desert_, Phillips exhibited it with works by Vincent van Gogh, Paul Cézanne, and Pierre Bonnard. In 1957, he paired it with his first work by Mark Rothko and one by Kenzo Okada in an installation entitled _Abstract Expressionists from the Collection_. This captured Phillips's ideal of joining Eastern and Western aesthetics into a fully realized vision of American abstraction as a transcendent, spiritualized experience of pure form and color. Phillips understood that Tack's aestheticism was not the same as the concerns of the abstract expressionists, but he believed that Tack's abstract ventures were connected to postwar abstraction and that Tack was feeling his way toward large-scale color symbolism. Tack's abstractions were never appreciated in the artist's lifetime, but they were a formative influence on artists who visited The Phillips Collection in the 1950s and 1960s and saw them installed in the galleries, for example Kenneth Noland, Morris Louis, Gene Davis, and Sam Gilliam. SBF and LF

Mark Tobey

b. 1890, Centerville, Wisconsin, d. 1976, Basel,
Switzerland

After the Imprint, 1961
Gouache on illustration board, 39 ⅝ × 27 ⅜
(99.7 × 69.8)
Acquired 1962

Born in the Midwest, a generation older than the abstract expressionists of the New York School with whom he is sometimes associated, Mark Tobey received greater honors and accolades in Europe than in his native country and chose to spend his last years living in Basel, Switzerland. In the mid-1950s he was Europe's "great new discovery." Tobey was the first American to be given a retrospective at the Musée du Louvre, Paris, and represented the United States at the Venice Biennale in 1954. The Phillips Collection presented a solo show in 1962 from which Duncan Phillips purchased *After the Imprint*.

Tobey's work was deeply inspired by ideas of universality. As a young man he joined the Baha'i Faith, espousing its tenets about the interdependence of humankind and the unity of all religions. During the 1930s Tobey lived seven years in England and in 1934 he traveled with potter Bernard Leach to China and Japan, a trip that indelibly marked his future artistic development. Always seeking a universal message in his work, he drew upon science, religion, music, and Asian calligraphy as well as his own visual experience to create an entirely original pictorial language that in its linear allover treatment of composition anticipates the work of Jackson Pollock, among others.

Usually small in scale and often on paper, Tobey's works are executed in a broad but subtle range of hues and variety of gestures, from curving strokes to angular ones, thick and thin, bold and fine. He arrived at his mature abstract style in the 1940s, deriving it from concepts of light as a unifying force, both physical and metaphorical, and from his study of Asian calligraphy, both in Japan and in Seattle, where he lived for many years. He established a reputation as the inventor of "white writing," a pictorial language that also was informed by his reading of such authors as Ernest Fenollosa and Alfred North Whitehead, whose books helped shape his unique merging of Eastern and Western philosophies and traditions.

The rhythm of Tobey's calligraphic strokes as they dance across the sheet speaks to the liveliness and contained energy that underlies all his work. In contrast to the skeins of Duco and oil paint poured and dripped by Jackson Pollock onto large swaths of canvas on the floor, Tobey sought a similarly "allover" treatment of the pictorial field but usually used brushes dipped in gouache to make his delicate markings. Tobey's way of animating a composition was also inspired by music; he played the piano and created musical compositions of his own. His art expresses a desire to transcend material existence, to create a visual equivalent to meditation and the life of the spirit. ER

Bradley Walker Tomlin

b. 1899, Syracuse, New York, d. 1953, New York City

No. 9, 1952
Oil on canvas, 84 × 79 (213.4 × 200.7)
Acquired 1957

By the late 1940s, Bradley Walker Tomlin had begun painting with greater improvisation, opening the structure of his cubist compositions and increasing their scale. Tomlin's exposure to the Museum of Modern Art's exhibition *Fantastic Art, Dada, and Surrealism* (1936–1937) played an important role in this transition, as did the work of abstract expressionist painters Adolph Gottlieb, Robert Motherwell, Philip Guston, and Jackson Pollock. By 1948, Tomlin's paintings appeared more abstract and gestural as he experimented with automatism and pictographic forms. His white calligraphic shapes had the look of primitive writing. As critic Lawrence Alloway explained: "The display of marks, though esthetically governed, project a lyrical pretense of antique messages, the challenge of symbols not yet decoded." *No. 9* exemplifies how Tomlin combined a sense of structure with improvisation in his mature work. The structure of the overlapping vertical and horizontal gridlike shapes relates rhythmically to the painting's overall spontaneous and freely handled brushwork. Luminous in palette, heightened by earth tones, *No. 9* confirms

Tomlin's standing as one of the most graceful and controlled painters of the abstract expressionist movement.

Attracted to the artist's "rich...tonal subtleties," Duncan Phillips probably first saw Tomlin's work at the Corcoran Gallery of Art in Washington, DC, in 1932. In 1955, ten years after his first purchase of a work by Tomlin, *Still Life* (1940), Phillips presented the artist's first solo museum exhibition with loans from the Betty Parsons Gallery and works from private collections. Two years later, Phillips acquired *No. 9* from Betty Parsons and installed it with a focused selection of abstract expressionist works from the permanent collection. That same year, *No. 9* was also featured in a major Tomlin retrospective, organized by the Art Galleries of the University of California, Los Angeles, and the Whitney Museum of American Art, New York. Phillips wrote for the exhibition catalogue: "Tomlin was neither strictly abstract in practice nor really expressionist in temperament. He was an individual stylist. Our age needed him." Phillips collected a total of three paintings by the artist. RM

John Henry Twachtman

b. 1853, Cincinnati, d. 1902, Gloucester, Massachusetts

Summer, late 1890s
Oil on canvas, 30 × 53 (76.2 × 134.6)
Acquired 1919

John Henry Twachtman, who trained in Munich from 1875 to 1879 and then in France between 1883 and 1885, was one of America's first and most noted impressionist painters. The American impressionists infused painting with optical light, changing seasons, and the sensation of air, which created a fresh interpretation of the national countryside. This new approach transformed the heroic American landscape of the Hudson River School and the genre scenes of rural America into a more modern idiom that favored the intimacy of familiar places rooted in the New England countryside.

Summer was painted on property in Greenwich, Connecticut, that Twachtman purchased in 1889. A frequent visitor to the Connecticut farm owned by his friend, the painter Julian Alden Weir, Twachtman seized the opportunity to acquire property that was not only within commuting distance to New York City, but also near his colleague. He was attracted by the surrounding fields and the sense of removal from the rest of the world. Although he taught regularly at the Art Students League in New York, Twachtman wrote in 1891 that he felt "more and more contented with the isolation of country life...we are then nearer to nature." This seventeen-acre farm with its old farmhouse, rolling hills, brook, and pond provided the artist with inspiration in all seasons over the next decade.

By the end of the 1890s, Twachtman was introducing more vivid color into his atmospheric landscapes. The large, rectangular format of Summer allows the artist to depict his Greenwich house as deeply rooted in the rolling hills, with light and shadow set within strongly defined contours. Abstract design, inspired in part by Japanese prints, plays an important role in the intersecting lines of rooftops, road, and hillside, as well as in the bold green-and-yellow pattern of grass in the foreground. Rather than breaking up color with short strokes in the vein of the French impressionists, Twachtman laid in broad areas, often with lighter colors over a darker ground and with brushwork ranging from scumbles to rich impasto.

During his Greenwich years, Twachtman usually painted outdoors, although he might return to a site many times before completing a work. He was known to finish canvases in his studio, where he crafted beautiful effects of surface and color through underpainting and unusual techniques aiming to create dry, matte surfaces, such as exposing the canvas to sun and rain to eliminate excess oil. His combined outdoor and indoor methods strove to achieve the impression of spontaneity.

Duncan Phillips ranked Summer as his best purchase of 1918–1919. He described it as "impressionism carried to the heights of spiritual expression...the subtle perception of the modern realist pervaded by an idealism which apprehends the universal in the local, the eternal in the temporal...even in the very likeness of the artist's little place in Connecticut." SBF and ET

Edouard Vuillard

b. 1868, Cuiseaux, France, d. 1940, La Baule, France

The Newspaper, 1896–1898
Oil on cardboard, 12 ¾ × 21 (32.4 × 53.3)
Acquired 1929

Woman Sweeping, 1899–1900
Oil on cardboard, 18 ⅜ × 18 ⅝ (44.1 × 41.3)
Acquired 1939

All four paintings by Edouard Vuillard in The Phillips Collection date from the 1890s, after Vuillard had joined Paul Sérusier, Maurice Denis, Ker Xavier Roussel, and Pierre Bonnard, among others, in forming the group they called the "Nabis" ("prophets" in Hebrew). Inspired by Paul Gauguin and the aesthetic of Japanese prints, the Nabis rejected impressionism in favor of a flatter, more decorative approach to color and pictorial space. Vuillard's early interest in theater and decorative commissions furthered the development in his painting of a shallow, stage-like space that emphasizes surface pattern and design. He often structured his imaginative compositions around vertical and horizontal aspects of his subject, nowhere more strikingly than in these two paintings.

Although born in Cuiseaux, Vuillard moved to Paris with his family as a child and was educated there at the Lycée Condorcet, where he began lifelong friendships with Denis as well as Roussel, who would become his brother-in-law. Vuillard lived with his mother, who ran a dressmaking business at home. He observed the seamstresses and his mother and sister at work and often made them the subject of his paintings. A devoted son, he enjoyed the company of women but never married. In his paintings a quiet domestic harmony prevails. Vuillard was constantly sketching and his rapid notations became an essential source for his paintings, which were often done using very lean oil paint, resulting in rich, matte surfaces perfectly suited to the textures and patterns that made up the environment in which he lived.

Doors, windows, and mirrors play an important structural role in Vuillard's compositions. Daylight by which the women could do their work is often a key feature. In *The Newspaper*, Vuillard depicts his mother in a quiet moment before the workshop has come alive with the day's activities. The French window that establishes the main elements of the composition offers a view of the trees outside. An open shutter suggests depth, and voile curtains gathered to either side filter the morning light. Rather than work with the window's verticality, Vuillard has cut across it with an emphatically horizontal composition. As is often the case in his paintings of this period, chair backs offer foreground framing of other elements, making the viewer feel close to and part of the scene. Madame Vuillard is barely visible behind the newspaper, which we identify by its dimensions and the way she holds it rather than by specific description. The brown horizontal dabs of pigment defining it differ only slightly from the gray-blue and beige ones patterning the wall behind her. She herself is caught be-

tween the two, seamlessly becoming part of her environment. All are bathed in the same morning light that highlights a triangle of the underside of the tablecloth, turning it a brilliant red, as well as shining through her left ear as it streams into the room, elucidating the page before her.

In *Woman Sweeping*, Vuillard's mother is seen in profile in her brown-and-black striped dress, her hands one above the other on the broomstick as she moves across the room. The painting is a study in subtle shades of brown, a perfectly balanced composition, the verticals and horizontals in the door to the left and the chest of drawers offset by the large curving shape of an upholstered armchair in the left foreground and the patterned wallpaper. On top of the bureau, a bowl is the only circular element besides the head of Vuillard's mother, its highlights corresponding to the white ruffle at her neck. All participate in this balanced image of a domestic routine that Vuillard so closely observed and from which he created paintings of exquisite balance and harmony. ER

James Abbott McNeill Whistler

b. 1834, Lowell, Massachusetts, d. 1903, London

Portrait of Miss Lilian Woakes, 1890–1891
Oil on canvas, 21 ⅛ × 14 ⅛ (53.3 × 35.5)
Acquired 1920

James Abbott McNeill Whistler was an American-born painter and printmaker who resided for most of his life in London and Paris. When he was eleven years old his parents moved to St. Petersburg, Russia, where Whistler studied drawing at the Imperial Academy of Fine Arts. He returned to the United States in 1848 after the death of his father and attended the Military Academy at West Point, but at age twenty-one he left America to study art in Paris, and four years later he moved on to London. He subsequently divided his time almost evenly between the two cities. Whistler is as renowned for his paintings as he is for his etchings and lithographs, whose quality matched the mastery of his paintings in color, tone, and composition.

In the 1890s, with his health failing, Whistler painted seascapes at the coast in the summer and portraits, mostly of women and children, in his studio in London during the cold winter months. The portraits are painted largely with luminous blacks that reflect the artist's debt to the Spanish court painter Diego Velázquez, as well as a renewed preoccupation with the compositions of the British painter and printmaker William Hogarth.

The portrait of Lilian Woakes was most likely commissioned by her father, Edward G. Woakes, a surgeon at London Hospital and an acquaintance of Whistler's brother, also a doctor. Lilian was twenty-four or twenty-five years old when she posed for Whistler. The paint is applied with delicate yet confident brushstrokes, but more thickly than in the artist's earlier portraits, especially in the area of the face. This may be attributed as much to the artist's abandonment of the use of thinned pigment in his later years as to repeated revisions prompted by Whistler's somewhat excessive perfectionism. Although the portrait is praised today for its fine coloration and graceful composition, Whistler himself was never satisfied with it, adding "the little Woakes" in 1894 to a list of works that should be destroyed or touched up. Duncan Phillips, who bought the portrait in 1920, admired it greatly, commending the "vitality and subtle spirit" of the young woman and the portrait's "expression of the 'eternal feminine.'"

Like every painting executed after 1866, the *Portrait of Miss Lilian Woakes* features the artist's famous butterfly signature, originally a decorative monogram of the letters "JMW," which he also used to sign his letters and which most certainly was inspired by the signature seals of the Japanese ukiyo-e woodblock printmakers. The Phillips portrait actually bears two butterfly signatures. Having intended the sitter's pink bow at her neck to stand for his signature, he unhappily added a second butterfly to her left shoulder after Miss Woakes insisted on a more obvious signature. KO

References

All quotations by Duncan Phillips are available in
The Phillips Collection Archives (TPC Archives).

Rathbone essay, page 17, **"Art offers two great gifts of emotion…."**
Duncan Phillips, *A Collection in the Making* (New York and Washington,
1926), 3–4; page 17, **"A man may succeed in memorizing…."** Phillips,
"The Need of Art at Yale," *Yale Literary Magazine* 72, no. 9 (June 1907):
356; page 18, **"My own special function…."** Phillips, "A Collection Still
in the Making," in *The Artist Sees Differently: Essays Based upon the
Philosophy of a Collection in the Making* (New York and Washington,
1931), 12; page 18, **"Instead of the academic grandeur of marble
halls…."** Phillips, *A Collection in the Making*, 5–6; page 18, **"The
possessor of one of the greatest paintings…."** Phillips, letter to Dwight
Clark, treasurer of the Phillips Memorial Gallery, July 10, 1923; page 19,
"I could get lesser examples…." Phillips, letter to Guy Pène du Bois,
International Studio, December 20, 1923; page 19, **"I avoid the usual
period rooms…."** Phillips, *A Collection in the Making*, 6; page 19, **"Mr.
Holmes has risked a good deal…."** Roger Fry, "El Greco," in *Vision and
Design* (London, 1920); page 19, **"Art of building forms in space…."**
"Phillips, El Greco—Cézanne—Picasso," *Art and Understanding* 1, no. 1
(November 1929): 102; page 20, **"Cézanne would not have altogether
approved…."** ibid., 104; page 20, **"In spite of the fact…."** Phillips,
letter to Paul Rosenberg, October 18, 1951; page 20, **"Bonnard is the
supreme sensitivity…."** Phillips, *A Loan Exhibition: Six Paintings by
Bonnard*, exh. cat., The Phillips Gallery, Washington, 1958; page 21,
"first of all to establish a collection…." *Painting and Sculpture in the
Museum of Modern Art*, ed. Alfred H. Barr Jr. (New York, 1948), 7; page
22, **"preference to accept only such works…."** Phillips, letter to Marcel
Duchamp, July 25, 1952; page 23, **"Lived with, worked with…."** Phillips,
transcript of radio talk, "The Pleasures of an Intimate Gallery," WCFM,
Washington, DC, February 24, 1954; page 23, **"Pictures send us back
to life…."** Phillips, *A Collection in the Making*, 5, quoted in "Duncan
Phillips, Collector, Dies," *New York Times*, May 11, 1956.

Frank essay, page 25, **"While Phillips's high-profile acquisitions…."**
Phillips, "The Phillips Collection," No. IV of unpublished outline
prepared for E. Newlin Price, 1924; formerly MS 89, TPC Archives; page
25, **"In 1912 he characterized…."** Duncan Phillips, "City in Painting
and Etching," in *The Enchantment of Art: As Part of the Enchantment
of Experience Fifteen Years Later* (Washington, rev. ed. 1927), 82–83
(hereafter *E of A*); page 26, **"James Abbott McNeill Whistler was…."**
E of A, 207; page 26, **"In 1922, Augustus Vincent Tack…."** Letter from
Augustus Vincent Tack to his dealer John Kraushaar, August 8, 1922,
quoted in David W. Scott, "Mutual Influences: Augustus Vincent Tack
and Duncan Phillips," in Leslie Furth et al., *Augustus Vincent Tack:
Landscape of the Spirit* (Washington, 1993), 79; page 26, **"Phillips
already had an early landscape…."** Phillips, "Modern Wit in Two
Dimensional Design," *A Bulletin of the Phillips Memorial Gallery*
(October 1931–January 1932): 22; page 27, **"In his book *A Collection
in the Making*…."** Phillips, *A Collection in the Making*, 69; page 27,
"By 1917 Stieglitz had soured…." For an in-depth discussion of the
Stieglitz circle between the wars, see Introduction, "Spiritual America,"
in Wanda Corn, *The Great American Thing: Modern Art and National
Identity, 1915–1935* (Berkeley, 1999), 3–40; page 27, **"Such an American
art…."** Letter from Alfred Stieglitz to Paul Rosenfeld, September 5,
1923, in Elizabeth Hutton Turner, *In the American Grain: The Stieglitz
Circle at The Phillips Collection* (Washington, 1995), 15, n. 9; page 27,
"'American,' 'soil,' and 'spirit'…." Corn, *The Great American Thing*,
31; page 27, **"Just a month after discovering…."** Letter from Alfred
Stieglitz to Phillips, April 16, 1926, TPC Archives; page 27, **"Determined
that his artists…."** Letter from Alfred Stieglitz to Phillips, December
11, 1926, TPC Archives; page 28, **"He constructed a season…."** Phillips,
A Collection in the Making, 11; page 28, **"He gave special emphasis…."**
Phillips, *A Bulletin of the Phillips Collection* (February and March 1927),
12; page 28, **"Phillips wrote to Alfred Barr…."** Letter from Phillips to
Alfred H. Barr Jr., January 15, 1927, TPC Archives; page 28, **"The artist
John Graham…."** Letter from Phillips to John Graham, February 9,
1927, TPC Archives; page 28, **"About this time Phillips…."** Phillips, "An
Exhibition of Expressionist Painters from the Experiment Station of

the Phillips Memorial Gallery," Baltimore Museum of Art, April 8–May 1, 1927; page 28, **"The collection was being 'molded'...."** Phillips, "Free Lance Collecting," *Space* 1 (June 1930): 7; page 28, **"Never concerned with creating...."** Phillips, *A Collection in the Making*, 8; page 29, **"From the outset Phillips envisioned...."** Letter from Phillips to Guy Pène du Bois, December 20, 1923, TPC Papers, AAA, Reel 1929, frame 283; page 29, **"That idea encapsulated Phillips's...."** Phillips, *A Collection in the Making*, 13; page 30, **"Phillips purchased her work in 1926...."** Letter from Alfred Stieglitz to Phillips, March 4, 1926, TPC Archives; page 30, **"He spoke reverently of the collection...."** Richard Diebenkorn interview with Fritz Jellinghouse, 1982; page 30, **"'I've discovered pieces of that....'"** Diebenkorn's comments from "Documentary Film on The Phillips Collection," produced by Checkerboard Film, 1986, quoted in *The Eye of Duncan Phillips: A Collection in the Making*, ed. Erika D. Passantino and David W. Scott (Washington and New Haven, 1999), 800, n. 14 (hereafter *Eye*); page 30, **"He spent long hours...."** Paul Richard, "Full Circle for Noland, The Artist's Tribute to the Phillips," *Washington Post*, May 4, 1982; page 30, **"Phillips was attracted to artists...."** Phillips, "Contemporary American Painting," *A Bulletin of the Phillips Collection* (February–May 1928): 37; page 30, **"In 1929 he wrote that...."** Phillips, "The Palette Knife: A Collection Still in the Making," *Creative Art* 4 (May 1929): 23.

BURCHFIELD, page 43, **"As a twenty-one-year-old...."** Journals, May 27, 1914, Charles E. Burchfield Archives, Burchfield-Penney Center, Buffalo State College, Buffalo, New York. CÉZANNE, page 47, **"However, the artist wrote in 1905...."** *Eye*, 97. DAVIS, page 59, **"He worked on the series exclusively...."** Karen Wilkin, *Stuart Davis* (New York, 1987), 104; **"Davis later remarked to curator...."** Lowery Stokes Sims, *Stuart Davis* (New York, 1991), 190. DOVE, page 70, **"As an artist seeking to express...."** Dove, "An Idea," in 1927 Exhibition Statement, The Intimate Gallery; **"In these paintings...."** Arthur Dove, in Arthur Jerome Eddy, *Cubists and Post-Impressionism* (Chicago, 1914) 48; **"Georgia O'Keeffe**

once said...."** Herbert Seligmann, *Alfred Stieglitz Talking: Notes on Some of His Conversations, 1925–1931*, cited in Barbara Haskell, *Arthur Dove* (Boston, 1974), 118; **"Critic Paul Rosenfeld echoed...."** Paul Rosenfeld, *Port of New York* (New York, 1924), 88, cited in Elizabeth Hutton Turner, *In the American Grain: Arthur Dove, Marsden Hartley, John Marin, Georgia O'Keeffe, and Alfred Stieglitz* (Washington, 1995), 38; **"Dove readily embraced the idea...."** Arthur G. Dove, "Notes by Arthur G. Dove," December 19 [1928] and March 5 [1929], cited in Judith Zilczer, "Synaesthesia and Popular Culture: Arthur Dove, George Gershwin, and the 'Rhapsody in Blue,'" *Art Journal* 44, no. 4 (1984): 361. GAUGUIN, page 82, **"Do not paint too much after nature..."** *Eye*, 111. GRAVES, page 94, **"seeker of truth, a thinker...."** *Eye*, 577; **"to symbolize the fate of man...."** *Eye*, 578; GRIS, page 96, **"Mine is the method..."** *Eye*, 264. KANDINSKY, page 113, **"Similarly, Kandinsky thought that line...."** *Eye*, 271; KLEE, pages 118, 119, **"From the beginning...."** Jürg Spiller, ed., *Paul Klee Notebooks*, vol. 1 (1961, repr. London, 1978), 105; **"Of course the painter...."** Ludwig Grote, ed., *Erinnerungen an Paul Klee* (Munich, 1959), 91, cited in Norbert Lynton, *Klee* (1964, repr. New York, 1975), 66; **"To Duncan Phillips...."** Phillips, "Modern wit in two-dimensional design," *Bulletin* (October 1931–January 1932): 20; KOKOSCHKA, page 120, **"Kokoschka wrote to her...."** *Eye*, 297. LOUIS, page 126, **"The work of Frankenthaler...."** James M. Truitt, "Art—Arid D.C. Harbors Touted 'New' Painters." *Washington Post* (December 21, 1961): A20; **"From the top of his large work stretcher...."** Diane Upright, *Morris Louis: The Complete Paintings* (New York, 1985), 57. **"The flare marks at top are drip marks...."** ibid. **"When asked if his paintings...."** Quoted in Daniel Robbins, "Morris Louis: Triumph of Colour." *Art News* 62, no. 2 (October 1963): 29. NOLAND, page 158, **"He then freely painted in...."** William C. Agee, *Kenneth Noland: The Circle Paintings 1956–1963* (Houston, 1994), 15; **"He based the color of each...."** ibid., 15; **"Nearly a decade after Duncan Phillips...."** *Eye*, 648, n. 9. O'KEEFFE, page 160, **"Art was about...."** Katherine Kuh, "Georgia O'Keeffe," in Kuh, *The Artist's Voice* (New York, 1962), 190; **"She called the massive adobe..."** Georgia

O'Keeffe, *Georgia O'Keeffe* (New York, 1976), opp. pl. 63; RENOIR, page 178, **Luncheon of the Boating Party is the subject of essays by** Charles S. Moffett, Eliza E. Rathbone, and Elizabeth Steele in *Impressionists on the Seine: A Celebration of Renoir's "Luncheon of the Boating Party,"* exh. cat., The Phillips Collection (Washington, 1996). See also *Eye*, 108–109. SHEELER, page 192, **"Sheeler had been drawn to the skyscraper...."** Jan-Christopher Horak, "Modernist Perspectives and Romantic Desire: Manhatta," *Afterimage* 15 (November 1987): 8–9, cited in Karen Ouci, *Charles Sheeler and the Cult of the Machine* (Cambridge, Mass., 1991), 51; **"As he once said...."** Martin Friedman and Charles Sheeler, "Charles Sheeler Talks with Martin Friedman," *Archives of American Art Journal* 16, no. 4 (1976): 18. SOUTINE, page 202, **"Created when Soutine was returning...."** Maurice Tuchman, *Chaim Soutine 1893–1943* (Los Angeles, 1968), 48; **"Although handled with a nervous...."** *Chaim Soutine 1893–1943*, exh. cat., Tate Gallery (London, 1963), 26; **"Looking to the history of art...."** Monroe Wheeler, *Soutine* (New York, 1950), 109; **"He used the great masters...."** Norman L. Kleeblatt and Kenneth E. Silver, *An Expressionist in Paris: The Paintings of Chaim Soutine* (New York, 1998), 138; **"The children have been interpreted...."** ibid., 138; **"Duncan Phillips described...."** *Eye*, 231; TOMLIN, page 212, **"The display of marks...."** Lawrence Alloway, "The New American Painting," *Art International* 111, nos. 3–4 (1959): 23; **"Luminous in palette...."** Irving Sandler, *The Triumph of American Painting* (New York, 1970), 244; **"Attracted to the artist's 'rich....'"** *Eye*, 557; **"Phillips wrote for the exhibition catalogue...."** *Bradley Walker Tomlin*, exh. cat., Whitney Museum of Art (New York, 1957), 13. WHISTLER, page 218, **"Although the portrait is praised today...."** Letter from J.A.M. Whistler to Beatrix Whistler, November 19, 1895, MS Whistler W637, Glasgow University Library.

Other authors who contributed to this volume are Virginia Speer Burden (VSB); Leslie Furth (LF); Grayson Harris Lane (GHL); Laurette E. McCarthy (LEM); Richard Rubenfeld (RR); Elizabeth Tebow (ET), and Leigh Bullard Weisblat (LBW).

Index

Page references in *italics* are to images shown in the introductory text. Page references in **bold** are to works illustrated in the entries for individual artists.